THE
NATIONAL PORTRAIT GALLERY

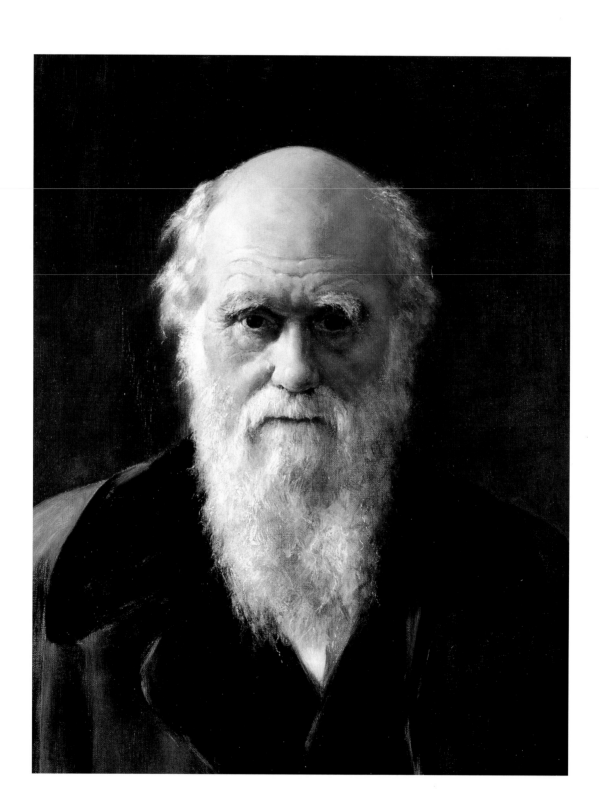

THE
NATIONAL PORTRAIT GALLERY

by

CHARLES SAUMAREZ SMITH

DIRECTOR

NPG

Published in Great Britain by
National Portrait Gallery Publications
National Portrait Gallery
St Martin's Place
London WC2H 0HE

ISBN hb 1 85514 214 7
 pb 1 85514 199 X

A catalogue record for this book is available from the British Library.

Publishing Manager: Jacky Colliss Harvey
Picture Research: Susie Foster
Designed by the Senate
Printed by PJ Reproductions

For a complete catalogue of current publications, please write to the address above.

Front cover: ELIZABETH I by Marcus Gheeraerts the Younger, *c.*1592 (detail). NPG 2561
Back cover: QUEEN ELIZABETH II by Andy Warhol, 1985 (detail). NPG 5882/1-4
Frontispiece: CHARLES DARWIN by John Collier, 1881 (detail). NPG 1024
All of the above portraits are illustrated in full within the book.

CONTENTS

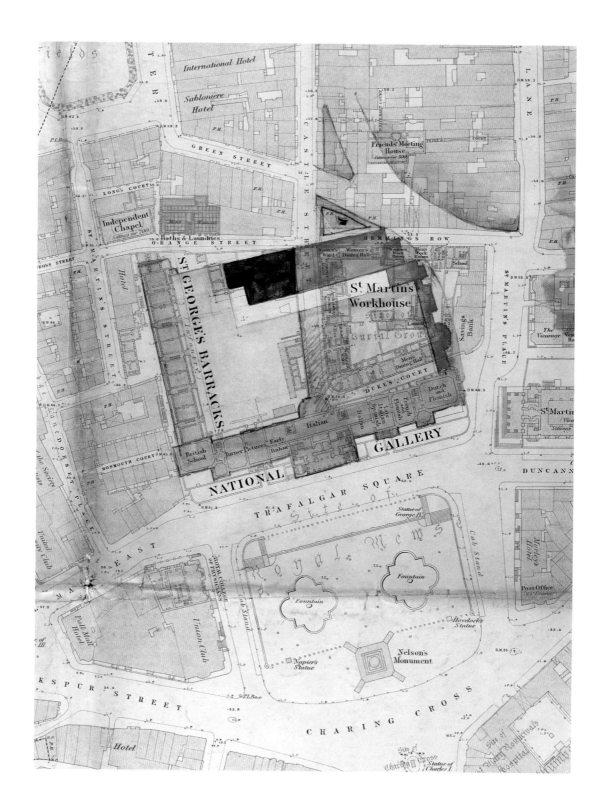

The site of the National Portrait Gallery, hand-coloured on an Ordnance Survey map of 1871.

ACKNOWLEDGEMENTS

Sometime in spring 1996 I was summoned to a meeting about the Gallery's publications, at which it was made clear that the well-established introduction to the Gallery, *The National Portrait Gallery Collection*, was due to sell out the remainder of its print run in 1997. Should it be reprinted? We agreed that ideally it should be not just reprinted but thoroughly revised. It was not only that the introduction was written by my predecessor, John Hayes: the balance of the plates inevitably reflected his views of the Gallery. Especial prominence was given to the Gallery's outstations, and there were not many plates devoted to sculpture, photography or to post-war portraits. The question arose as to who should undertake the task of revision and I was volunteered. I agreed because I viewed it as an extremely beneficial way of familiarising myself with the full range of the Gallery's collection; but, in saying this, I should make clear that this book is *not* intended for specialists and that I have written it in such a way that it provides the type of information I wanted to know about the portraits when I joined the staff of the Gallery as Director in January 1994.

In undertaking the task, I have been enormously assisted by my colleagues. There are two great benefits of working at the National Portrait Gallery (and others besides): one is that there is always someone who can answer any question one has about the collection; and the other is that the collection is extraordinarily well documented, with a long and admirable tradition of keeping information relating to acquisitions. I have made free use of the files and of the Gallery's published catalogues. Most especially, I am grateful to Lucy Clark, Honor Clerk, Jacky Colliss Harvey, John Cooper, Judith Flanders, Emma Floyd, Susie Foster, Peter Funnell, Robin Gibson, Julia King, Catharine MacLeod and Jacob Simon. I am also indebted to Claire Tomalin, who read and provided detailed comments on the text on behalf of the Trustees.

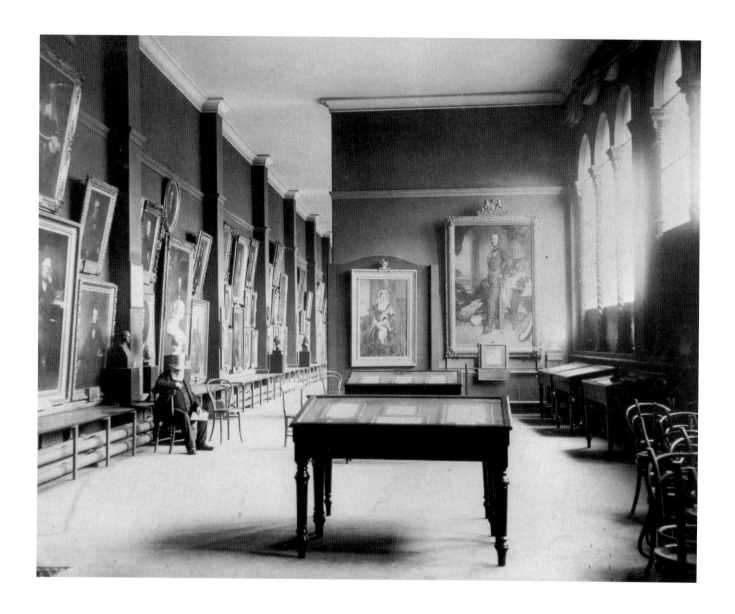

George Scharf (1820-95), originally secretary to the Trustees of the National Portrait Gallery, and in 1882 given the title of the Gallery's first Director, photographed in the South Kensington building which the Gallery occupied from 1870 to 1885. Among the nineteenth-century portraits identifiable in this photograph are Lady Julia Abercrombie's watercolour of Queen Victoria (1875) and Francis Xavier Winterhalter's full-length oil of Prince Albert (1867).

INTRODUCTION

On 4 March 1856, Philip Henry Stanhope, 5th Earl Stanhope, made a statement to the House of Lords in which he pleaded for the establishment of a National Portrait Gallery:

> He thought he could not better introduce this question to their Lordships than by asking the greater number of them to recall to mind what they had seen in the galleries of the Palace of Versailles. Many among their Lordships must there have felt no small degree of weariness and disgust on passing through an almost interminable line of tawdry battle scenes and Court pageants of the largest dimensions. Not a few of these battle scenes would no doubt recall the words of a modern author, who had described another such huge picture in England as "an acre of spoiled canvas". Many such acres of spoiled canvas presented themselves upon the walls of Versailles; but their Lordships would also recollect the great pleasure, and as it were refreshment, with which they passed from these tawdry battle pieces and Court pageants into a gallery of much smaller dimensions, and much less gorgeous decorations, containing excellent contemporary portraits of celebrities in French history. He thought few Englishmen could have been at Versailles without wishing that in our own country, while the errors of the larger galleries should be avoided, some attempt should be made not only to emulate, but to extend the example set in the smaller one.

The rhetoric that Lord Stanhope uses to introduce the idea of a National Portrait Gallery is revealing. He plays upon three notions behind the idea of establishing one. He appeals to residual anti-French sentiment by referring to how boring are large acres of historical painting in Versailles; then he encourages a spirit of national rivalry by making it clear that, although other members of the peerage may not previously have recognised it, there was an area in which the French had done something better than the English – the display of historical portraits; then he points out that these exist in ample numbers in English country houses, implicitly invoking a sense of public good that these might be better out of the hands of private owners and transferred into the care of the state.

Three months after the debate in the House of Lords, Parliament agreed to vote a sum of £2,000 to the establishment of a 'British Historical Portrait Gallery'. William Gladstone, then Chancellor of the Exchequer, answered a question in Parliament as to the purposes of the Gallery, which echoed the sentiments of Lord Stanhope, describing how,

> Owing to our happy exemption from intestine disturbances, civil wars, and other causes by which the houses of distinguished families in other countries had been destroyed and their collection of works of art dispersed, there existed, he believed, in the Inns of Court, the colleges, the bishops' palaces, the public institutions, and the large country houses of this country, a greater number of valuable historical portraits than any other nation of Europe would be found to possess.

Plaster cast from the medallion portrait bust of Philip Henry Stanhope, 5th Earl Stanhope (1805-75), situated above the main entrance to the National Portrait Gallery.

The medallion portrait bust of Sir Thomas Carlyle (1795-1881), *in situ* above the main entrance to the Gallery. Julia Margaret Cameron's 1867 photograph of Carlyle is reproduced on page 137.

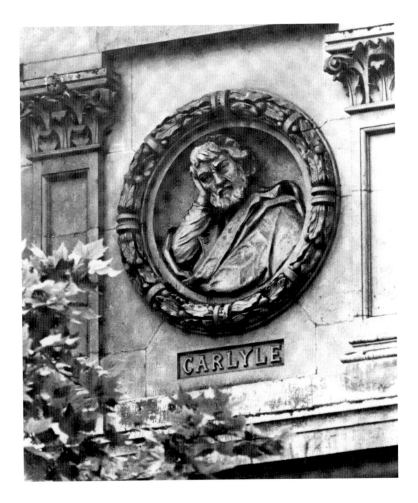

Almost immediately following this debate, Lord Ellesmere, a former Trustee of the National Gallery and the owner of a house in Cleveland Row to which the public were admitted to view his collection of paintings, offered to the nation the so-called Chandos portrait of Shakespeare as the first portrait for the newly established collection. In a letter thanking him on 10 June 1856, Gladstone wrote:

> I quite concur in your remarks as to the propriety of making history, and not art, the governing principle for the formation of this gallery, and it is the intention of the government to regulate the selection of trustees or managers by this standard. The authenticity of a portrait, and the celebrity of the person represented, will be the grounds for the admission of a picture, and not its excellence as a work of art.

The criteria for admission to the Gallery, then, were quite clear. The Gallery was to be about history, not about art, and about the status of the sitter, rather than the quality or character of a particular image considered as a work of art.

The first chairman of Trustees was Lord Stanhope. The idea for a National Portrait Gallery had been his. He was a historian – not, even by the standards of his day, a very good historian, but an extremely conscientious and industrious one committed to the study of original documents, and the author of now unread, multi-volume works such as *The History of the War of Succession in Spain*, first published in 1832, and *The History of England from the Peace of Utrecht to the Peace of Versailles*.

Alongside Lord Stanhope sat other Victorian grandees. There was the Marquess of Lansdowne, a former Chancellor of the Exchequer; Lord Elcho, a staunch Tory and art collector; Sidney Herbert, a former minister in Palmerston's administration; Disraeli, who had supported the establishment of the Gallery when it was first proposed in 1852; Lord Macaulay, the first volumes of whose great *History of England* had been published in 1849, to tremendous critical as well as popular acclaim; Sir Francis Palgrave, another formidable historian; Sir Charles Eastlake, Director of the National Gallery, President of the Royal Academy and himself a portrait painter of some note; and William Carpenter, Keeper of Prints and Drawings at the British Museum, who acted as secretary to the Trustees until the appointment of George Scharf the following year. Oddly, Thomas Carlyle was made a Trustee only on the death of Lord Ellesmere in February 1857.

The founding fathers of the National Portrait Gallery appear in roundels over the front door to the Gallery: Stanhope, with his historical and documentary sense of the importance of preserving records of British history; Macaulay, with his highly developed idea of the destiny and trajectory of the British past, shaped by Whig ideals; and perhaps above all Thomas Carlyle, who in 1854, when advocating a National Exhibition of Scottish Portraits in Edinburgh in 1855, had written a letter describing the importance which he attached to the study of portraits:

> I have to tell you, as a fact of personal experience, that in all my poor Historical investigations it has been, and always is, one of the most primary wants to procure a bodily likeness of the personage inquired after; a good *Portrait* if such exists; failing that, even an indifferent if sincere one. In short, *any* representation, made by a faithful human creature, of that Face and Figure, which *he* saw with his eyes, and which I can never see with mine, is now valuable to me, and much better than none at all. This, which is my own deep experience, I believe to be, in a deeper or less deep

degree, the universal one; and that every student and reader of History, who strives earnestly to conceive for himself what manner of Fact and *Man* this or the other vague Historical *Name* can have been, as the first and directest indication of all, search eagerly for a Portrait, for all the reasonable Portraits there are; and never rest till he had made out, if possible, what the man's natural face was like. Often I have found a Portrait superior in real instruction to half-a-dozen written "Biographies", as Biographies are written; or rather, let me say, I have found that the Portrait was a small lighted *candle* by which the Biographies could for the first time be *read*, and some human interpretation be made of them.

This then was the spirit in which the National Portrait Gallery was founded: a spirit of high Victorian enquiry into the character of important figures in the British past; celebratory perhaps, but animated by much more than just an idle desire to commemorate famous individuals; moralistic certainly, in terms of the discussion as to who should be represented and why, although it should be pointed out that, in the first parliamentary debate about the proposed formation of the Gallery, it was recognised that the selection should be reasonably inclusive in terms of its understanding of what constituted fame. The intention of the National Portrait Gallery was perhaps above all documentary, animated by a desire to provide an insight into the past, which is not necessarily provided by more conventional, text-based, source material.

The Trustees first met on 9 February 1857. Between them Lord Stanhope and William Carpenter drafted the Resolutions that were to guide the Trustees in future acquisitions. Although there have been some slight changes to this wording and one very significant alteration, the Rules remain substantially those that guide acquisitions to the present day. Indeed, even now Trustees have an updated version in front of them at every meeting. Rule 1 was as follows:

I. The rule which the Trustees desire to lay down to themselves, in either making purchases or receiving presents, is to look to the celebrity of the person represented rather than to the merit of the artist. They will attempt to estimate that celebrity without any bias to any political or religious party. Nor will they consider great faults and errors, even though admitted on all sides, as any sufficient ground for excluding any portrait which may be valuable, as illustrating the civil, ecclesiastical, or literary history of the country.

This is a fine piece of Victorian constitution making: clear, explicit and well judged.
Rule 2 was that:

II. No portrait of any person still living, or deceased less than 10 years, shall be admitted by purchase, donation, or bequest, except only in the case of the reigning Sovereign, and of his or her Consort, unless all the Trustees in the United Kingdom, and not incapacitated by illness, shall either at a meeting or by letter signify their approbation.

This was the rule that was changed in 1969 in order to encourage a policy of admitting living sitters.
Rule 3 was:

III. No portrait shall be admitted by donation, unless three-fourths at least of the Trustees present at a meeting shall approve it.

My experience of the rules in operation is that they work well. They indicate the key considerations of the status and significance of the sitter, without stating how that status and significance should be assessed, beyond the fact that the decision should be non-partisan. In practice, the process of selection has always been, and remains, a matter of judgement for the Trustees, who have tended to be a mixture of historians, landed gentry with family collections of portraits, writers and especially biographers, the odd peer and, now, one or two businessmen, together with two members who are *ex officio*, the President of the Royal Academy, who provides an admirable counter-balance by virtue of not being a government appointee, and the Lord President of the Council, who, in living memory, has not been known to attend.

If one is to try to get beyond the rules into the process of acquisition and the criteria that have governed the selection of portraits, one can only try to analyse actual acquisitions and how judgements were made about the desirability or otherwise of particular portraits. Some indication of the way the process operates can be determined by analysis of the earliest acquisitions.

After Shakespeare, the second acquisition for the collection was a portrait of the artist Thomas Stothard by James Green, which was presented in February 1857 by J.H. Anderdon. W.H. Carpenter wrote to Lord Stanhope on 23 February 1857:

> I have great pleasure in stating to your Lordship that my friend Mr Anderdon of Up[per] Grosvenor Street, who I saw at Christies after the meeting this afternoon has signified to me his wish to present to the Trustees a portrait of the late Thomas Stothard the eminent artist. It is painted by Green and was purchased at the sale of Mr Samuel Rogers and is unquestionably the most characteristic resemblance of the man extant. Mr Anderdon wishes it exhibited at Manchester; but he at the same time desires me to say, that if the Trustees desire it, it shall at once be sent to Gt. George Street.

The tone is one that I recognise: in case Lord Stanhope is sceptical that Thomas Stothard was worthy of consideration, W.H. Carpenter describes him as 'the eminent artist'; and he reinforces the appropriateness of the acquisition by stating that it is 'unquestionably the most characteristic resemblance'; the appeal is both to likeness and to the fact that the opportunity to acquire a good likeness might not occur again. It probably did not hurt that the portrait was offered as a gift.

The acceptance of NPG 2 shows the beginning of a subtly different categorisation from NPG 1: Stothard may not have been of great national importance but he is important as a British artist, and portraits of artists, especially self-portraits, have always been admitted slightly more generously than, say, portraits of engineers. It is quite a fine portrait but not one of the stars of the collection.

NPG 3 was a portrait of William Wilberforce by Sir Thomas Lawrence. This was offered to the Trustees by Sir Thomas Acland of Killerton in Devon, who was acting as executor for the will of Sir Robert Inglis, who had commissioned the painting. He wrote:

The interior of 29 Great George Street. As in his later sketches of the Gallery's other homes at South Kensington and Bethnal Green, Scharf was careful to annotate his drawings with details of the building's condition.

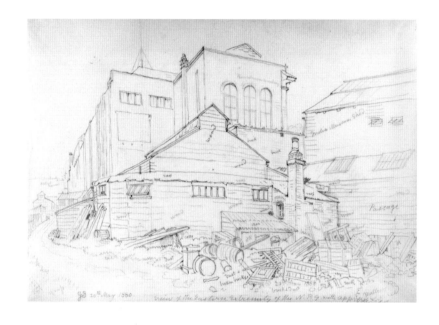

Scharf's sketch of the back of the South Kensington building. The danger that would have been posed by a fire on this site is all too obvious, even without Scharf's annotations of 'wood', 'straw', 'sack' and 'dust and broken bricks'.

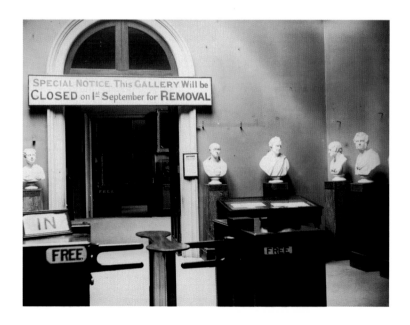

'Closed for removal' - the turnstiles at South Kensington on the eve of the Gallery's removal to Bethnal Green. Marks and bare fixings on the walls indicate where paintings have already been taken down. A number of the busts recorded here can be seen in the new nineteenth-century galleries of the present-day Gallery.

The will bears date in February 1854 when the Establishment of the National Portrait gallery had not been I think even proposed publicly and therefore as some discretion with regard to the actual localization of the bequest seems still to rest with the Executors we consider ourselves justified in making your Lordship and your colleagues the Commissioners for the formation and superintendence of the Portrait gallery the first offer of such of the Portraits named in the Codicil to Sir Robert's will as you may think conformable with the object for which the Gallery is established and shall feel very happy in so contributing in whatever degree to the value of your undertaking on behalf of our excellent friend than whom had he lived, no one would have more highly appreciated the design of your Labours.

At the same time as the Trustees accepted the portrait of Wilberforce – a painting of obvious national importance – they turned down a portrait of Sir Hugh Inglis by Romney on the grounds, as they described it, of 'it not coming within the rules they have found it necessary to lay down for their guidance: they however venture to suggest that from the eminence of the Artist the picture in all probability be considered a desirable acquisition to the National Gallery Trafalgar Square'. In other words, in spite of the picture's being by Romney, an artist of obvious national importance, Sir Hugh Inglis was not regarded as up-to-snuff. This is how acquisitions policy has traditionally been established: then as now, as much by what was turned down as by what was accepted.

Soon after the first meeting of the Board, the Trustees set about selecting someone to run the affairs of the Gallery. George Scharf, the thirty-seven-year-old son of a Bavarian watercolour painter, was appointed secretary to the Trustees in a Treasury minute dated 4 March 1857. It was an inspired choice.

All new acquisitions for the collection were hung hugger-mugger in what was regarded as temporary accommodation at 29 Great George Street, Westminster, where Scharf himself took up residence, so as to act as custodian and nightwatchman, alongside his other duties. In fact, as so often happens with public expenditure, the public had to wait forty years before the collection was properly displayed in purpose-built accommodation in St Martin's Place, just north of the National Gallery. In the interim, the Gallery was moved – first to South Kensington, where it joined the miscellaneous collections of the Department of Science and Art in 1870, and then, following a fire in 1885, to Bethnal Green. Conditions there were generally regarded as a disgrace, and a campaign was mounted both in Parliament and in the correspondence columns of the newspapers for Parliament to provide it with its long-promised permanent building.

The new building was the result of a private benefaction by a philanthropist, W.H. Alexander, who on 4 May 1889 was reported to have offered to pay for the building, provided the government gave a site within a mile and a half of St James's Street. The site they gave, immediately adjacent to the National Gallery, is not, and never was, ideal, wrapped around the much more prominent National Gallery, as Henry James described it, like a bustle attached to the cladding of the National's posterior; but it provides part of

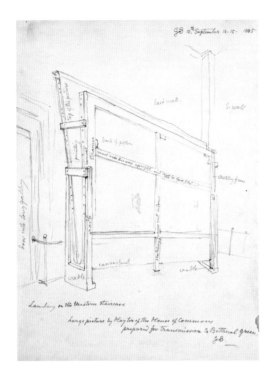

Sir George Hayter's oil-painting of *The House of Commons* (1833-43) prepared for its move to Bethnal Green. This work, which contains nearly 400 figures, measures 3 metres high by almost 5 metres wide. Scharf's notes on the sketch, annotated precisely to 12.15pm on the 10th September 1885, include the warning 'must ride this way upright and <u>not</u> be laid flat'.

A view across the interior of the Bethnal Green building. The paintings on the ground floor shared space with an exhibition of animal products.

Inside the Bethnal Green building. The portraits visible in this 1880s photograph include *Oliver Cromwell* by Robert Walker (see page 62).

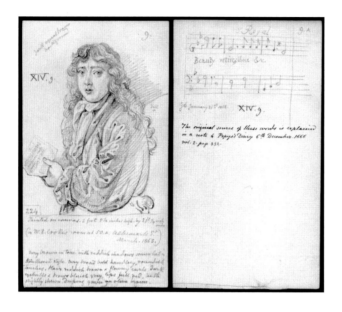

Scharf's sketches of *Samuel Pepys* by John Hayls (see page 69), with meticulous notes on colour, condition and on the extra detail of the sheet of music Pepys holds in his hand. There is also a further record that in March 1863, when Scharf presumably made this drawing, the painting was in 'Mr R. Cooks's rooms at 50A Albemarle Street'. The work entered the collection of the National Portrait Gallery in 1866.

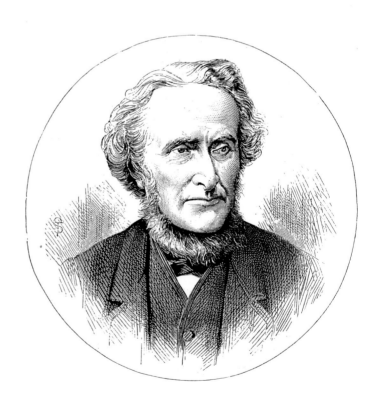

Ewan Christian (1814-95), the architect nominated by W. H. Alexander to design the National Portrait Gallery.

the character of the institution, its slight reticence, its absence of a pompous façade, the fact that it is in the centre of town but not known to everybody.

One of W.H. Alexander's other requests was that the building should be designed by an ecclesiastical architect, Ewan Christian; and he too contributed a great deal of the character of the building, by producing a design that, in its east wing, deliberately adopted the style of the National Gallery and, in its main façade at the bottom of St Martin's Lane, changed to an under-articulated version of an Italian palazzo. It is not a great work of architecture but it provides well-lit, reasonably small-scale galleries.

Only three weeks after the announcement of W.H. Alexander's gift to the nation at a Royal Academy dinner, George Scharf had drawn up a brief for the architect. His 'Requirements for a National Portrait Gallery' is an interesting document. The first requirement was that there should be 'No communication whatever with the National Gallery', a request the architect adhered to; and no pictures were 'to be beyond reach of the eyes & the rooms not required to be very lofty' (Scharf added that 'Those in the N[ational] G[allery] are in the main much higher than portraits would require'). In fact, part of the rationale behind the design was precisely that it should be different from the National Gallery, less grand, more accessible, planned with the pictures in mind and to provide a feeling of domestic space.

In accomplishing their purposes, George Scharf and Ewan Christian were remarkably successful but, sadly, neither of them lived to see the opening of the building. Ewan Christian died of a chill in February 1895; George Scharf was compelled by ill health to resign from the post of Director shortly afterwards and died on 19 April 1895. He was a great man, meticulous, deeply knowledgeable, committed to the Gallery and especially to its acquisitions, travelling the country with a notebook in which he would record features of portraits, which remain an important record of those that have been lost.

Scharf was succeeded by a much more worldly character, Lionel Cust, an Old Etonian who had previously worked in the Department of Prints and Drawings at the British Museum. He, like Scharf, was a good antiquarian, with an encyclopaedic memory, but one has the impression from the book he wrote about *Edward VII and His Court*, published posthumously in 1930, that he appreciated the position principally for its salary, however meagre, and the opportunities it afforded for making friends with the Prince of Wales. He quite soon accepted a second position, as Surveyor of the Royal Collections, a position to which he devoted much more of his energy. In 1909 he resigned the post of Director, because of problems with his eyesight.

Cust was succeeded by a painter, Charles Holmes, who also wrote an autobiography, *Self and Partners (Mostly Self) Being the Reminiscences of C.J. Holmes*, an attractive volume of reminiscences about his exploits as an angler. But Holmes, I suspect, should not be underestimated. He set about the task of redisplaying the collection with vigour. As he wrote in his autobiography:

> The building in St Martin's Place, a generous gift from Mr W.H. Alexander, was
> singularly ill-adapted to its purpose. Even when first opened, it could barely house
> the portraits; as these increased in number year by year, the congestion became worse
> and worse. Plans and talk of extension, at some future date, there might be; but

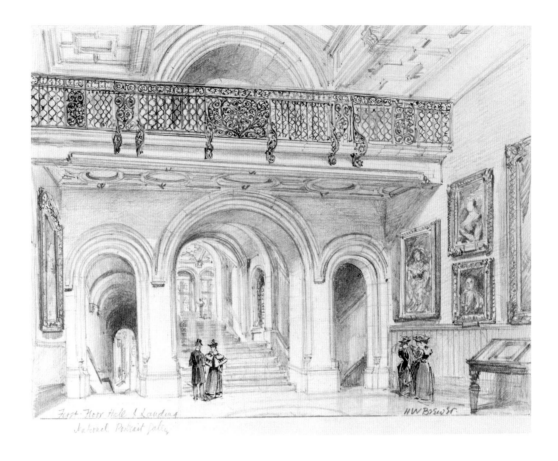

The staircase landing of the new National Portrait Gallery, reproduced in a sketch by H. W. Brewer for the *Graphic* of 4 April 1896. The influence of Ewan Christian's earlier training in ecclesiastical architecture is clear.

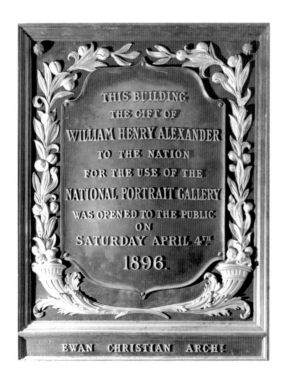

The dedication plaque for the National Portrait Gallery.

nothing more. The potentialities of the Gallery as a vivid illustration of our national history had always appealed to me. This power for good was obscured, almost annihilated, by the very look of the place. If it was ever to become a real educational influence it would have to attract the public by its general appearance, its contents, and its publications. What were the facts? The portraits, good and bad, important and unimportant, were crowded together in monotonous rows, according to size, against a shabby green wall-paper. The catalogue was equally crowded and uninviting. The floor was of rough bare boards. The gloomy entrance and cavernous stairways were obstacles which we should have to accept: the rest could be dealt with, in time.

Holmes stayed for what he described as the seven happiest years of his life, blessed by friendly and supportive Trustees, before being translated next door to the Directorship of the National Gallery, where the Trustees were neither friendly nor supportive but constantly trying to pre-empt the decisions of the Director and bickering among themselves. Nonetheless, the time Holmes spent at the National Portrait Gallery was not without incident. In July 1914 Millais' portrait of Carlyle was attacked by a suffragette, and at the time of Holmes' move to the National Gallery, the Portrait Gallery had been closed to the public and much of the collection removed for fear of its being damaged by German air-raids. The Portrait Gallery was not re-opened until 1920.

The next Director was Holmes' assistant, James Donald Milner, a conscientious but perhaps rather dim figure who had joined the staff of the Gallery in 1893 as clerk to George Scharf and had been passed over for the Directorship in 1909 on the grounds that he was a second-division civil servant, at a time when the civil service was profoundly hierarchical. He lasted till 1927, when he was replaced by Henry Mendelssohn Hake, a larger-than-life character, who was always known as 'Imperial Hake'. He was well described by a later Director, Sir David Piper, in a chapter of his unpublished autobiography, as

> … a tall but squareish man, large brow, with a square head, light hair cropped very close, pale eyes, thin mouth. He dressed in a dark jacket and trousers, ankle boots. He moved with a certain ponderous deliberation, sometimes, I used to think, as if he were a man-of-war manoeuvring in a dock too small for comfort. His hands, though, and his handling, of books, photographs or works of art, were unexpectedly delicate, and his features, when so engaged, would screw up, almost crack, in concentration. His smile, when it came, was slow and warm, but, if roused, he bristled, and an armament, indeed as if a man-of-war, threatened.

Until 1950 Hake ruled the Gallery with great authority and a detestation of large classes of person, including all art historians associated with the Courtauld Institute. He oversaw the opening of the Duveen wing in 1933, the removal of much of the collection to Mentmore for safekeeping in 1939, and the eventual full re-opening of the Gallery to the public in July 1945. Hake was succeeded by Charles Kingsley Adams, a saintly and rather unworldly character, who joined the staff of the Gallery in 1919 under Milner and retired as Director in 1964.

The post-war National Portrait Gallery was, so far as it is possible to judge from Sir David Piper's autobiography, a fairly quiet and scholarly establishment, allowing time for him when he was an Assistant

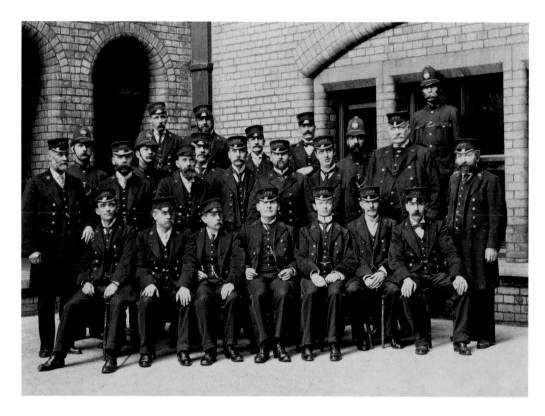

National Portrait Gallery attendants and police in the early 1900s.

H. M. Hake (1892-1951), Director of the National
Portrait Gallery from 1927 to 1950.

Keeper to make long peregrinations at lunchtime, before tea in the Director's office, and the writing of detective novels in the evening. But the Gallery continued to make fine acquisitions, to devote resources to the conservation of pictures and to assist scholars with access to the Gallery's excellent archives. In 1959 David Piper published the first of a new series of scholarly catalogues on the seventeenth-century collection, and in 1964 he became Director, remaining only for a period of three years before moving on to become Director of the Fitzwilliam Museum in Cambridge. Although the Gallery may not have attracted large numbers of visitors, my impression is that it was well run in an unpretentious way. The Trustees' Reports reveal how much was achieved with very limited resources and a minuscule staff, including exhibitions on Shakespeare and the Winter Queen.

Meanwhile a more revolutionary figure had been appointed to the staff, the young Roy Strong, who joined the Gallery as an Assistant Keeper in 1959, after completing a doctorate at the Warburg Institute. In 1967 he succeeded David Piper as Director.

Sir Roy Strong and his successor John Hayes have, in their very different ways, been important figures in the museum world and have contributed to the high standing of the Gallery today. Roy Strong was responsible for fireworks during his period as Director: a succession of great and memorable exhibitions, including one of Cecil Beaton's photographs in 1968, which was designed by Richard Buckle and attracted 75,000 visitors, and an exhibition on Samuel Pepys in 1970, designed by Julia Trevelyan Oman; the redisplay of the top-floor galleries, with accompanying historical documentation, engravings, maps, furniture, arms and armour; the end of the so-called ten-year rule, whereby the Gallery would only acquire portraits of sitters who were dead, and the beginnings of the Contemporary Portraits Collection; the opening of a department of film and photography; the commissioning of Annigoni to paint the Queen, a portrait seen by nearly 250,000 people during the first two months that it was on display in 1970; and, not least, the decision in 1972 to make a substantial loan of sixteenth- and seventeenth-century portraits to Montacute, a National Trust house in Somerset, in order to show portraits in their original surroundings, an idea that Strong had first suggested in his interview for the post of Director in 1967.

In a lecture Roy Strong gave, published in 1970, he described how

> It still comes as something of a pleasurable surprise to be introduced these days as Director of the National Portrait Gallery and get an immediate warmth of response. Eight years ago when I began there as a humble Assistant Keeper I spent most of my time trying to cover up my connection with the Gallery or apologising for the place. "Oh, that awful morgue" was a not unusual response. To have begun to erode this equation of Portrait Gallery with instant gloom and a foot weary depression of spirits, both aesthetic and intellectual, may, one hopes, be counted as something of an achievement.

Indeed it was; and it was not, I suspect, an easy task that John Hayes faced as incoming Director in 1974, when Roy Strong left for the Directorship of the V&A. But John Hayes' achievements, although different in character, are equally notable. Certainly I feel that the National Portrait Gallery is an institution that has been extraordinarily well run, with good staff relations and high morale, a remarkable output of excellent exhibitions, especially considering the small numbers of professional staff, and a notable track record of judicious acquisitions, though since 1982 the government grant for acquisitions has been frozen at £310,000, a sum that is not really enough to buy a single major painting.

The Duveen wing of the National Portrait Gallery, opened in 1933.

Sir Roy Strong, photographed by Cecil Beaton in front of *The Somerset House Conference*
(see page 50).

John Hayes embarked on the policy of commissioning portraits. Under his aegis, the Gallery established the BP Portrait Award (originally the Imperial Tobacco Award), which has become an extremely valuable part of its public programme, both popular and important in the way in which it encourages young artists to take up the challenge of portraiture. Perhaps above all, he was responsible for the launch of the development appeal for the Gallery in November 1989, an appeal that succeeded in completely transforming the public face of the Gallery, when the new twentieth-century galleries were opened in November 1993, beautifully designed by the architect John Miller and his partner, Su Rogers; it has a new exhibition gallery, funded by the Wolfson Foundation; it has studio space for the education department, which enables its staff to introduce issues (to adults as well as to children) relating to portraiture, including portrait photography, through its practice; we have much better access for disabled visitors; and, across the road, in new premises on the north side of Orange Street, we have a new archive and library, generously funded by Mrs Drue Heinz DBE, and new offices for all the staff – a great contribution to good staff morale.

For the future, plans and funding are in place for further developments and improvements to the gallery. These will include a new basement lecture theatre, a new Tudor gallery, housing some of the most popular and important portraits in the collection, and a new balcony gallery for portraits from the 1960s and 1970s. After just over a hundred years, Ewan Christian's original plans for the site of the National Portrait Gallery will finally be brought up to the present day, thanks to the generosity of the Heritage Lottery Fund and individual donors.

The new early
twentieth-century gallery.

The corridor in the new nineteenth-century gallery.

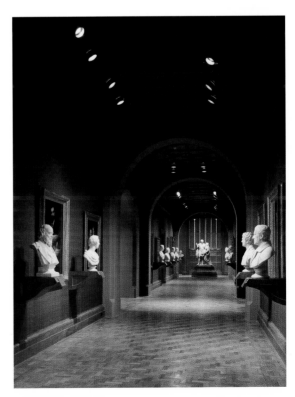

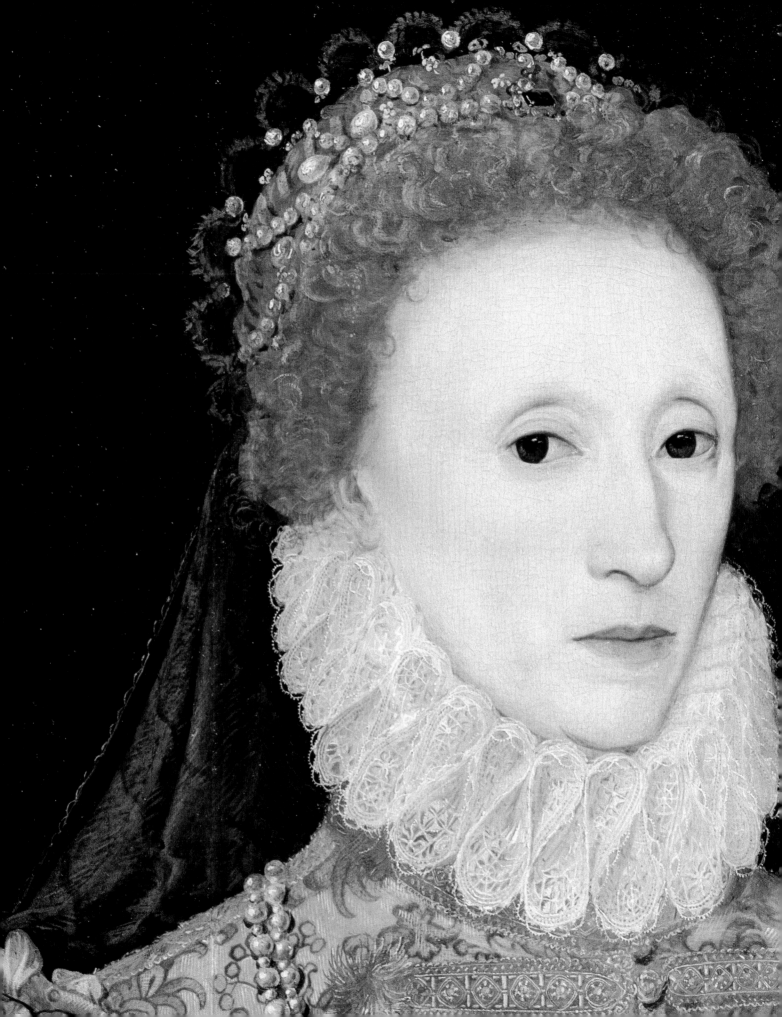

Pre-Tudor and Tudor Portraits

RICARDVS · III · ANG · REX ·

RICHARD III (1452–85)

Unknown artist
Oil on panel, 63.8 x 47cm (25⅛ x 18½")

It is appropriate to begin any discussion of the Portrait Gallery's collection with the painting of Richard III, acquired in 1862. Nobody claims that it is a great work of art. It is thought to be a late sixteenth-century copy of a fifteenth-century painting, which itself was not necessarily done from life. On the other hand, paintings of Richard III – and particularly this one – have always been regarded as essential documents in the interpretation of his character, as is evident in Josephine Tey's novel *The Daughter of Time*. The portrait shows him tight-lipped and slightly puzzled, not necessarily the villain he was subsequently thought to be.
(NPG 148)

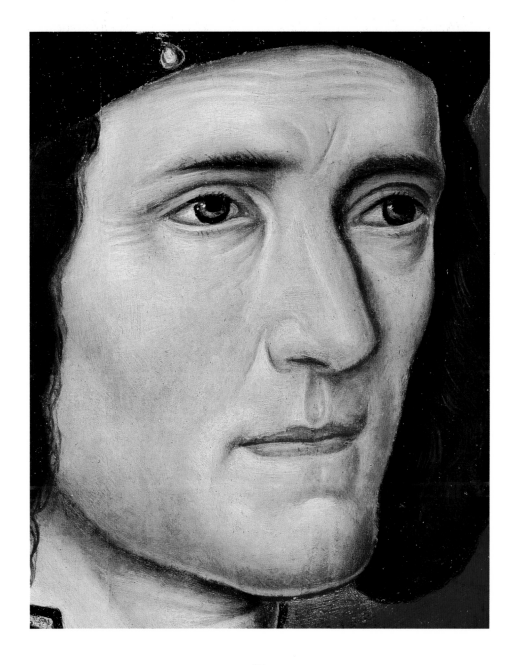

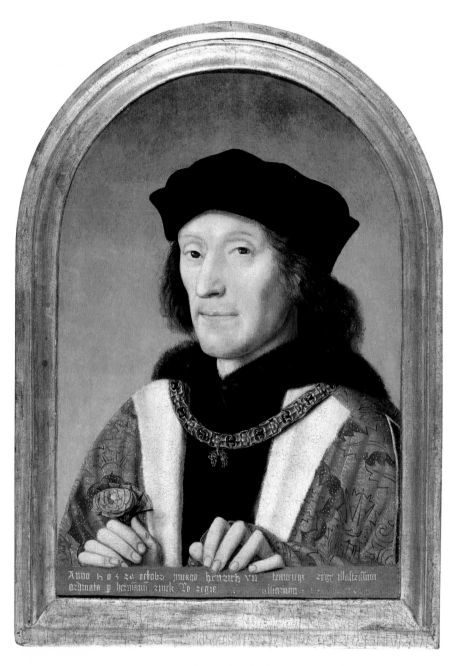

HENRY VII (1457–1509)
Unknown Netherlandish artist
1505
Oil on panel, 42.5 x 30.5cm (16¾ x 12")

According to the inscription, this portrait of Henry VII, large-nosed and without eyelashes, was painted on 2 October 1505 for Herman Rinck, agent to the Emperor Maximilian I. Rinck was in charge of negotiations to marry Henry VII to the Emperor's daughter, Margaret of Savoy, so the painting was done in order to give her an idea of what Henry VII looked like. It succeeds admirably in suggesting a man who was shrewd in all that he did to establish the Tudor dynasty; but it did not persuade her to marry him.
(NPG 416)

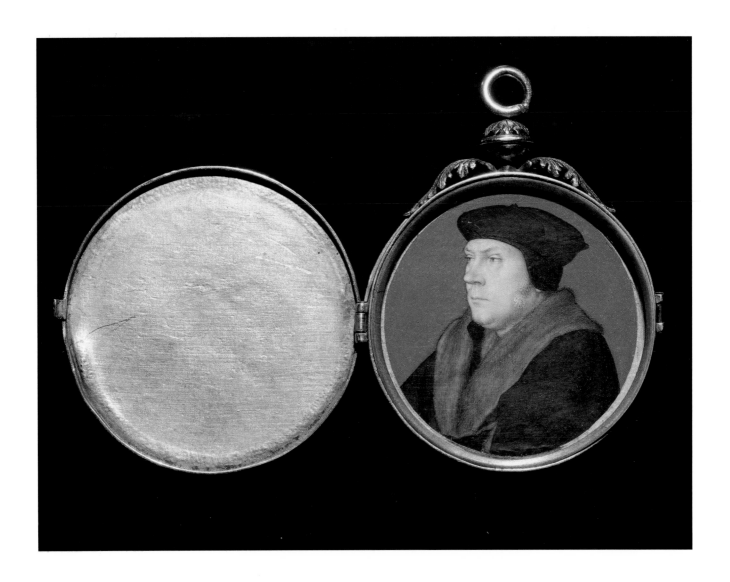

THOMAS CROMWELL (1485?–1540)
Hans Holbein
*c.*1532–3
Miniature on vellum, height 4.4cm (1¾")

Holbein is known to have painted Thomas Cromwell sometime between April 1532, when Cromwell became Master of the Jewel House, and April 1533, when he was appointed Chancellor of the Exchequer, since a bill survives addressed 'To our trusty and right well beloved Councillor, Thomas Cromwell, Master of our Jewel House'. But how this miniature relates to the commission is unknown. Indeed, it is not necessarily by Holbein himself, although no contemporary is known to have been master of such a fine and fastidious technique. What is indisputable is that it shows Thomas Cromwell, the great Tudor statesman and chief architect of the Reformation, at an early stage of his career.

(NPG 6310)

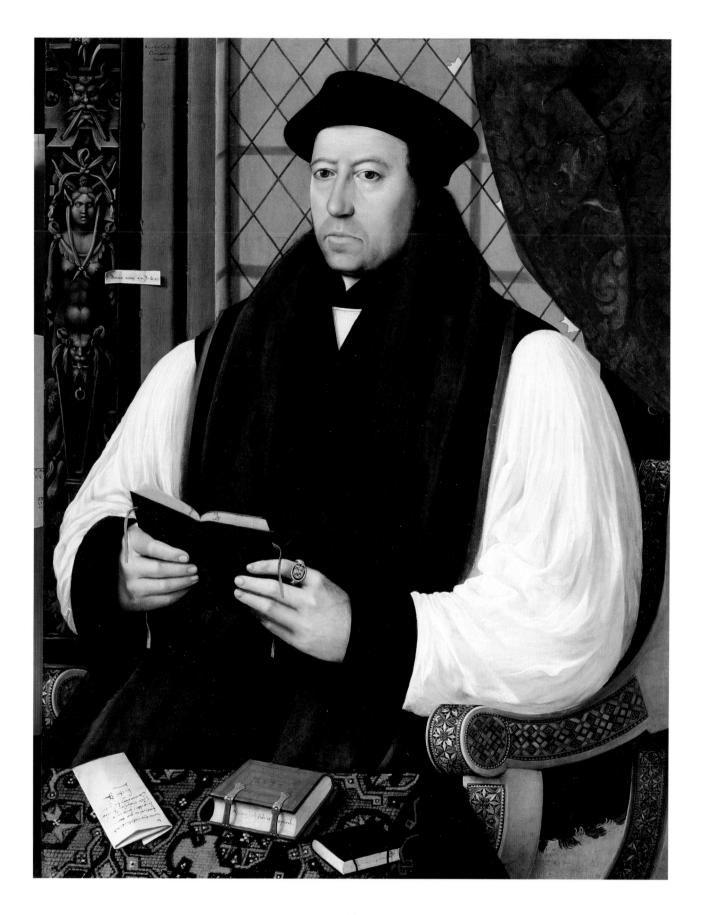

THOMAS CRANMER (1489–1556)

Gerlach Flicke

1546

Oil on panel, 98.4 x 76.2cm (38¾ x 30")

Cranmer became Archbishop of Canterbury in 1533 and drove through the ecclesiastical reforms associated with the English Reformation, including the introduction of the *Book of Common Prayer* in 1548. This portrait shows him engaged in devotional reading of the *Epistles* of St Paul, with one of St Augustine's works lying on the table. The artist was Gerlach Flicke, who worked in the tradition of Holbein but with an even more meticulous attention to surfaces and materials, evident here in Cranmer's lawn sleeve and the decoration of the Turkey carpet on the table. Also, two further, slightly unexpected details have been revealed during conservation: the broken panes in the casement window and the word '*rot*' (meaning red) on his cushion.

(NPG 535)

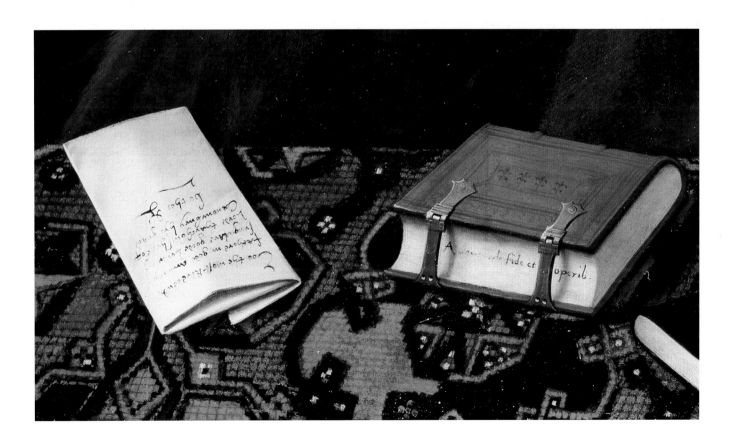

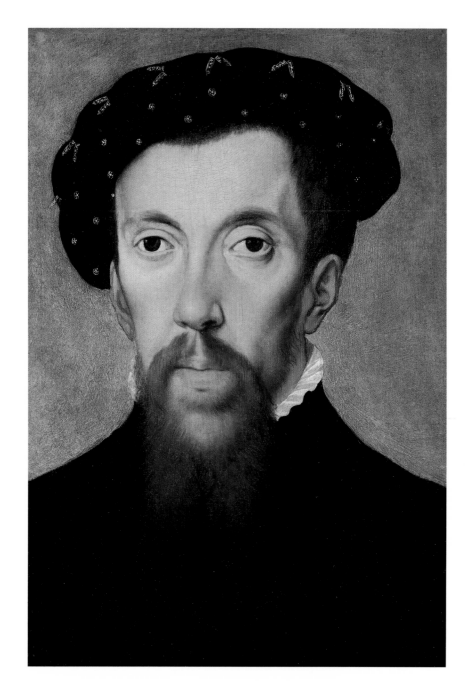

Henry Howard, Earl of Surrey (1517?–47)
Attributed to William Scrots
1546(?)
Oil on panel, 48 x 30.1cm (18⅞ x 11⅞")

The Earl of Surrey was a scholar and a poet, translator of the *Aeneid* and author of verses in imitation of Petrarch. This panel, perhaps cut down from a larger work and, when it was acquired by the Gallery in 1973, spliced down the middle, shows him with eyes that are quizzical and intelligent.
(NPG 4952)

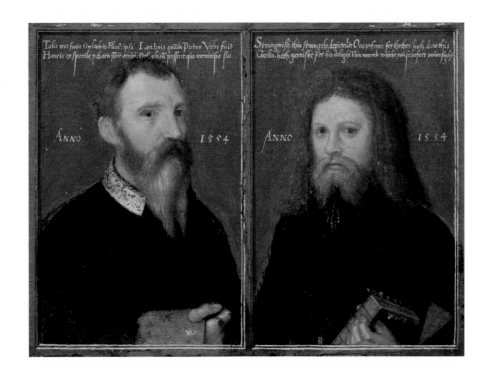

GERLACH FLICKE AND HENRY STRANGWISH
Gerlach Flicke
1554
Oil on paper or vellum laid on panel, 8.8 x 11.9cm (3½ x 4¾")

This is the earliest self-portrait in the Gallery's collection. As the Latin inscription records, 'Such was the face of Gerlach Flicke when he was a painter in the City of London. This he himself painted from a looking-glass for his dear friends. That they might have something by which to remember him after his death.' It shows him bearded, lugubrious and holding the palette that was the mark of his profession. He was to die four years later, in 1558. His companion, described in the inscription as 'Strangwish', is thought to be Henry Strangways (d.1562), a gentleman pirate, who was imprisoned in the Tower for privateering.
(NPG 6353)

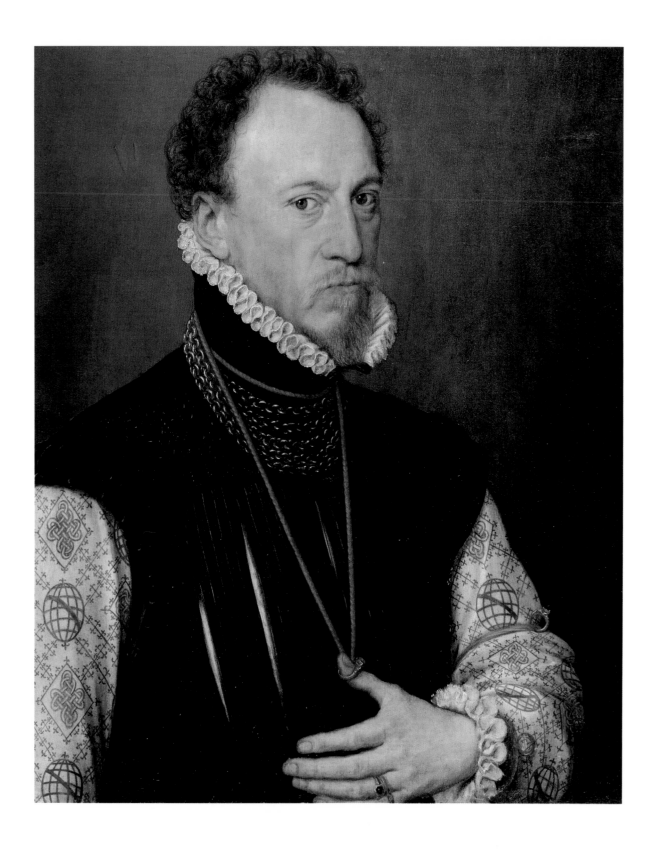

SIR HENRY LEE (1533–1611)

Antonis Mor

1568

Oil on panel, 64.1 x 53.3cm (25¼ x 21")

Sir Henry Lee, one of Elizabeth I's favourite courtiers, was responsible for organising the Accession Day tilts, which were chivalric events in honour of the Queen and which became annual. He appears in this portrait with his left thumb inserted into a ring, suggesting that it was an image of love, so it is possible that it was intended as a token of his love for the Queen. Certainly, in terms of English painting, it is an unusually sophisticated image for this period, and was probably painted when Lee visited Antwerp in June 1568.

(NPG 2095)

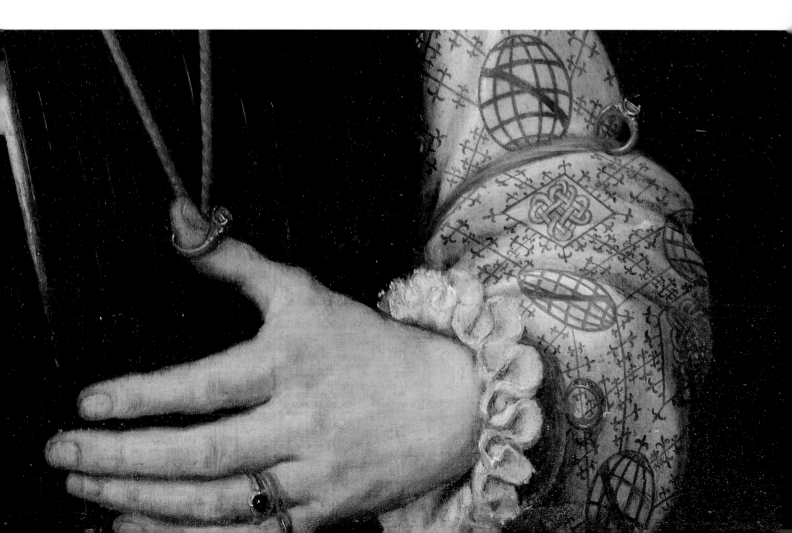

ALLEGORY OF THE REFORMATION
Unknown artist
*c.*1568–71
Oil on panel, 62.2 x 90.8cm (24½ x 35¾")

This complex allegorical painting has been the subject of a complete monograph, *The King's Bedpost*, by the historian Margaret Aston. She has managed to make sense of what is going on in the picture. Henry VIII is sitting on his deathbed and pointing towards Edward VI, his son and heir. Beneath Edward is the vanquished Pope, with the inscription on his chest ALL FLESHE IS GRASSE. To the right sit Edward's Privy Councillors. It was always assumed that the painting dated from 1547, but the ornamental bedpost of Henry VIII's bed derives from a print published in 1564, and the detail in the top right-hand corner in which soldiers are smashing images comes from a print published in the second half of the 1560s. So instead of being a work of ecclesiastical propaganda from Edward's reign, it must date from the late 1560s and indicates the tremendous hostility to the Pope still current in Elizabeth I's reign.

(NPG 4165)

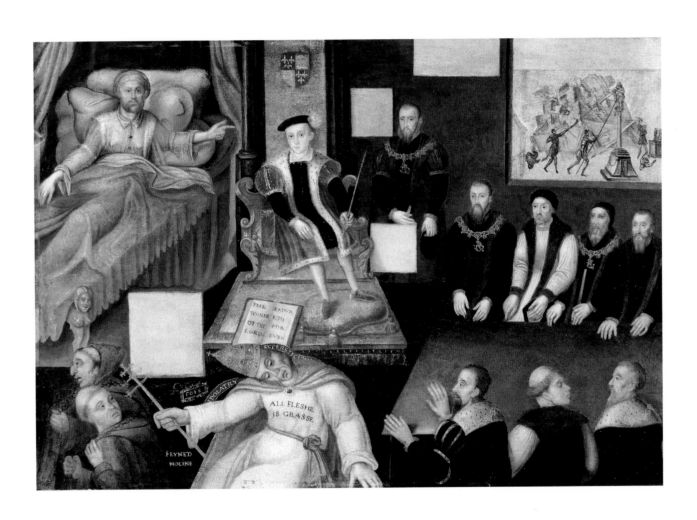

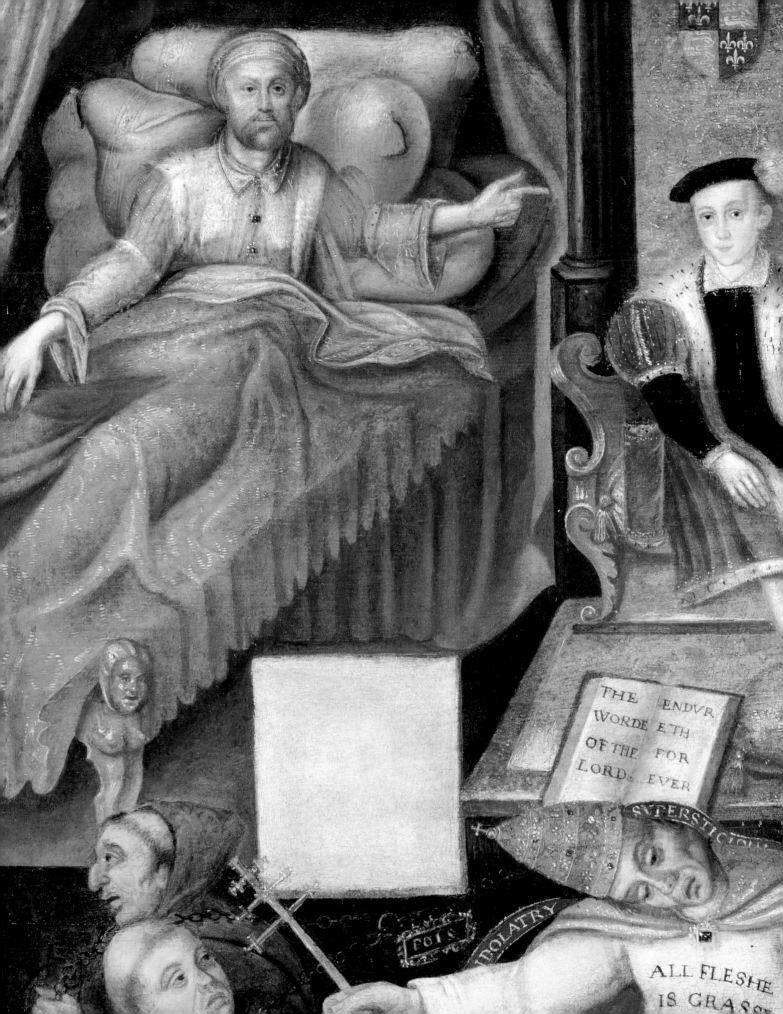

THE ENDVR
WORDE ETH
OF THE FOR
LORD EVER

SVPERSTICION

IDOLATRY

ALL FLESHE
IS GRASS

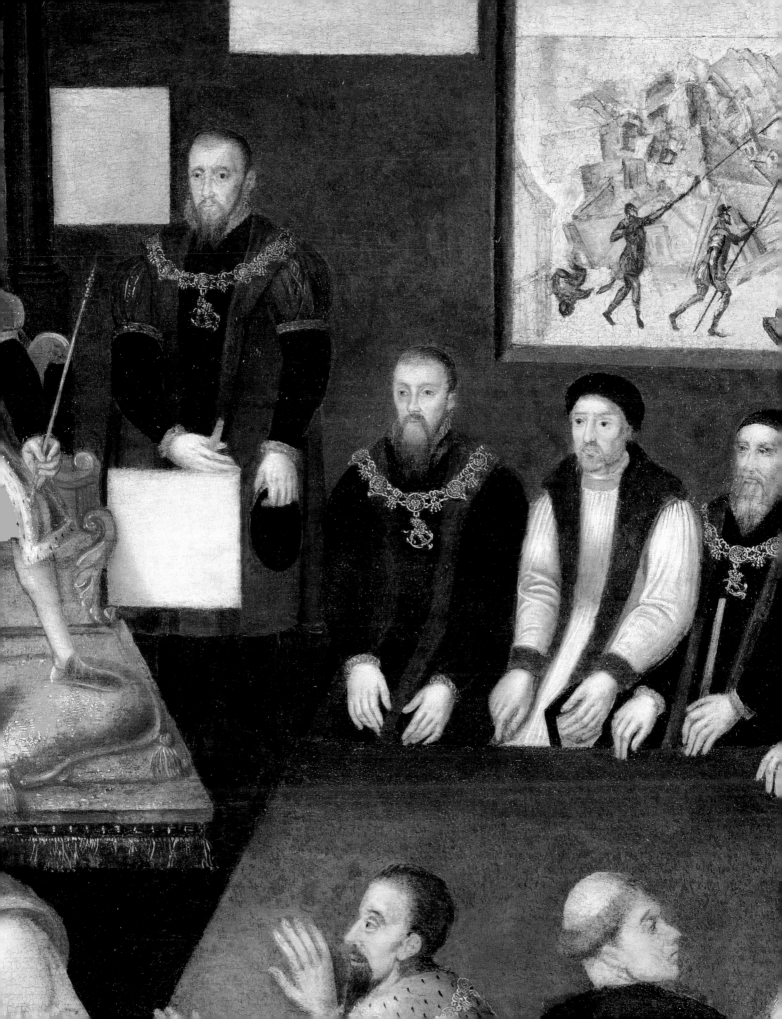

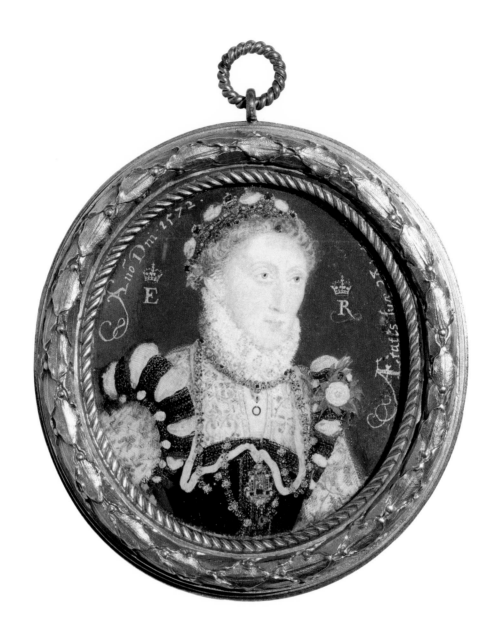

ELIZABETH I (1533–1603)
Nicholas Hilliard
1572
Miniature on vellum, 5.1 x 4.8cm (2 x 1⅞")

The earliest and most winsome of the images of Queen Elizabeth in the NPG's collection shows her looking pale and intense, festooned with an extraordinary array of jewellery, pearls, a black enamelled choker round her neck and a white rose pinned to her left-hand shoulder roll. It is assumed that this was the miniature Hilliard referred to in *A Treatise Concerning the Arte of Limning*, when he described how 'when first I came in her highnes presence to drawe, whoe after showing me howe shee noted great difference of shadowing in the works' stipulated that she should be painted 'in the open ally of a goodly garden, where no tree was neere, nor anye shadowe at all'. This has produced a smoothness of polished skin as if Elizabeth was indeed sitting in bright sunlight when this work was done.

(NPG 108)

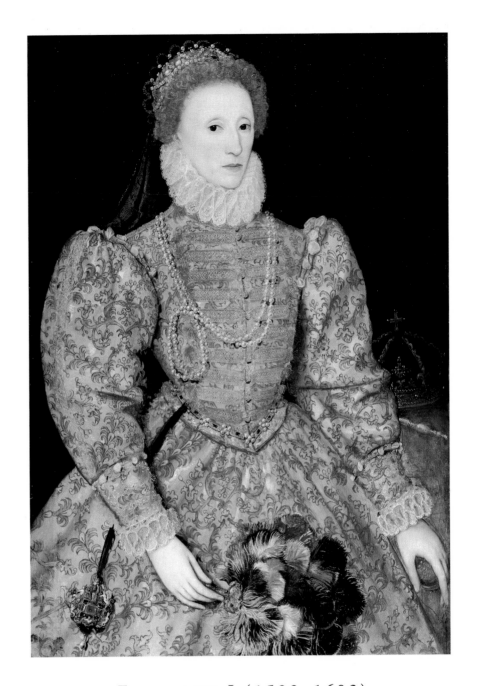

ELIZABETH I (1533–1603)
Unknown artist
*c.*1575
Oil on panel, 113 x 78.7cm (44½ x 31")

The 'Darnley Portrait' of Elizabeth I, so called because it used to belong to the Earls of Darnley, is one of the key images of the Queen. It shows her looking cold, haughty and imperious, wearing a rather masculine doublet with a lace ruff collar, a double string of pearls looped around her neck, and carrying an ostrich-feather fan. Behind her on a table lies her crown. It was an image that was much reproduced, and is rather more lifelike than some of the later portraits which created the idea of an ageless Virgin Queen.

(NPG 2082)

ELIZABETH I (1533–1603)
Marcus Gheeraerts the Younger
*c.*1592
Oil on panel, 241.3 x 152.4cm (95 x 60")

This immense and highly ornate image of the Queen floating over a map of England, with thunderclouds behind her and bright sun in front, is thought to have been commissioned by one of her courtiers, Sir Henry Lee, in honour of her visit to his country house, Ditchley Park north of Oxford, in September 1592. It provides the most extreme idea of her as the incarnation of supreme majesty, with pinched waist and puffed sleeves and a dress festooned with jewels. But although the trappings suggest a complete lack of realism, her face has some elements of her appearance in late middle age, with wrinkled skin and hooked nose. The spirit of this portrait echoes Sir John Harington when he wrote of the Queen, 'When she smiled, it was a pure sun-shine, that every one did chuse to bask in, if they could; but anon came a storm from a sudden gathering of clouds, and the thunder fell in wondrous manner on all alike.'

(NPG 2561)

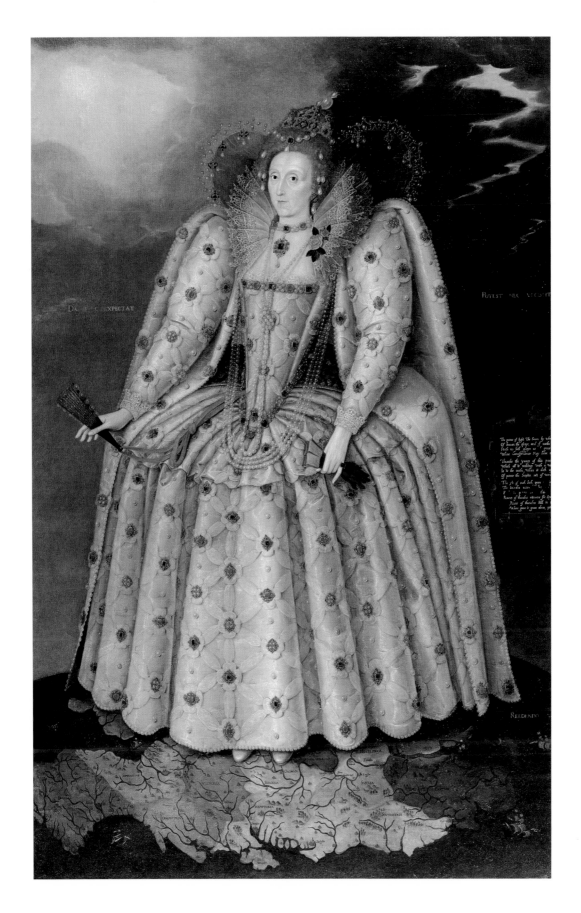

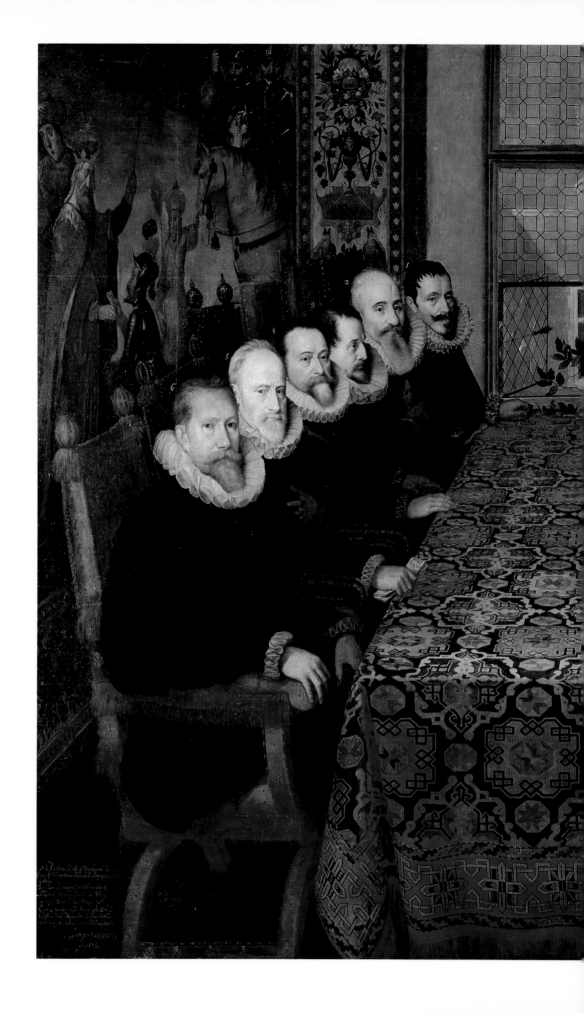

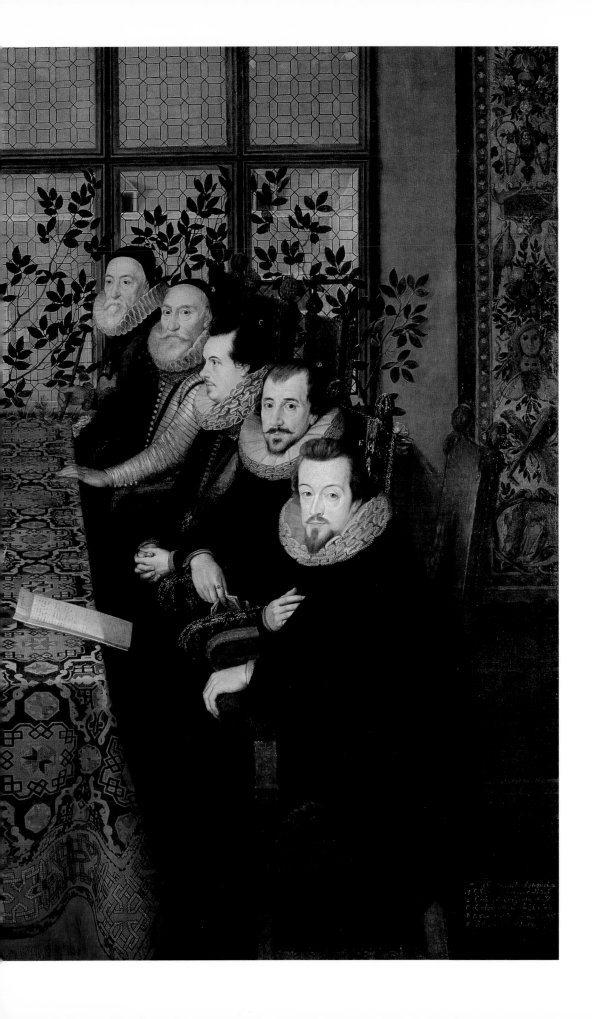

(Previous pages)
SOMERSET HOUSE CONFERENCE
Unknown artist
1604
Oil on canvas, 205.7 x 268cm (81 x 105½")

This painting is a record of the conference held at Somerset House in August 1604 to determine the terms of peace between England and Spain after nearly twenty years of war. To the left sit the Spanish delegates, including (nearest to the window) the Constable of Castile. To the right are the English delegates, the Earls of Dorset, Nottingham, Devonshire and Northampton and, nearest the spectator, Robert Cecil, Viscount Cranborne. According to an early but probably not original inscription, it may have been by a Spanish artist, Pantoja de la Cruz, who painted portraits of the Spanish aristocracy, but there is no supporting evidence that he was in England in 1604, and the style of the painting is more Flemish than Spanish.

(NPG 665)

WILLIAM SHAKESPEARE (1564–1616)
Attributed to John Taylor
*c.*1610
Oil on canvas, 55.2 x 43.8cm (21¾ x 17¼")

This was the first portrait to be acquired by the Gallery and remains one of its most important, since it is the only reasonably authentic contemporary likeness of Shakespeare. It was said by George Vertue, the eighteenth-century antiquary, to have been painted 'by one *Taylor* a Player and painter contemporary with Shakespeare and his intimate friend' and to have been left by John Taylor to Sir William Davenant, the poet laureate, who claimed to be Shakespeare's godson. On Davenant's death, it was acquired by the actor Thomas Betterton and, while owned by him, was copied by Kneller. When Betterton died, it was acquired for 40 guineas by a barrister, Robert Keck, who provided information about it to Vertue. So its early history is fairly well documented. But who John Taylor might have been has never been definitively established. There was an actor called Joseph Taylor mentioned in the First Folio; and a John Taylor is recorded in the minute books of the Company of Painter-Stainers in the 1620s; but there is only one person in Shakespeare's life who was well regarded as a painter and as an actor and he was Richard Burbage. Whoever it is by, the portrait is fascinating as a document of Shakespeare's appearance, with an earring in his left ear and a look of ruffian intelligence.

(NPG 1)

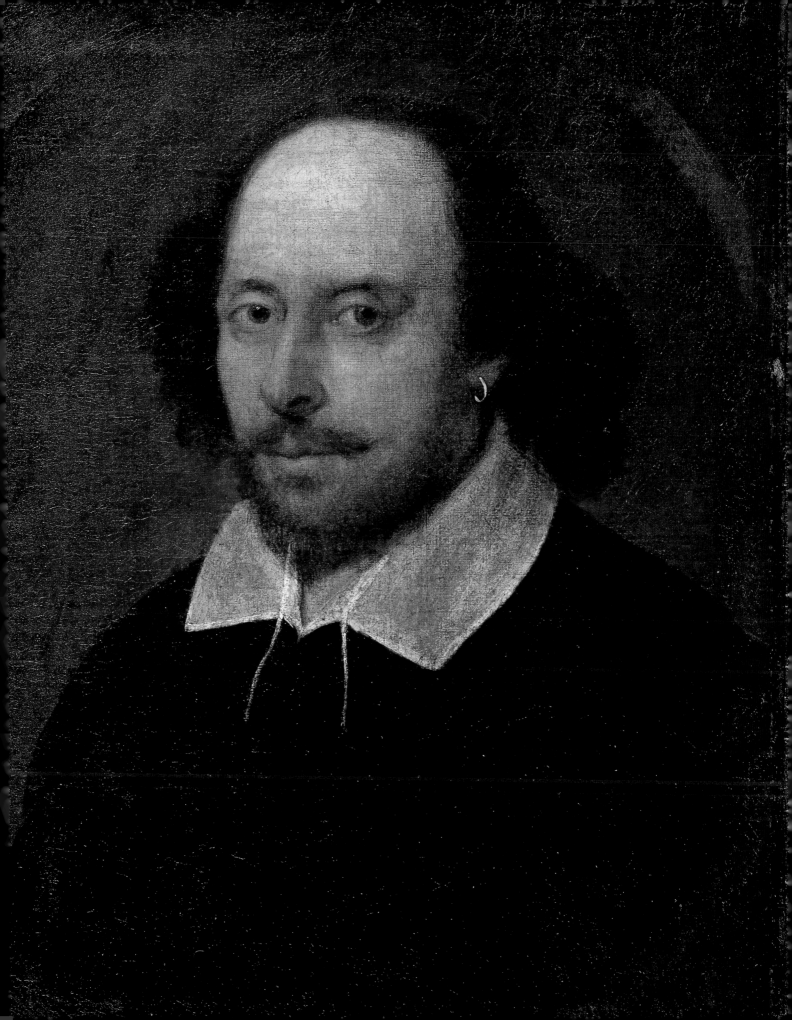

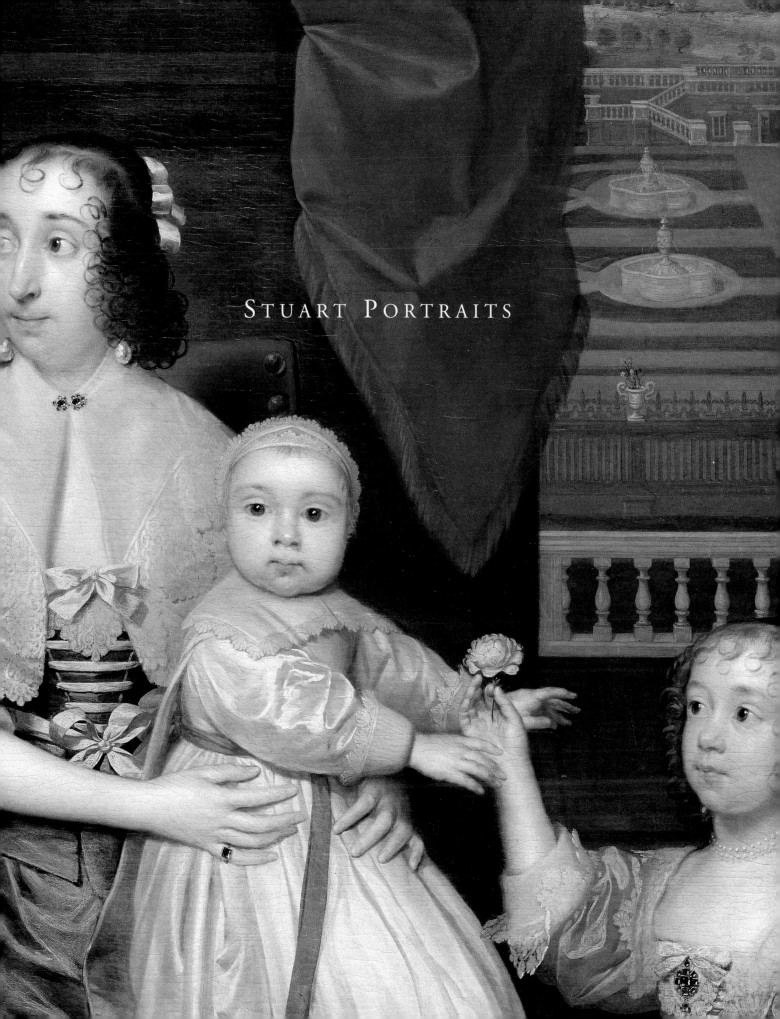

STUART PORTRAITS

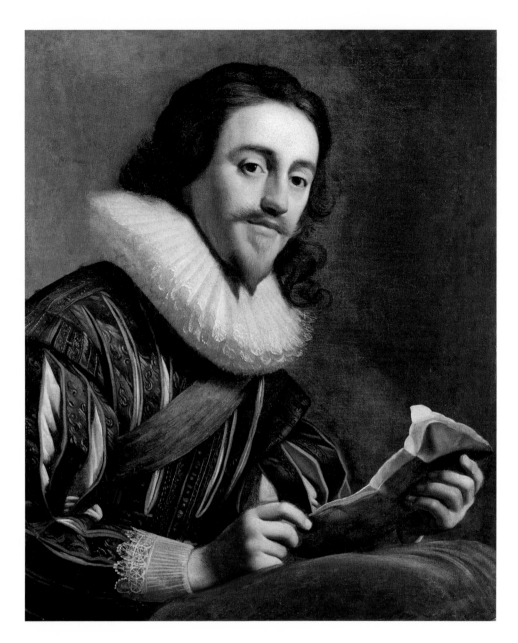

CHARLES I (1600–49)
Gerrit van Honthorst
1628
Oil on canvas, 76.2 x 64.1cm (30 x 25¼")

Charles I is generally remembered from images of him on horseback, looking imperious but with an air of melancholy about him. By contrast, this image by Gerrit van Honthorst shows him just before he had embarked on his personal rule and suggests his character as a scholar and an aesthete. It is assumed to have been painted between April and December 1628, when Honthorst was in London at the King's invitation; and to have been a preliminary study for a much larger, semi-mythological painting of *The Seven Liberal Arts Presented to Apollo and Diana* (now at Hampton Court), in which Charles I is seated on a cloud as Apollo, flanked by Henrietta Maria, his queen, as Diana.

(NPG 4444)

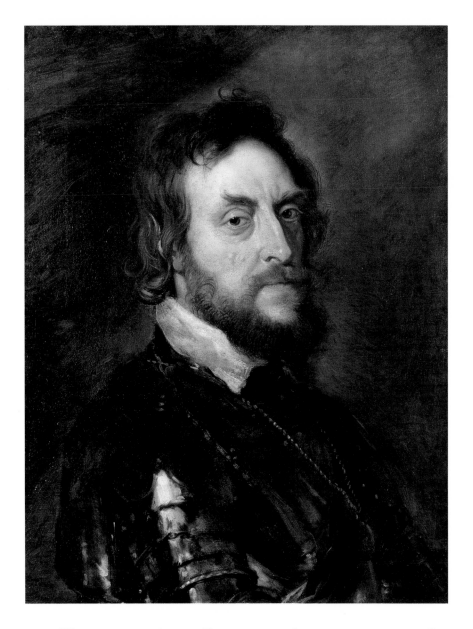

THOMAS HOWARD, 2ND EARL OF ARUNDEL AND SURREY
(1585–1646)
Sir Peter Paul Rubens
1629
Oil on canvas, 68.6 x 53.3cm (27 x 21")

The magnificent portrait of the Earl of Arundel shows him not only as a connoisseur – he acquired one of the most important seventeenth-century collections of paintings and sculpture – but also with a certain braggadocio, as befitted his status as Earl Marshal. It was painted in 1629, when Rubens came to London as an emissary of Philip IV of Spain, and was a study for a larger, three-quarter-length portrait of him (now in the Isabella Stewart Gardner Museum, Boston) As a sketch it has an exceptional liveliness in its characterisation of a man with a worldly and perhaps slightly cynical mind.

(NPG 2391)

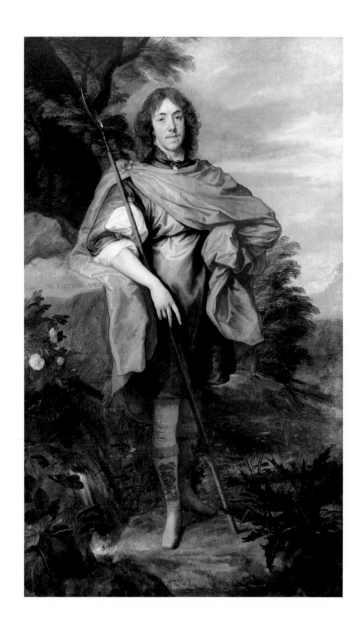

LORD GEORGE STUART, SEIGNEUR D'AUBIGNY (1618–42)
Sir Anthony van Dyck
*c.*1638
Oil on canvas, 218.4 x 133.4cm (86 x 52½")

The sitter was described by Lord Clarendon in his *History of the Rebellion* as 'a gentleman of great hopes, of a gentle and winning disposition, and of a very clear courage'. He was typical of the young men who flocked to the King's standard, but he was killed at the Battle of Edgehill in 1642, while leading a troop in the Prince of Wales' Regiment of Horse. His portrait is thought to have been painted by Van Dyck just before the Civil War and may date from 1638, when he secretly married Katherine, daughter of Theophilus Howard, 2nd Earl of Suffolk. It shows him in the guise of a shepherd, languid and rather effete, standing in a landscape with a rock inscribed ME FIRMIOR AMOR – 'Love is stronger than I am'.

(NPG 5964)

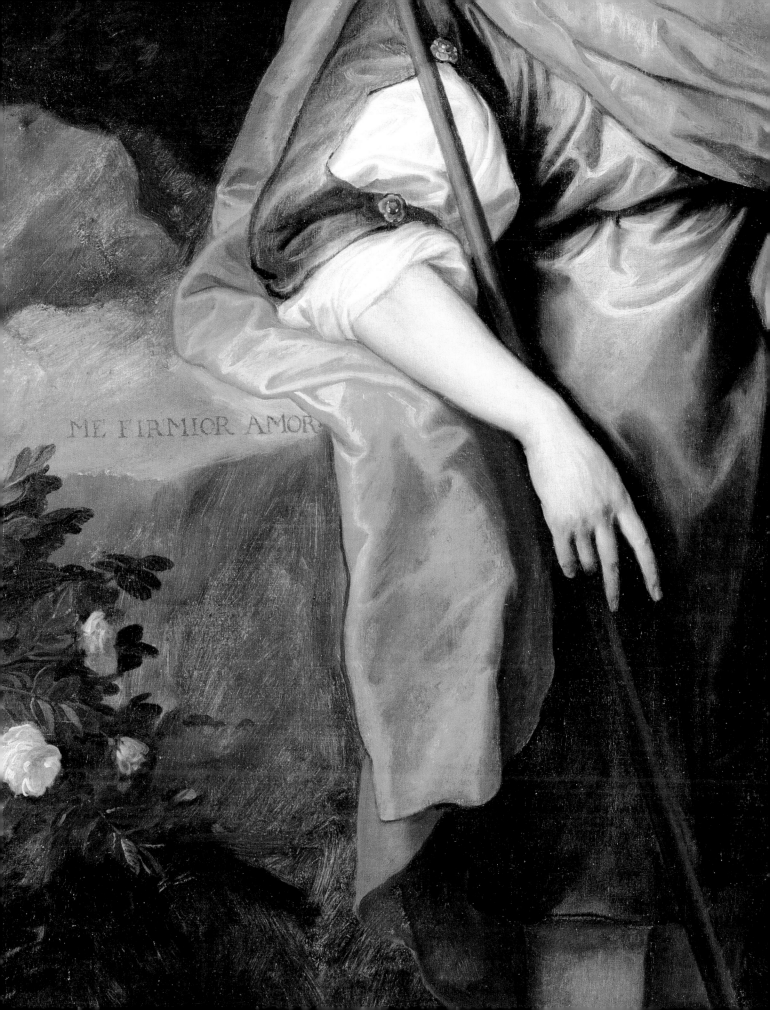

ME FIRMIOR AMOR

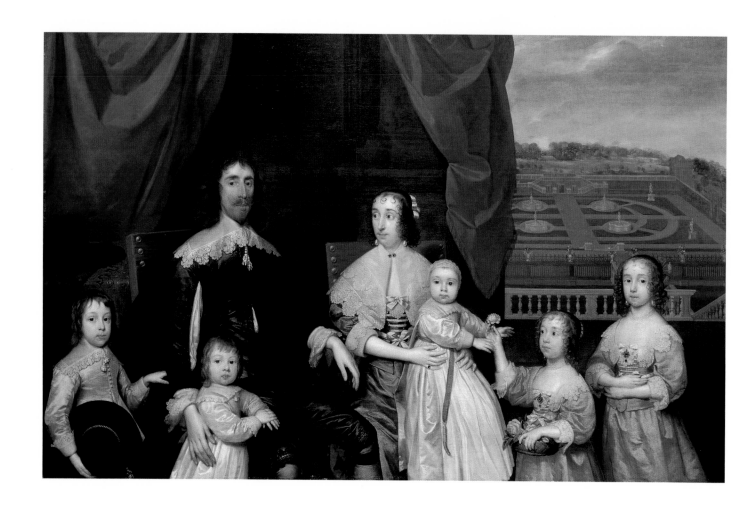

THE CAPEL FAMILY
Cornelius Johnson
*c.*1639
Oil on canvas, 160 x 259.1cm (63 x 102")

This great family portrait shows the Capels, a prominent Hertfordshire family, just before the outbreak of the Civil War. Sitting on the left is Arthur Capel (1604–49), who in 1641 was made a Baron, fought in the Civil War as a Royalist and was subsequently to die on the scaffold shortly after Charles I. He was described as representing 'the honourable royalism which stooped to no intrigue, and would soil itself by no baseness'. To his right (and looking fondly at him) is his wife, Elizabeth, and standing beside him is his oldest son, Arthur, who was created Earl of Essex by Charles II at the Restoration and who committed suicide in the Tower of London in 1683 after being implicated in the Rye House Plot. What is striking about the portrait is that there is no hint of the political troubles to come. Rather it is a scene of peaceful domesticity, with a view to the right of their garden at Much Hadham, Hertfordshire.
(NPG 4759)

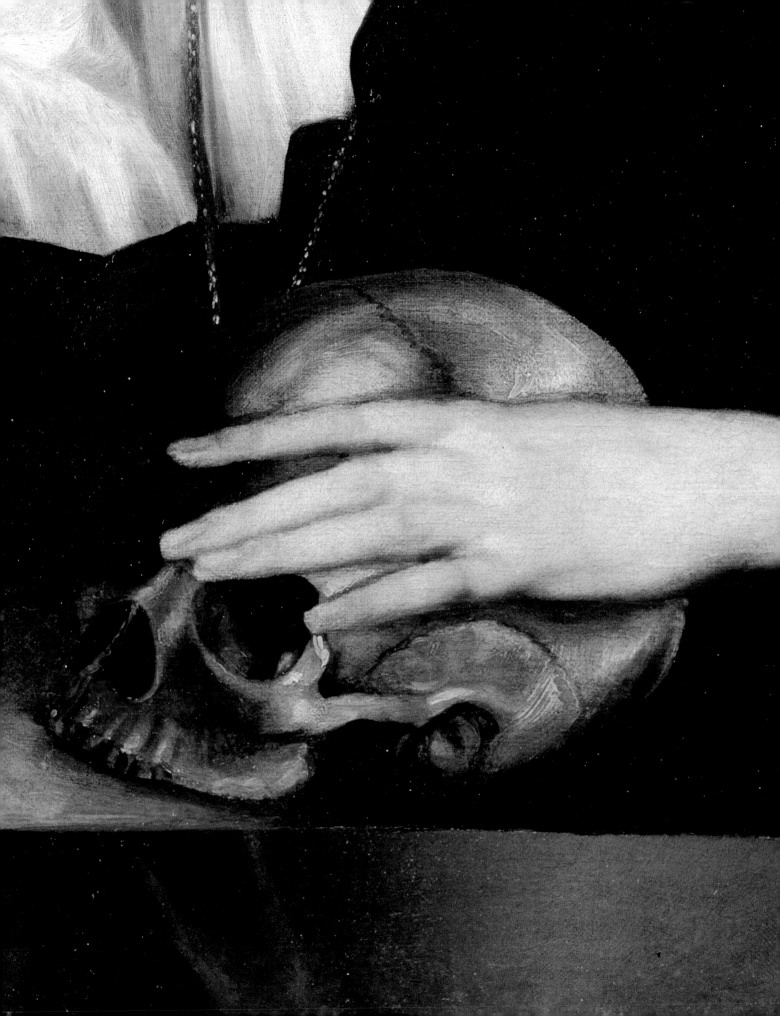

JOHN EVELYN (1620–1706)

Robert Walker

1648

Oil on canvas, 87.9 x 64.1cm (34⅝ x 25¼")

This lugubrious portrait of John Evelyn, the famous diarist and virtuoso, was painted when he was 27. The year before he had married Mary Browne, the daughter of the English ambassador in Paris; she was then aged 12. Evelyn was subsequently to describe her as 'the best wife in the world, sweet and agreeable'. In 1648 he wrote a treatise on the benefits of marriage, called *Instruction Oeconomique* (he later wrote treatises on a huge range of subjects, including London smog); and on 1 July of that year recorded in his Diary that he 'sate for my *Picture* (the same wherein is a *Deaths head*) to Mr *Walker* that excellent Painter'. It has been assumed that the portrait was commissioned in order to accompany the treatise on marriage and X-ray photographs have demonstrated that Evelyn's hand originally rested on a medallion or miniature, probably a portrait of his wife. It was subsequently replaced by a skull, making the portrait into a *memento mori*, with a quotation from Seneca above to the effect that 'When death comes to meet him, no one welcomes it cheerfully.'

(NPG 6179)

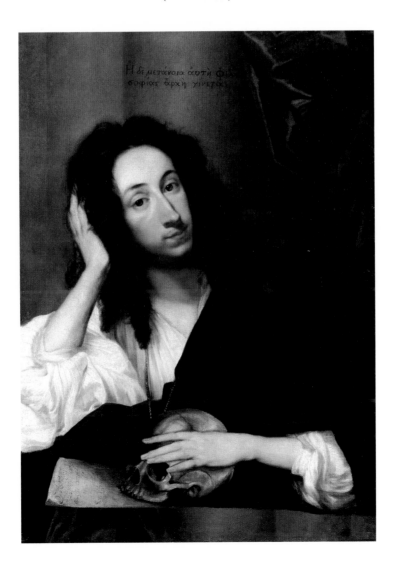

61

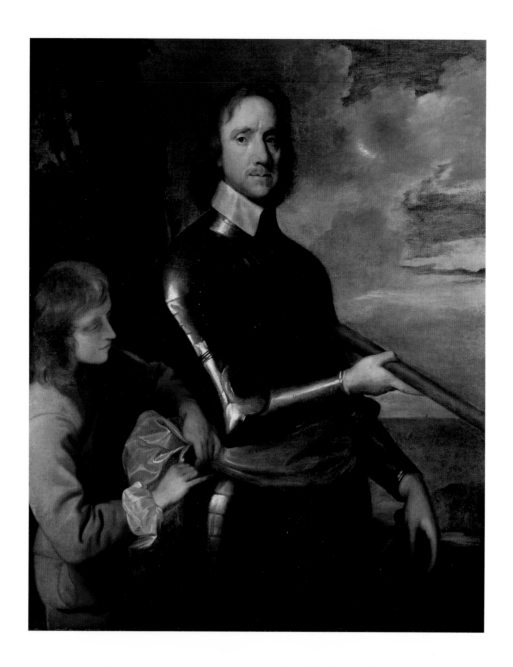

OLIVER CROMWELL (1599–1658)
Robert Walker
*c.*1649
Oil on canvas, 125.7 x 101.6cm (49½ x 40")

This slightly dandified portrait of Oliver Cromwell, with a sash being tied round his waist, has an inscription on the back: 'This Original Picture of Oliver Cromwell. Presented by him to Nathaniel Rich Esqr. then serving under him as *Colonel* of a Regiment of Horse in the Parliament Army, was Bequeathed to the Trustees of the British Museum, for the Use of the Public.' As a portrait of the Parliamentarian leader painted around the time of the execution of Charles I, it is intriguing in suggesting a clear continuity in style with portraiture before the Civil War.

<div align="center">(NPG 536)</div>

OLIVER CROMWELL (1599–1658)

Samuel Cooper

1649

Miniature on vellum, 5.7 x 4.8cm (2¼ x 1⅞")

Samuel Cooper, the miniaturist who was described by the Grand Duke of Tuscany as 'a tiny man, all wit and courtesy', produced this fine portrait of Oliver Cromwell in 1649, the year of Charles I's execution. Cromwell at the time was in the process of becoming the effective leader of the Parliamentarian forces, and is depicted looking callous and determined, but not yet disfigured by the pimples and warts that were the distinguishing features of later portraits of him.

(NPG 5589)

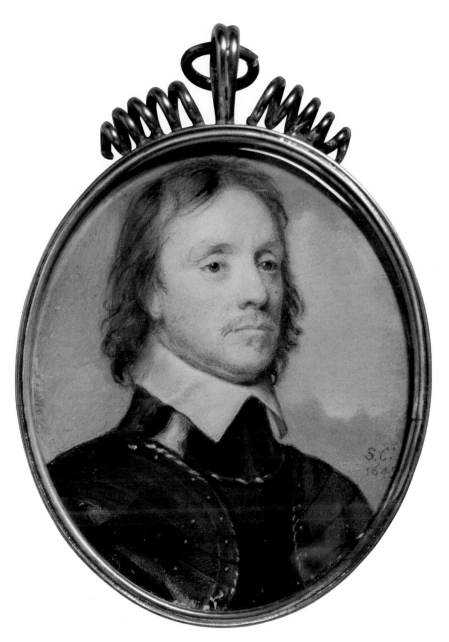

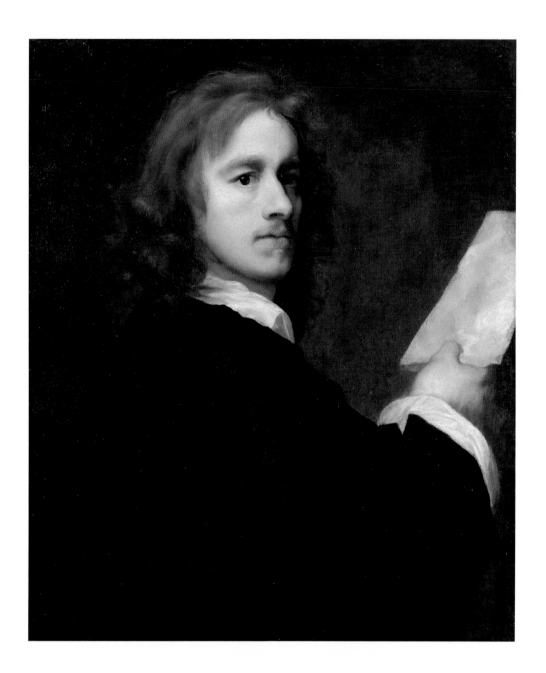

ROBERT WALKER (1599–1658)
Self-portrait
*c.*1650
Oil on canvas, 73.7 x 61cm (29 x 24")

Not much is known about Robert Walker, the artist who painted both John Evelyn and Oliver Cromwell and who is known to have been favoured by leading Parliamentarians, beyond the fact that he was a member of the Painter-Stainers' Company, had rooms in Arundel House in 1652 and maintained the style of Van Dyck for his portraits of the Parliamentarian leaders. In 1658 he was described as one of the most eminent masters in England. Otherwise almost the only evidence of his personality appears in this dashing self-portrait.

(NPG 753)

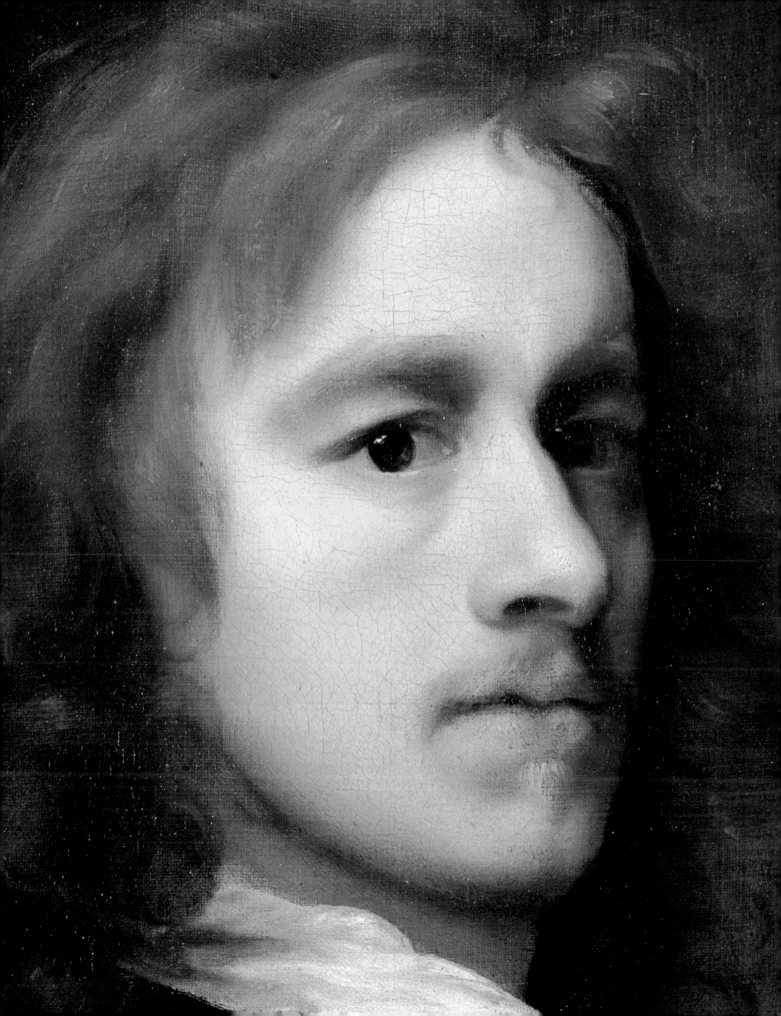

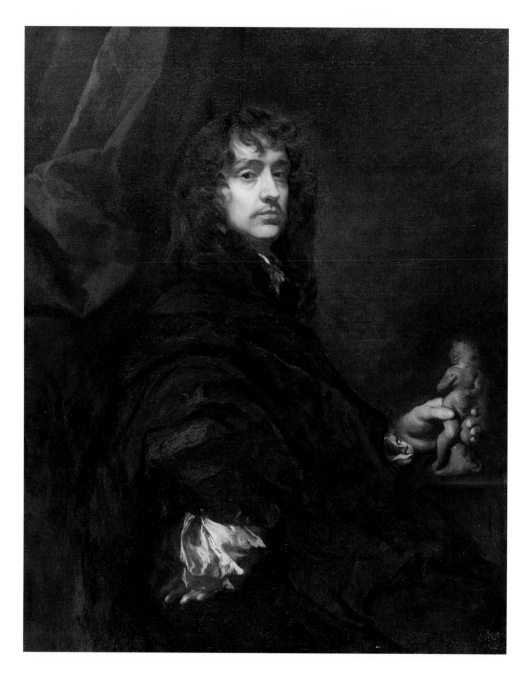

SIR PETER LELY (1618–80)
Self-portrait
*c.*1660
Oil on canvas, 108 x 87.6cm (42½ x 34½")

Lely's self-portrait is the best surviving image of him around the time of the Restoration, when he was appointed Principal Painter to Charles II. He is known to have been a collector, particularly of drawings, and shows himself with a small figurine clutched in his left hand, to indicate his status as a connoisseur. Pepys called him 'a mighty proud man, and full of state', and this is certainly his character as suggested by this portrait.

(NPG 3897)

JOHN MAITLAND, 1ST DUKE OF LAUDERDALE (1616–82)

Samuel Cooper
1664
Miniature on vellum, 8.6 x 7cm (3⅜ x 2¾")

John Maitland, who became Duke of Lauderdale in 1672, was one of the most prominent political figures in Charles II's government. A Scot, he began his career as a supporter of the Solemn League and Covenant against Charles I in 1643 but switched his loyalties to Charles II. At the Restoration he was rewarded by being made Secretary of State for Scotland, a post in which he was exceptionally successful, as well as providing a fortune that he was able to spend on luxuries at his house at Ham near London. According to Bishop Burnet, Maitland was physically a disgusting figure, 'very big; his hair red, hanging oddly about him; his tongue was too big for his mouth, which made him bedew all that he talked to; and his whole manner was rough and boisterous, and very unfit for a court'; but he was also highly intelligent, well read and a bibliophile.

(NPG 4198)

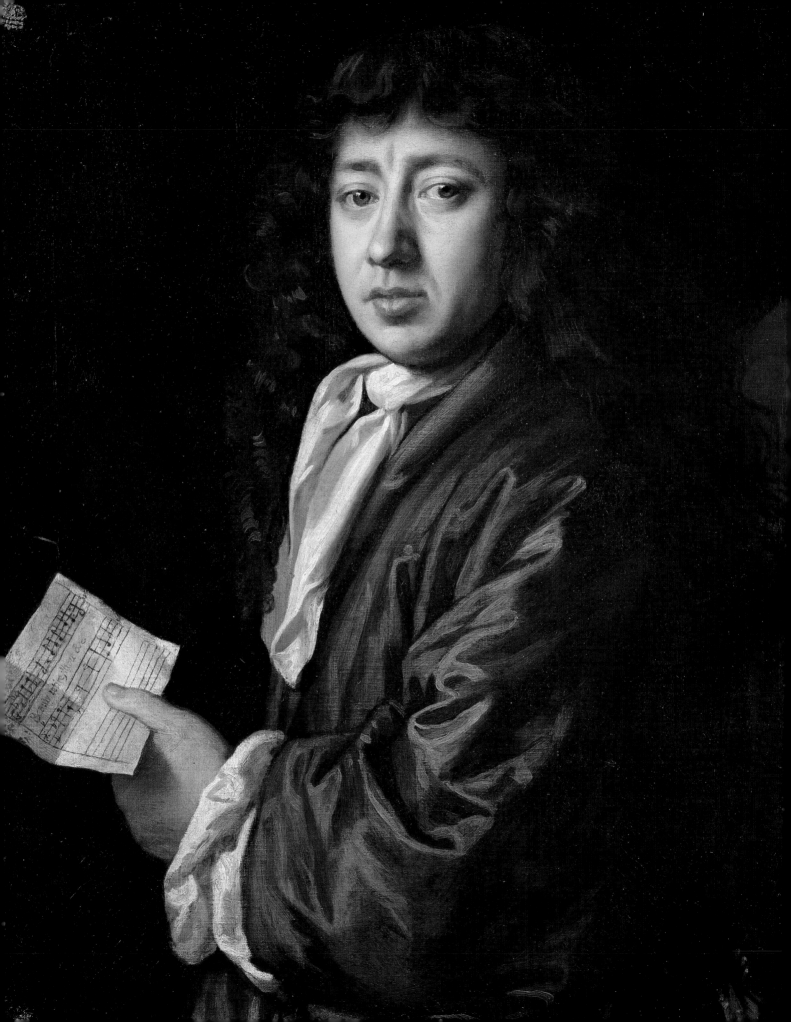

SAMUEL PEPYS (1633–1703)

John Hayls
1666
Oil on canvas, 75.6 x 62.9cm (29¾ x 24¾")

This is one of the most important portraits in the collection, not in artistic terms but because Pepys is so significant historically and because the circumstances in which the portrait was painted are recorded in his diary. John Hayls painted Mrs Pepys in February 1666. On 17 March 1666, Pepys had his first sitting and recorded how 'I sit to have it full of shadows and do almost break my neck looking over my shoulders to make the posture for him to work by.' By the end of the month, Hayls was working on the Indian gown Pepys had specially hired, and on 11 April he was painting the page of music Pepys holds in his hands and which 'pleases me mightily, it being painted true'. On 16 May Pepys paid Hayls £14 for the picture and 25 shillings for the frame. He wrote, 'I am very well satisfied in my pictures and so took them in another coach home along with me, and there with great pleasure my wife and I hung them up, and that being done, so to dinner.' The portrait shows Pepys as he was, a rising man of affairs, with social pretensions but also with an engaging honesty.

(NPG 211)

SIR ROBERT VYNER AND HIS FAMILY
John Michael Wright
1673
Oil on canvas, 144.8 x 195.6cm (57 x 77")

Sir Robert Vyner (1631–88) was a prominent City goldsmith, who supplied the regalia for Charles II's coronation in 1661 and made enough money to build a country house at Swakeleys in Middlesex. Pepys visited him there and described it as 'a place not very moderne in the gardens nor house, but the most uniforme in all that I ever saw – and some things to excess'. This portrait of him, in company with his wife, two children and their dog, surrounded by the trappings of their country estate, gives a good idea of the prominence and prosperity of City financiers in the period after the Restoration.

(NPG 5568)

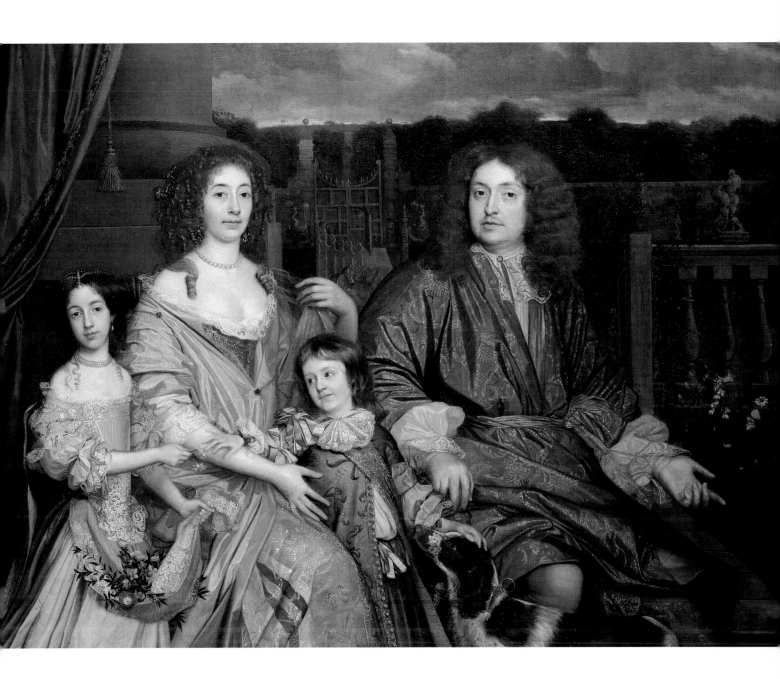

CHARLES II (1630–85)

Edward Hawker

*c.*1680–85

Oil on canvas, 226.7 x 135.6cm (89¼ x 53⅜")

This portrait of Charles II shows him towards the end of his life, looking lubricious and rather saturnine. It is not a particularly attractive image but an important one, assumed to have been painted by the minor artist Edward (or Thomas) Hawker, on the basis of a comparison with a portrait of the 1st Duke of Grafton at Euston Hall in Suffolk.

(NPG 4691)

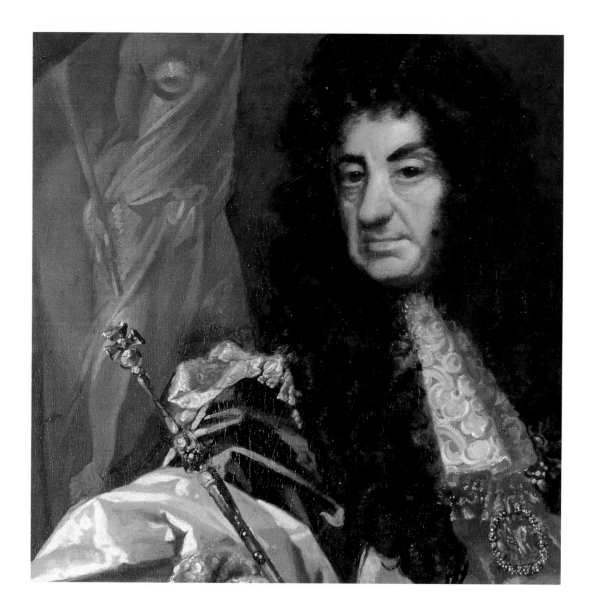

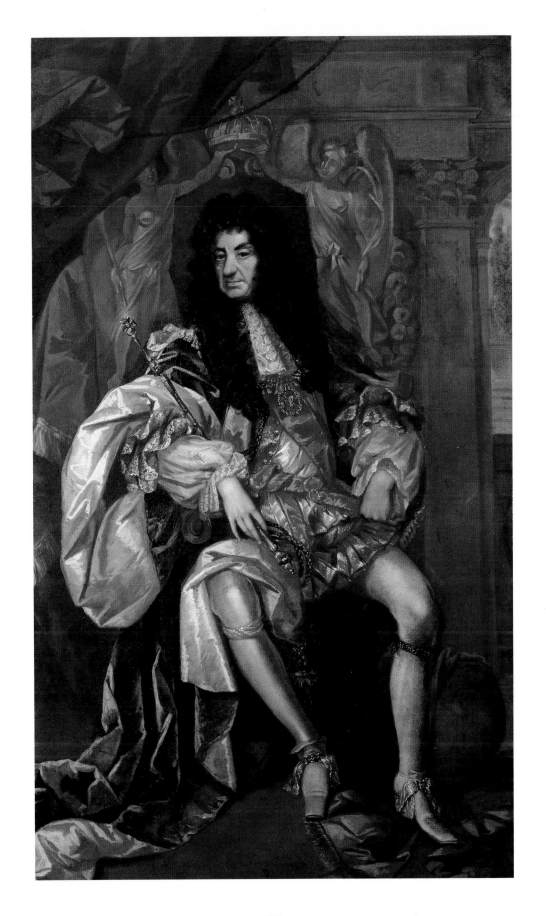

73

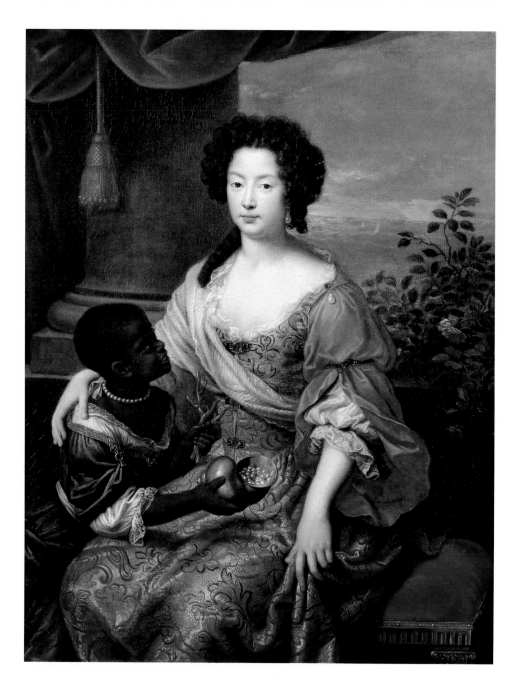

LOUISE DE KÉROUALLE, DUCHESS OF PORTSMOUTH (1649–1734)

Pierre Mignard
1682
Oil on canvas, 120.7 x 95.3cm (47½ x 37½")

The Duchess of Portsmouth was one of Charles II's mistresses and was used as a diplomatic pawn by the French government. John Evelyn described her 'childish, simple and baby face' and her lavish apartments in Whitehall, which had 'ten times the richnesse & glory beyond the Queenes'. The Duchess is shown with her arm round the shoulder of a black page, and an inscription indicates that the portrait was painted by Pierre Mignard in Paris in 1682.

(NPG 497)

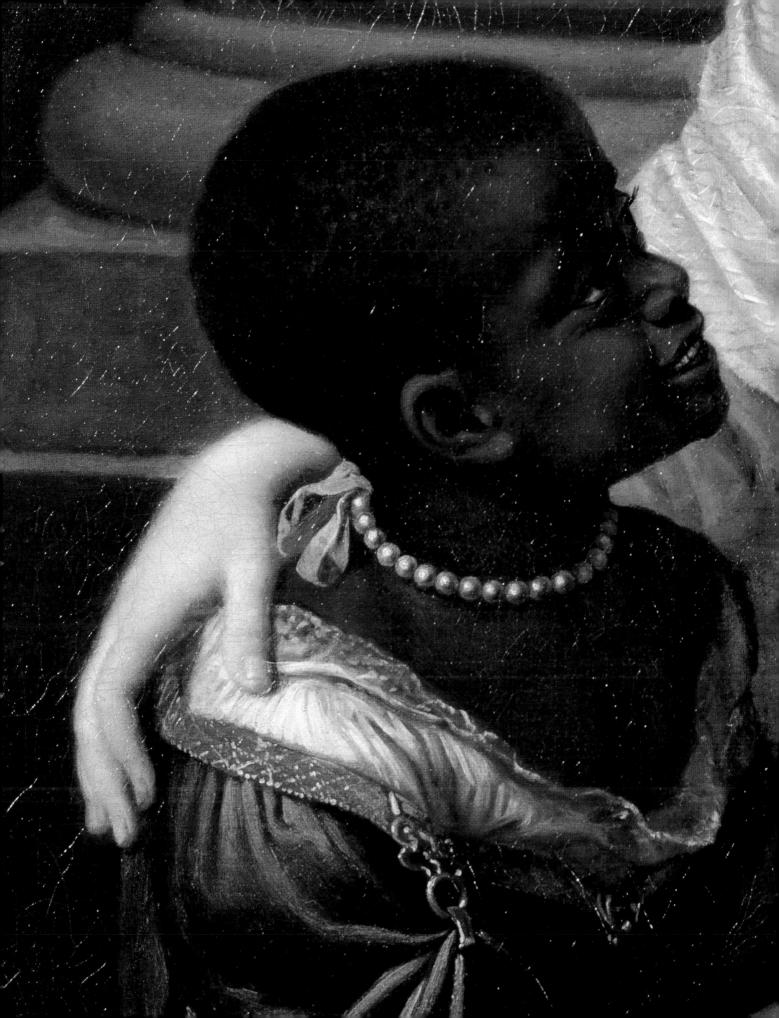

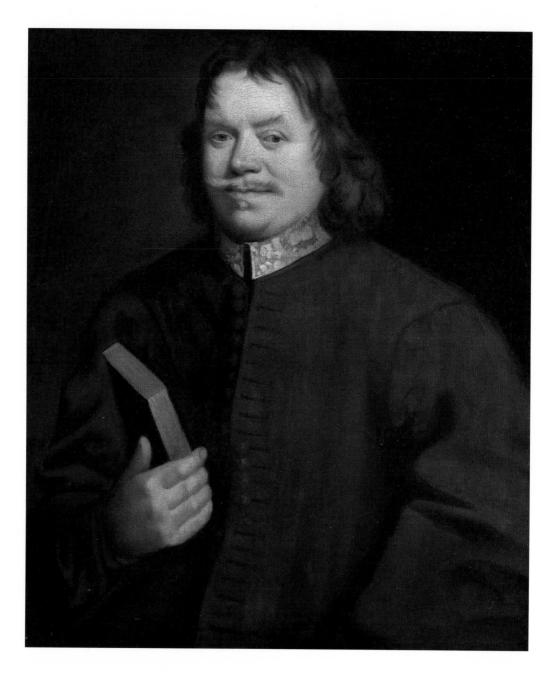

JOHN BUNYAN (1628–88)

Thomas Sadler

1684–5

Oil on canvas, 74.9 x 63.5cm (25 x 19½")

Most people's idea of the Restoration is dominated by images of the Court, so it is useful to have a corrective in this portrait of John Bunyan, tinsmith, soldier and preacher, best known as the author of *The Pilgrim's Progress*. It was painted by Thomas Sadler, about whom little is known apart from the fact that he is thought to have been a pupil of Lely. It shows Bunyan aged 56, broad-faced, clutching a Bible and dressed in a plain brown coat with an unexpectedly ornate lace collar.

(NPG 1311)

SIR GODFREY KNELLER (1646–1723)
Self-portrait
1685
Oil on canvas, 75.6 x 62.9cm (29¾ x 24¾")

Dashing and worldly, Kneller was trained as an artist in Holland and Italy and came to England in 1676, where he rapidly established an extremely successful business as a portrait painter. This self-portrait is signed 'G. Kneller. F. 1685' and shows his powers as an artist before they were diluted by mass production. (NPG 3794)

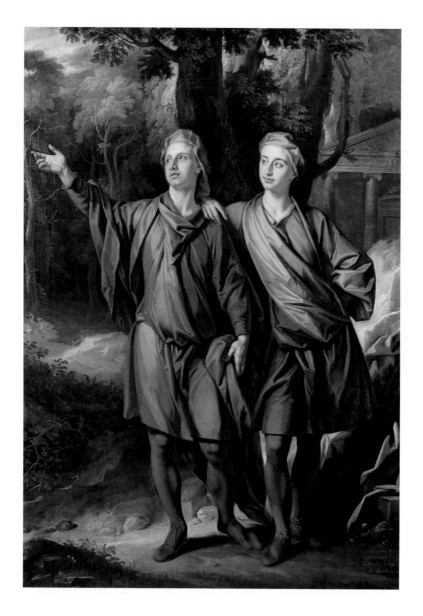

ANTHONY ASHLEY COOPER, 3RD EARL OF SHAFTESBURY, AND THE HON. MAURICE ASHLEY COOPER

John Closterman
1702(?)
Oil on canvas, 243.2 x 170.8cm (95¾ x 67¼")

This extraordinary double portrait is quite unlike any other portrait of its period. The figure on the right is the 3rd Earl of Shaftesbury (1671–1713), well known as a writer and philosopher (although many of his ideas became influential only after his death). He was passionately interested in Platonism, as was his younger brother Maurice (1675–1726), who is shown gesturing towards the light of ideas in the distance. It seems the brothers commissioned this portrait in order to show themselves in an idealised Classical landscape and wearing what was thought to be Ancient Greek dress. Behind them is a Classical temple with a Greek inscription demonstrating that it was dedicated to Apollo.

(NPG 5308)

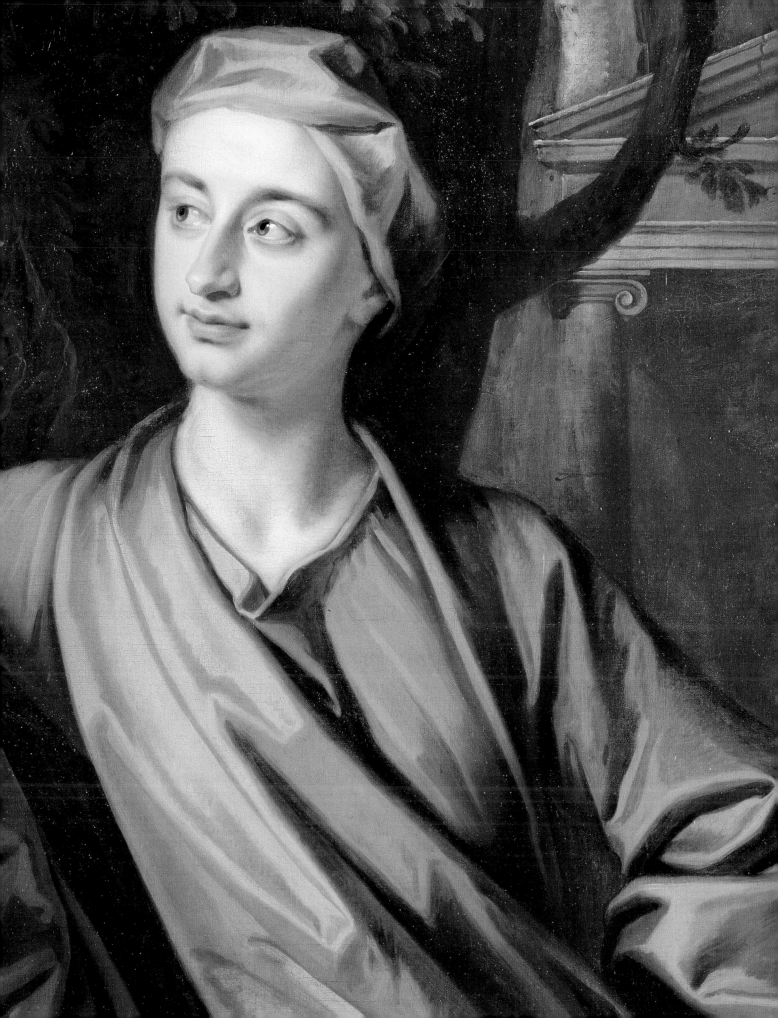

SIR JOHN VANBRUGH (1664–1726)
Sir Godfrey Kneller
*c.*1705
Oil on canvas, 91.4 x 71.1cm (36 x 28")

Both Kneller and the architect and dramatist John Vanbrugh were members of the Kit-Cat Club, a club established by the publisher Jacob Tonson, which originally met in a tavern near Temple Bar kept by Christopher Cat and from 1703 onwards sometimes met in Tonson's house at Barn Elms near Putney. It was essentially a drinking club but, as often happens in clubs, attracted a group of like-minded individuals united by politics (they were almost all Whigs) and by intellectual and artistic interests. So this portrait is not only a record of a great architect, painted when he was at the height of his career, presumably soon after he received the commission to design Blenheim Palace, but also a record of friendship between the painter and sitter.

(NPG 3231)

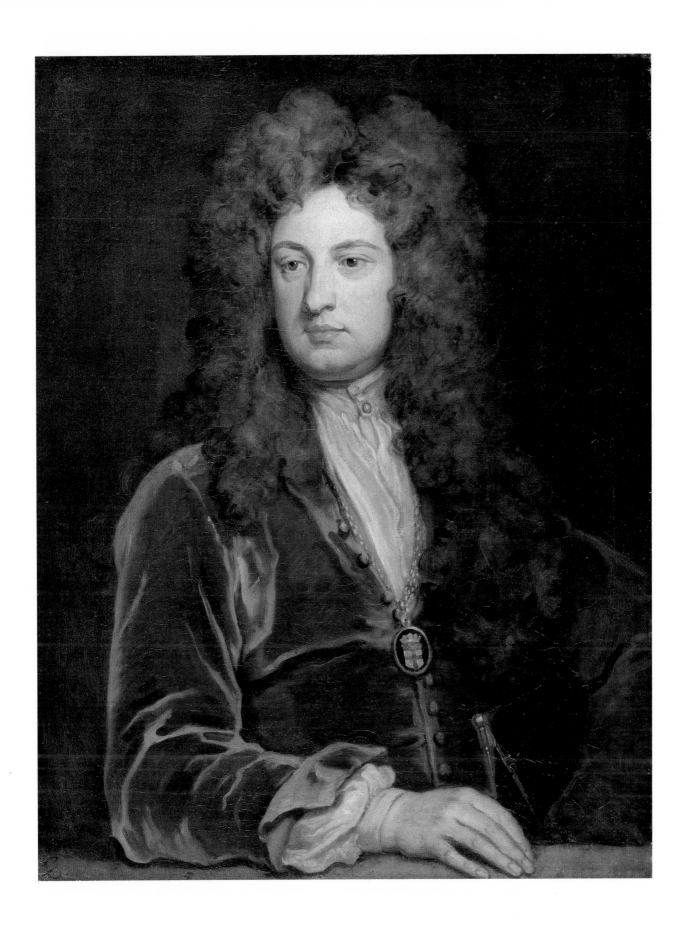

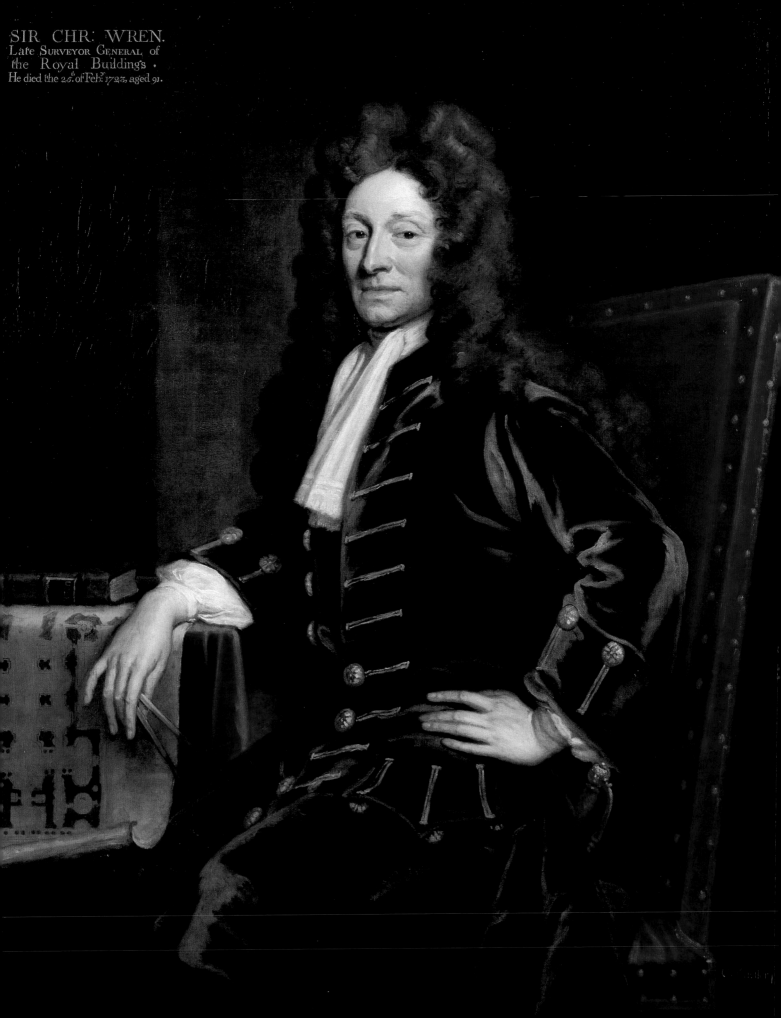

SIR CHR: WREN.
Late Surveyor General of
the Royal Buildings.
He died the 25th of Feby 1723, aged 91.

SIR CHRISTOPHER WREN (1632–1723)
Sir Godfrey Kneller
1711
Oil on canvas, 124.5 x 100.3cm (49 x 39½")

Wren became increasingly embittered towards the end of his career as he was supplanted by younger architects, who favoured a much freer and more inventive interpretation of the Classical precepts of architecture. Indeed, his style of architecture began to be regarded as outmoded, representative of the court of Charles II and inappropriate for a more democratic age. This sense of a grand old man, who had been a great figure throughout the latter half of the seventeenth century but who by 1711 was no longer so central to the architectural profession, is communicated by Kneller's rather stiff and perhaps deliberately old-fashioned portrait of him sitting erect with his compasses dangling over the plans for St Paul's.

(NPG 113)

GEORGIAN PORTRAITS

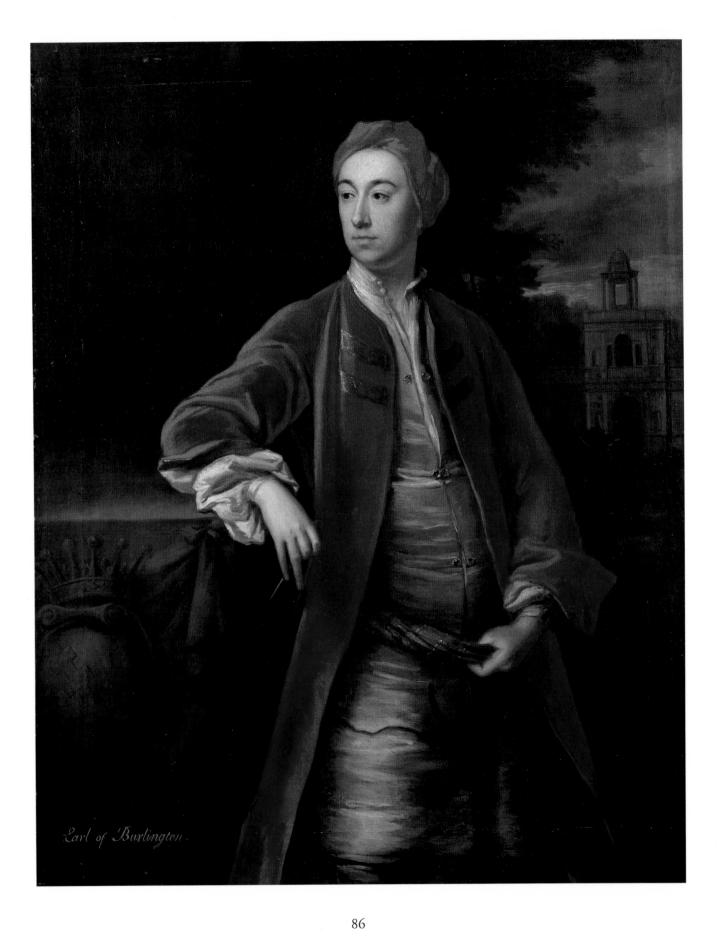

Earl of Burlington.

RICHARD BOYLE, 3RD EARL OF BURLINGTON (1694–1753)
Jonathan Richardson
*c.*1717
Oil on canvas, 146.1 x 116.8cm (57½ x 46")

Richard Boyle, 3rd Earl of Burlington, was one of the greatest and most influential 'milordi' of the early eighteenth century. Having inherited substantial estates in Ireland, he took himself off on the Grand Tour and became infatuated with the ideals of Palladian architecture. On his return, he began to disseminate his ideas through designs and publications, and most of all through the architecture of Chiswick House, a villa that he regarded as a model of neo-Palladian ideals. This portrait shows him looking languid and supercilious, with the bagnio he designed for Chiswick in the background. It is always assumed that it was painted by Jonathan Richardson, who was interested in the revival of British portrait painting for reasons closely comparable to Lord Burlington's zeal for Palladianism: a belief that Britain's wealth and status as a maritime power should prompt British citizens to devote resources to the support of the arts.

(NPG 4818)

(Overleaf)
FREDERICK, PRINCE OF WALES, AND HIS SISTERS
Philippe Mercier
1733
Oil on canvas, 45.1 x 57.8cm (17¾ x 22¾")

Philippe Mercier was an artist of French Huguenot origin who had arrived in London soon after the Hanoverian accession and in 1729 had been appointed 'Principal Portrait Painter' to Frederick, Prince of Wales (1707–51). In 1733 Frederick started to play the bass-viol and was so pleased with it that he was described as having 'his violincello between his legs, singing French and Italian songs to his own playing for an hour or two together, while his audience was composed of all the underling servants and rabble of the Palace'. Evidently inspired by his new-found interest, he commissioned Mercier to paint a group portrait of himself playing the bass-viol in the grounds of Kew House, in company with three of his sisters, Princess Anne, Princess Amelia and Princess Caroline. Mercier's portrait shows a new informality in which the action and setting are more important than his vapid depiction of character.

(NPG 1556)

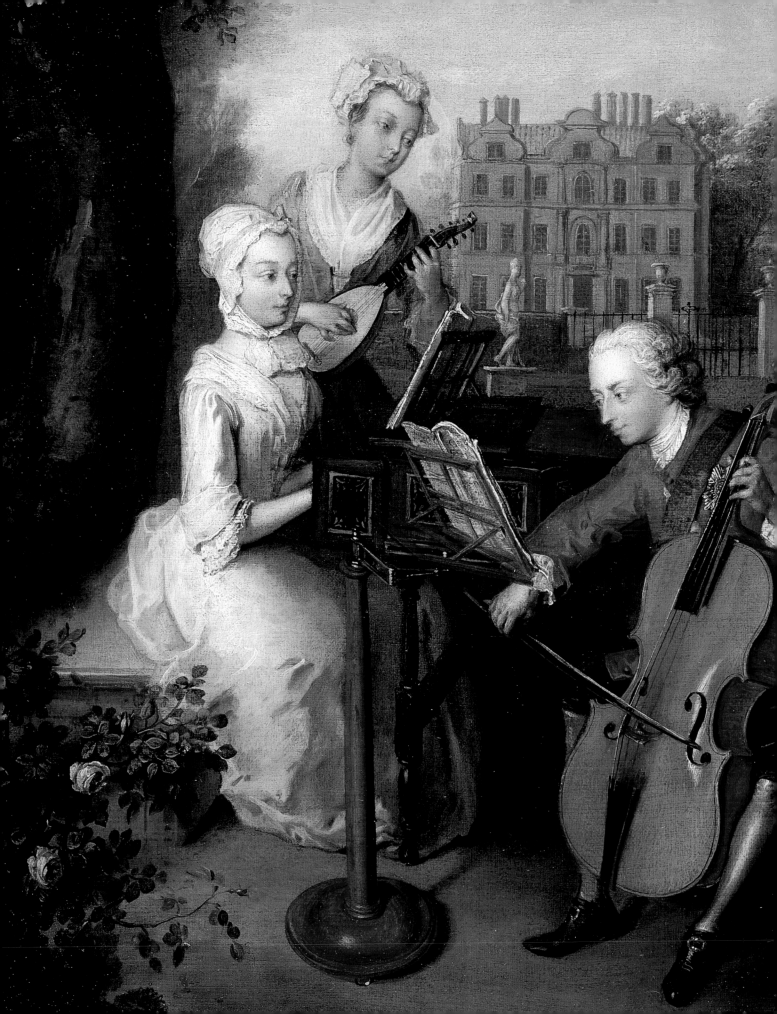

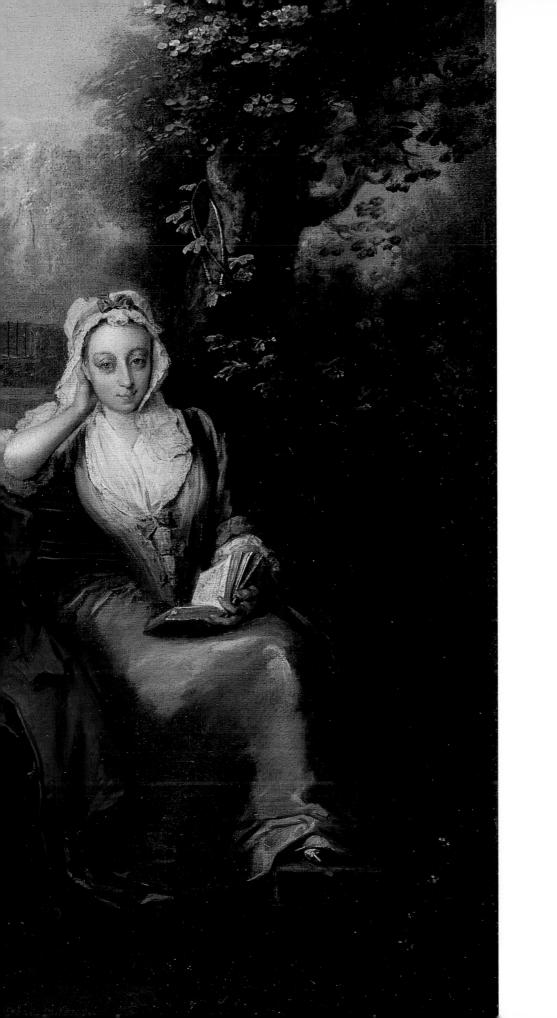

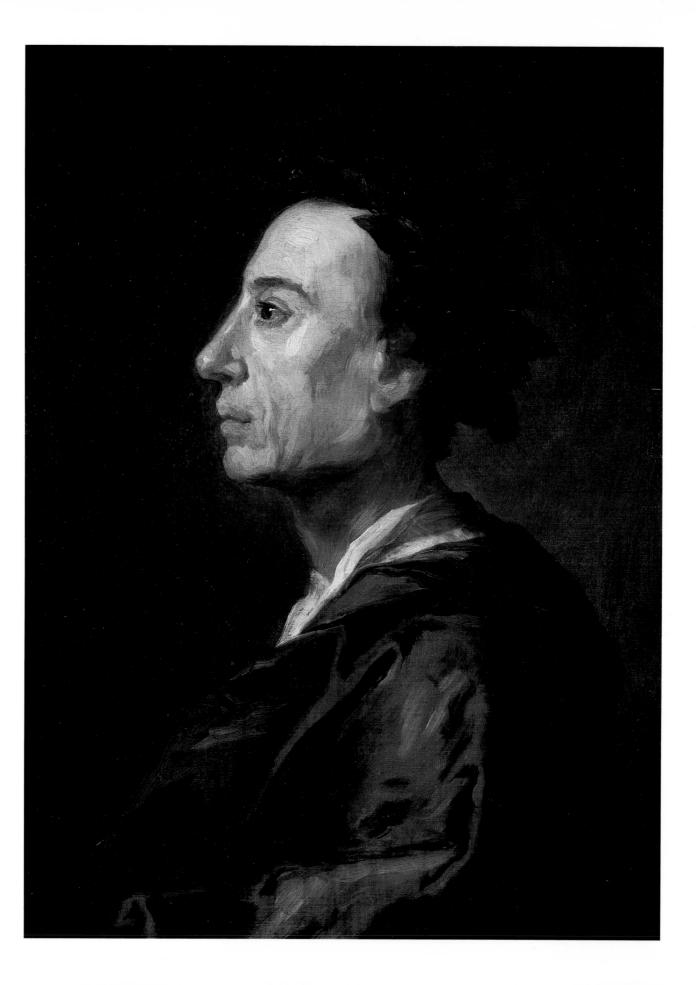

ALEXANDER POPE (1688–1744)
Jonathan Richardson
c.1737
Oil on canvas, 61.3 x 45.7cm (24⅛ x 18")

This highly evocative profile portrait of the great Augustan poet Alexander Pope shows him as he appeared towards the end of his life: physically crippled, with a face that had been ravaged by illness, but as a poet immortal. Pope was himself interested in painting and sat to almost all the major artists active during his lifetime, including Charles Jervas, from whom he took painting lessons in 1713, and Jonathan Richardson, whom he had known for at least a decade before Richardson painted this portrait and whom he assisted in the preparation of a commentary on Milton's *Paradise Lost*, published in 1735. It is a great portrait. As David Piper has written of Pope's fascination with images of himself, 'Vanity was intensified by the need to rectify the tragic twisted reality of his crippled body with an image worthy of the lucid beautifully articulated construction and spirit of his poetry – the need very literally to put the image straight.'

(NPG 1179)

(Overleaf)
THE SHUDI FAMILY
Carl Marcus Tuscher
c.1742
Oil on canvas, 83.4 x 141.5cm (32¾ x 55¾")

Burkat Shudi was Swiss, his name being Burkhardt Tschudi before anglicisation. He settled in England in 1718 and soon afterwards is known to have been working for the harpsichord maker Hermann Tabel. By 1729, he was in independent practice and signed a harpsichord said to have been given by Handel to his favourite soprano, Anna Strada. Indeed, Shudi was a friend of Handel, described as a 'constant guest at his table [which was] ever well covered with German dishes and German wines'. In 1739 Shudi was living in Meard Street, Soho, where he remained until 1742, when the *Daily Advertiser* reported that he had 'removed from Meard's Street to Great Pulteney Street, Golden Square'. This group portrait of his family was painted at about that time and remained in the same house in Great Pulteney Street until the twentieth century. It was sold to the National Portrait Gallery by the Broadwood Trustees, since the firm of Shudi, which made harpsichords in the mid-eighteenth century, turned into Broadwood's, the greatest manufacturer of pianos throughout the nineteenth century.

(NPG 5776)

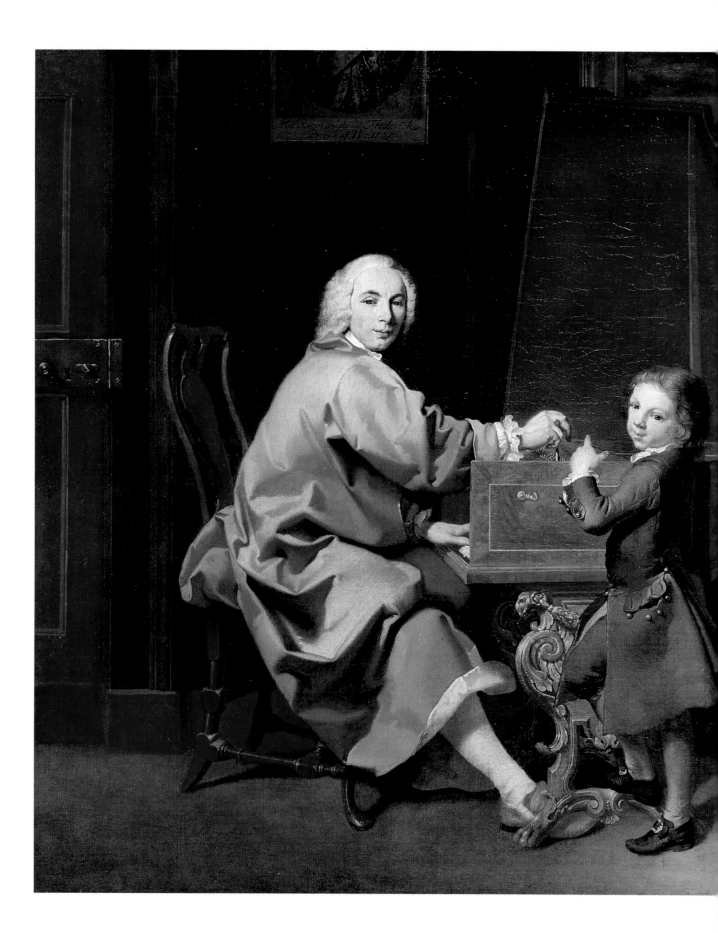

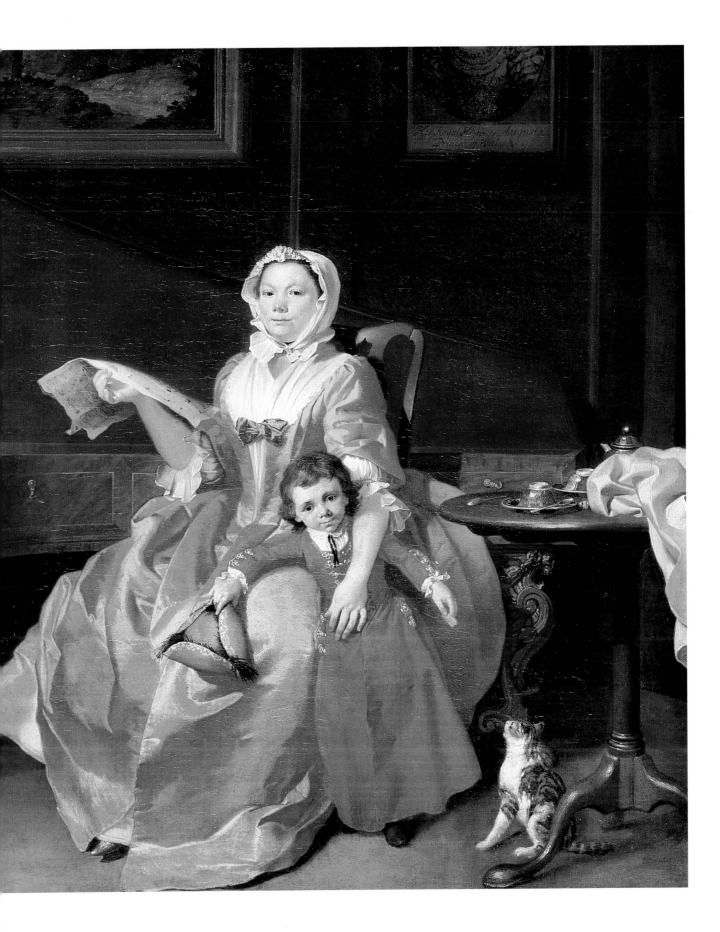

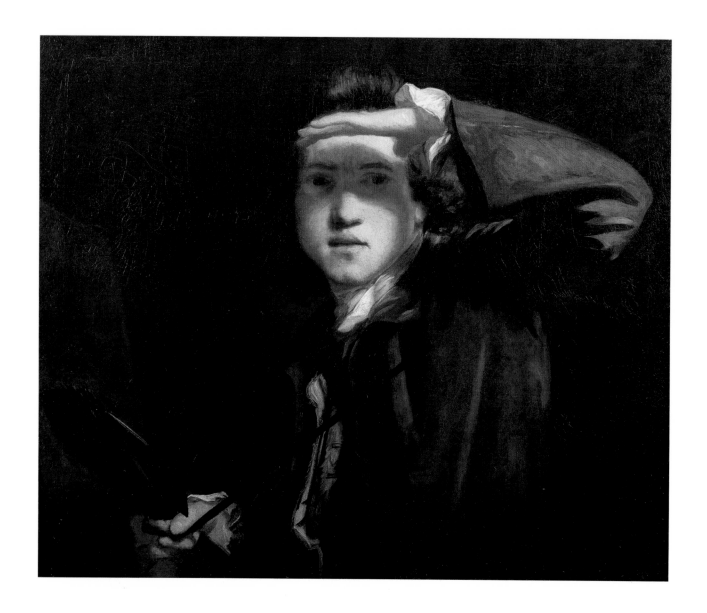

SIR JOSHUA REYNOLDS (1723–92)
Self-portrait
*c.*1747
Oil on canvas, 63.5 x 74.3cm (25 x 29¼")

Blessed with talent and determined to make good in the metropolis, Reynolds painted himself in his early twenties, wearing a brown coat with a velvet collar worn loose over a blue silk waistcoat, looking out towards the horizon and shading his eyes against the intensity of the light. It is an image that shows him holding the tools of his trade and at the beginning of his career as an artist, before he travelled to Italy. The self-portrait is highly suggestive of Reynolds' confidence in his artistic powers and the nature of his ambition to compete with the great artists of the past, particularly Rembrandt.

(NPG 41)

SAMUEL RICHARDSON (1689–1761)
Joseph Highmore
1750
Oil on canvas, 52.7 x 36.8cm (20¾ x 14½")

Samuel Richardson, the author of *Pamela* and *Clarissa*, described himself to Lady Bradshaigh, an admirer of his work, as 'short; rather plump than emaciated … about five foot five inches'. This is precisely how he looks in this engagingly domestic work, which, in contrast to the grander traditions of much eighteenth-century portraiture, shows Richardson at home, with a large vase of flowers in the chimneyplace behind him, and his writing materials on the table beside him. The painting was, in fact, undertaken at the express wish of Lady Bradshaigh, who had greatly admired Highmore's illustrations to *Pamela* and decided that she would like to commission a portrait. She was very specific in her instructions, writing to Richardson, 'If you think proper, Sir, I would chuse to have you drawn in your study, a table or desk by you, with pen, ink and paper; one letter just sealed, which I shall fancy is to me.'

(NPG 1036)

WILLIAM HOGARTH (1697–1764)
Self-portrait
*c.*1757
Oil on canvas, 45.1 x 42.5cm (17¾ x 16¾")

In contrast to Reynolds, who always saw himself as a highly professional artist, the friend of men of letters and the social equal of many of his sitters, Hogarth cultivated a much rougher and more self-consciously belligerent idea of himself as a native-born talent, able to compete with other artists but on his terms rather than theirs. Some of these attitudes are evident in his self-portrait, in which he depicts himself sitting down, palette in hand and painting a picture of the comic muse which, as with so much of his work, teeters on the edge of parody. Not least he shows himself dressed casually, without a wig and with a maroon velvet cap askew. X-rays have also revealed that in the portrait as originally painted, there was a dog peeing on some Old Master paintings in the corner.

(NPG 289)

THOMAS GAINSBOROUGH (1727–88)
Self-portrait
*c.*1759
Oil on canvas, 76.2 x 63.5cm (30 x 25")

Modest, informal, approachable and amusing, Gainsborough was the opposite of Reynolds in temperament. There is an engaging directness in his gaze and in the looseness of the brushwork that suggests, but no more than suggests, autumn trees in the background. This self-portrait dates from the early part of his career, when he was making a living as a painter in Suffolk, living in Ipswich and making friends with people in the neighbourhood. In autumn 1759 (about the time the self-portrait was painted) he moved to Bath and a grander manner.

(NPG 4446)

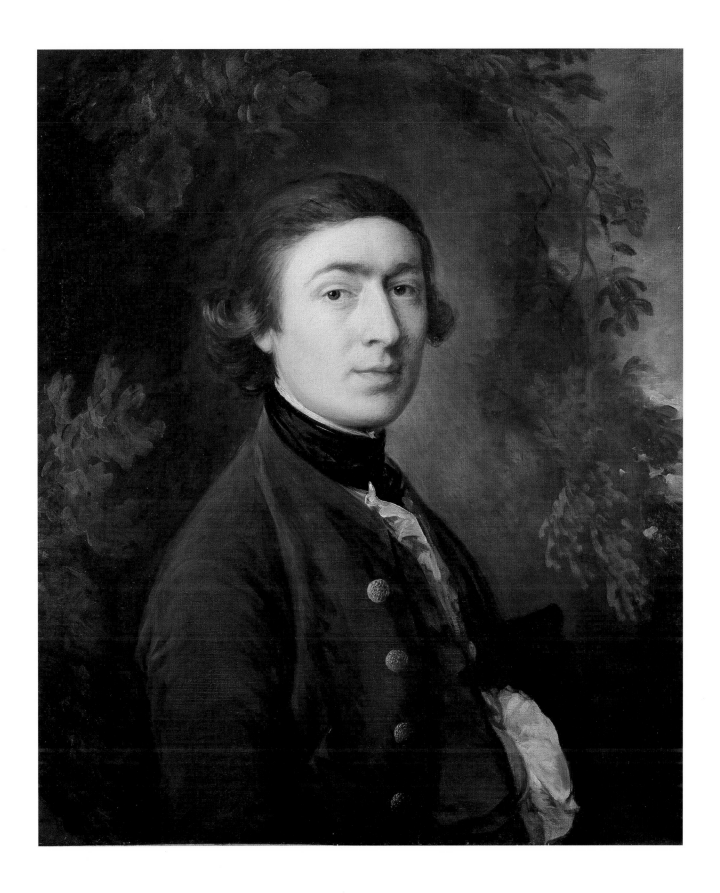

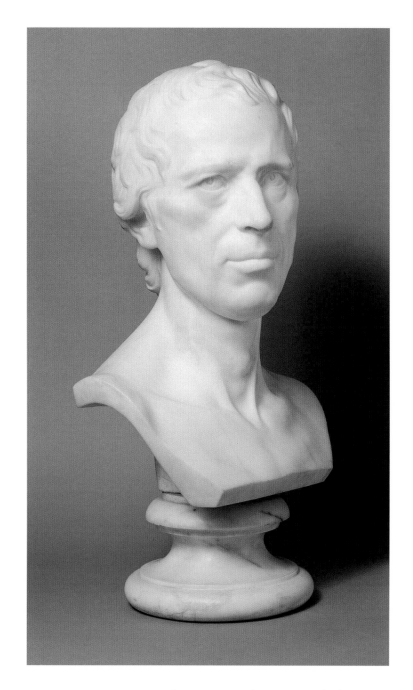

LAURENCE STERNE (1713–68)
Joseph Nollekens
*c.*1766
Marble, height 39.4cm (15½")

Laurence Sterne, author of *Tristram Shandy*, visited Italy in 1765, travelling from Florence south to Rome and Naples in early 1766. His travels resulted in his book *A Sentimental Journey through France and Italy*, published in 1768. While in Rome Sterne sat to the young sculptor Joseph Nollekens, who produced a portrait bust of exceptional authority – austere, dignified and Roman.
(NPG 1891)

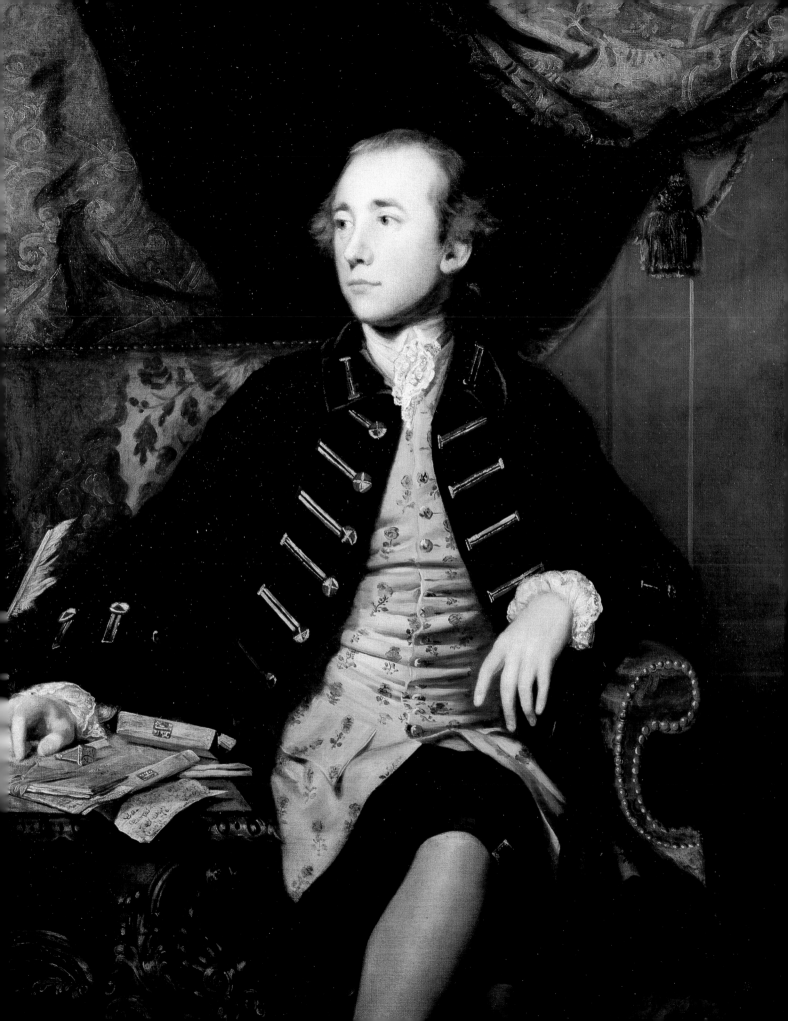

(Previous page)
WARREN HASTINGS (1732–1818)
Sir Joshua Reynolds
1766–8
Oil on canvas, 126.4 x 101cm (49¾ x 39¾")

Warren Hastings, educated as a King's Scholar at Westminster, was sent out to India by his guardian as an administrator. In 1764 he returned to England with plans for the establishment of the East India College at Haileybury and made friends with Dr Johnson. On 9 September 1768, shortly before his return to Madras, he paid 70 guineas for his portrait by Reynolds. It shows him as a young man, highly intelligent, well dressed, socially and intellectually ambitious, and not without a touch of conceit. Hastings subsequently became Governor of Bengal and Governor-General of India, but was impeached on the grounds of corruption in 1787, and only cleared in 1795 after a trial that cost him £70,000.
(NPG 4445)

WILLIAM BECKFORD (1760–1844)

Sir Joshua Reynolds

1782

Oil on canvas, 72.7 x 58.4cm (28⅝ x 23")

Young, rich and vain, William Beckford sat to Sir Joshua Reynolds in February 1782, soon after his return from the Grand Tour and when he had already written his great Gothic novel, *Vathek*. The portrait remained in Beckford's possession until his death and before it was engraved in 1835, the background was repainted, making him look much less of a dandy. This was discovered only when the portrait was acquired by the National Portrait Gallery in 1980 and cleaned, revealing the swashbuckling pose and the sky. It was said to be Beckford's favourite image of himself.

(NPG 5340)

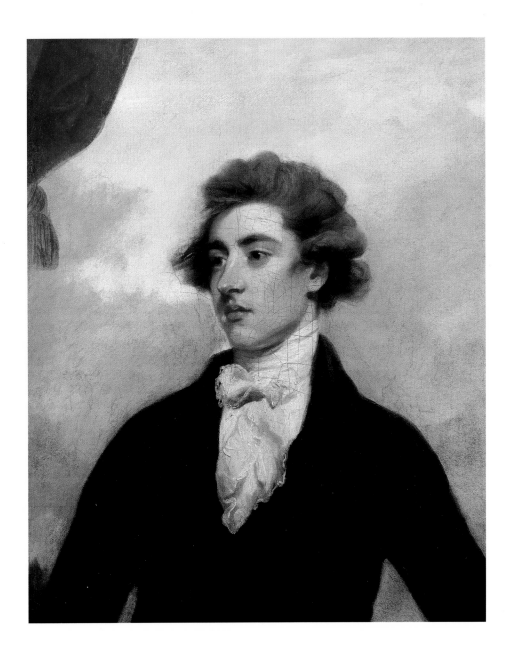

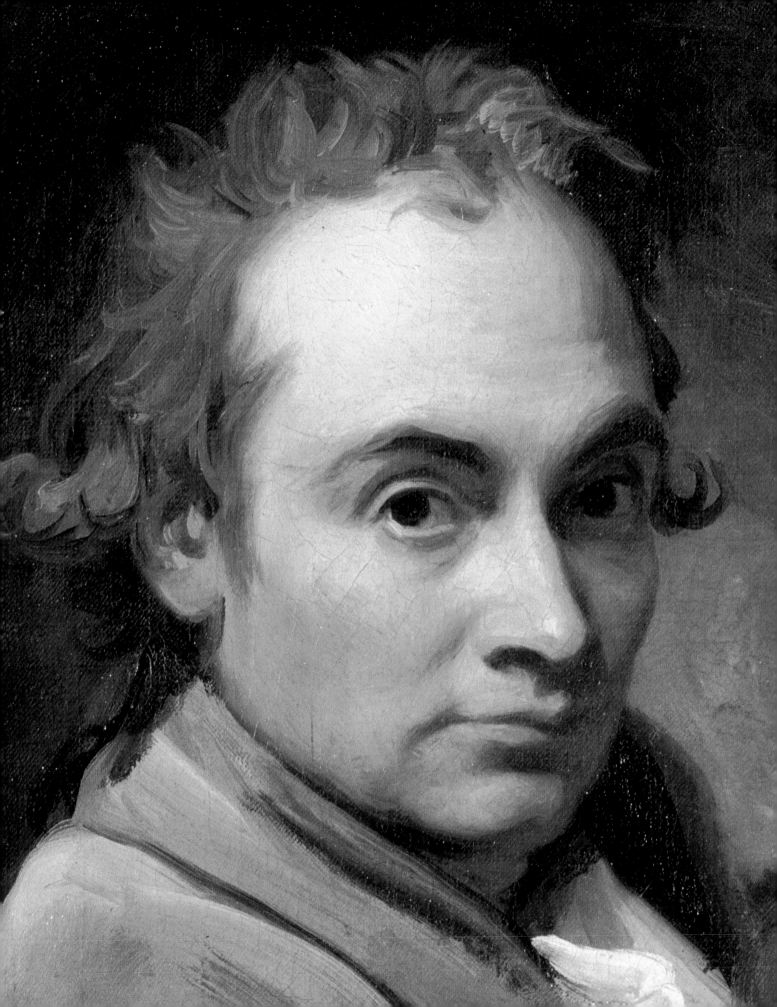

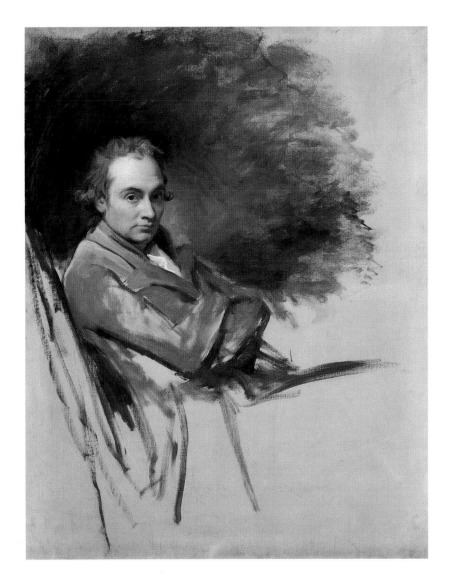

GEORGE ROMNEY (1734–1802)
Self-portrait
1784
Oil on canvas, 125.7 x 99.1cm (49½ x 39")

According to William Hayley, Romney's friend and biographer, Romney 'enlivened the autumn of 1784 in a manner peculiarly memorable to me, for he interested himself most kindly in the decoration of a new library, that I was then fitting up, and began at my request, on that occasion, the striking resemblance of himself in oil, which may be regarded as the best of his own portraits, and which is marked in the frontispiece to this volume with the year of his age, forty-nine'. I am inclined to believe this account of the circumstances that led to the painting of Romney's self-portrait rather than that of the artist's son, who dated the portrait to 1782. It shows Romney as he was in the 1780s, gloomy and anti-social, disliking his facility at painting society portraits and inclined to escape into the country to stay with Hayley, who wrote that this portrait 'well expresses that pensive vivacity, and profusion of ideas, which a spectator might discover in his countenance, whenever he sat absorbed in studious meditation'.

(NPG 959)

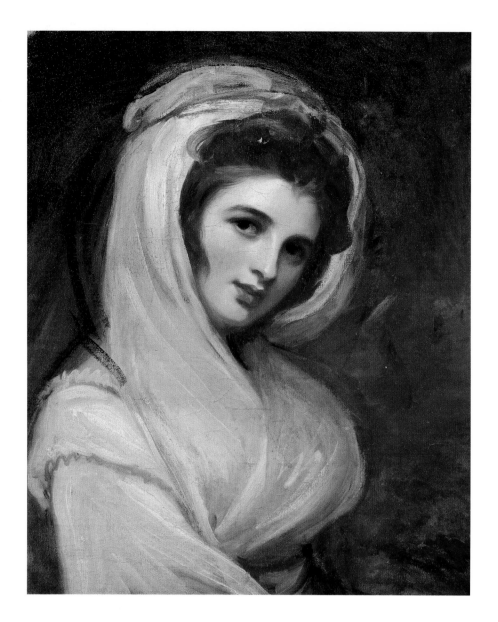

EMMA HAMILTON (1765–1815)
George Romney
*c.*1785
Oil on canvas, 62.2 x 54.6cm (24½ x 21½")

The daughter of a Cheshire blacksmith, Emma Hart had a spectacularly successful career as mistress to a succession of older men, finally marrying Sir William Hamilton, the British envoy in Naples. Romney met her when she was only seventeen and the mistress of Charles Greville. He was clearly besotted by her and painted her again and again, becoming her friend but probably not her lover, however much he might have liked to be. As she wrote to him on 20 December 1791, 'you was the first dear friend I open'd my heart to, you ought to know me, for you have seen and discoursed with me in my poorer days, you have known me in my poverty and prosperity'. This portrait is one of many that Romney kept back in his studio for his private delectation. It conveys something of his feeling for her doe-eyed beauty.
(NPG 4448)

WILLIAM COWPER (1731–1800)

George Romney
1792
Pastel, 57.2 x 47cm (22½ x 18½")

William Hayley, who was always keen to act as patron of artists and men of letters, met the poet William Cowper in May 1792. He immediately wished to have their friendship recorded by George Romney, when Romney next came to stay at his house at Eartham near Chichester. Hayley himself describes in his *Life of George Romney* how 'Romney was eager to execute a portrait of a person so memorable, and in drawing it he was particularly desirous of making the nearest approach to life, that he possibly could: for this purpose he chose to make use of coloured crayons, a mode of painting in which he had indeed little experience ... He worked with uncommon diligence, zeal, and success, producing a resemblance so powerful, that spectators who contemplated the portrait with the original by its side, thought it hardly possible for any similitude to be more striking, or more exact.' It is indeed an extraordinarily powerful image, strongly suggestive of Cowper's slight diffidence and imaginative intensity.

(NPG 1423)

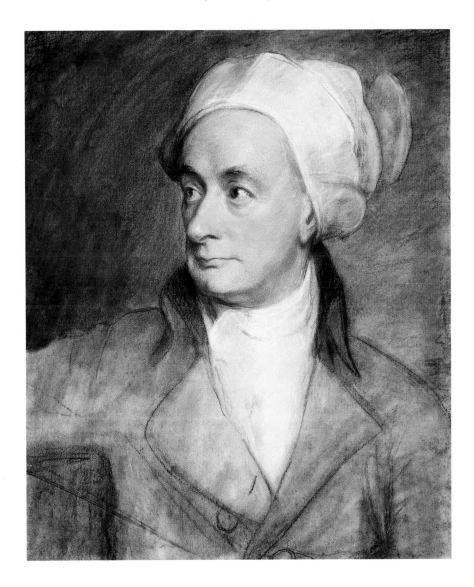

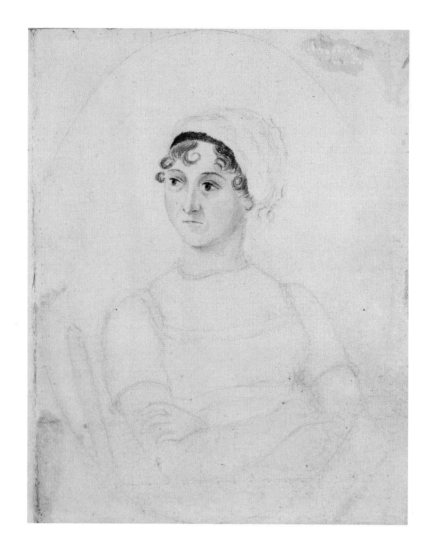

JANE AUSTEN (1775–1817)
Cassandra Austen
*c.*1810
Pencil and watercolour, 11.4 x 8cm (4½ x 3⅛")

When Jane Austen's brother Henry was asked to provide a 'Memoir of Miss Austen' for a new edition of *Sense and Sensibility* published in 1833, he wrote, 'So retired, unmarked by contemporary notoriety was the life Miss Austen led, that if any likeness were ever taken of her, none was ever engraved.' Presumably he thought that this drawing of her by her sister Cassandra was insufficiently substantial to merit publication. However, it was engraved for a *Memoir* by her nephew, James Edward Austen-Leigh, published in 1870. Ever since it has been regarded as the most (and possibly the only) authentic likeness. It was acquired by the Gallery in 1948 from a sale of manuscripts at Sotheby's, when it was described as a 'Pencil Sketch … the face and hair in water-colours, of JANE AUSTEN, in a blue wrapper inscribed "Cassandra's sketch of Jane, from which a picture was drawn by Mr Andrews of Maidenhead to be engraved for the Memoir".' It is an unsophisticated but nonetheless highly expressive image of an intense and determined woman, described by her nephew as having 'full round cheeks, with mouth and nose small and well formed, light hazel eyes and brown hair forming natural curls close round her face'.

(NPG 3630)

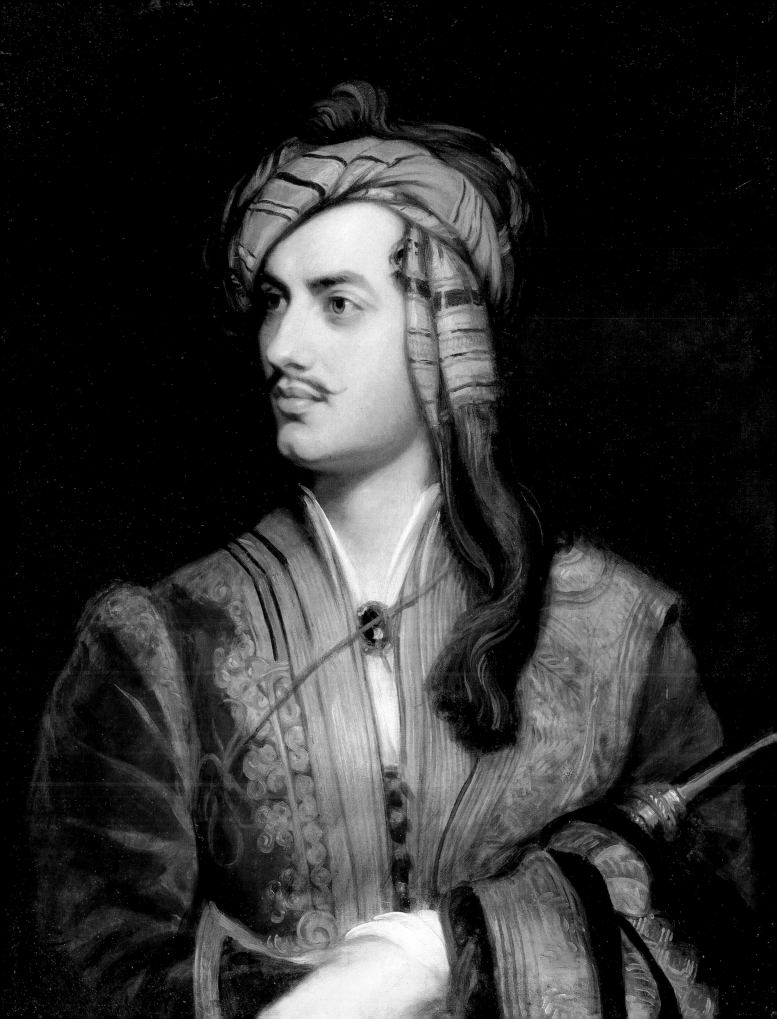

(Previous page)

GEORGE GORDON, 6TH BARON BYRON (1788–1824)

Thomas Phillips
[copy of 1813 original]
Oil on canvas, 76.5 x 63.9cm (30⅛ x 25⅛")

Although this is one of the best-known paintings in the collection, much reproduced, it is in fact a copy by
Thomas Phillips from the original he painted in the summer of 1813, which is now in the British Embassy
in Athens. Byron had acquired the Albanian costume in 1809 and was clearly pleased to be painted in it
for a portrait commissioned by his publisher, John Murray. When it was exhibited the following year at the
Royal Academy, Hazlitt wrote that it was 'too smooth, and seems, as it were, "barbered ten times o'er" –
there is however much that conveys the softness and wildness of character of the popular poet of the East'.
Its whiff of the Orient and its air of theatricality are both entirely appropriate to the sitter.
(NPG 142)

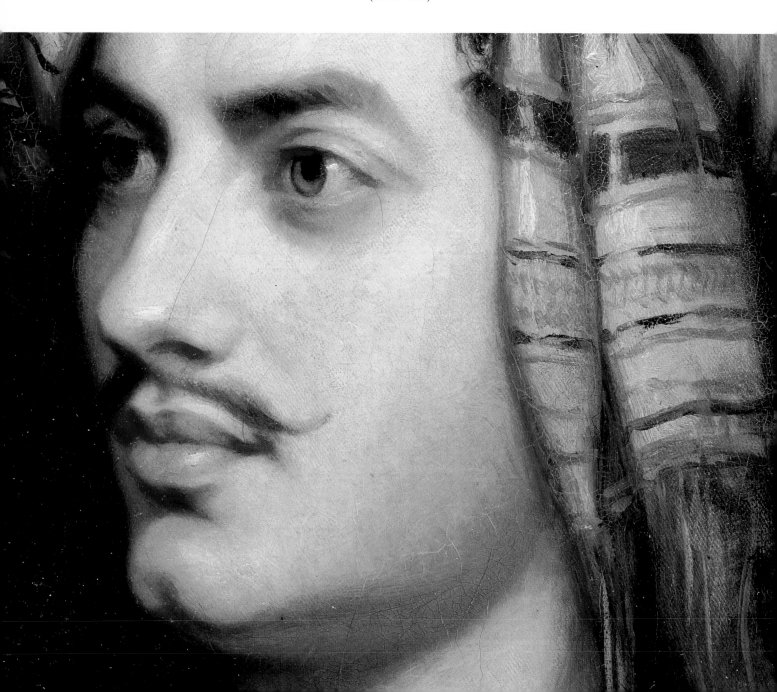

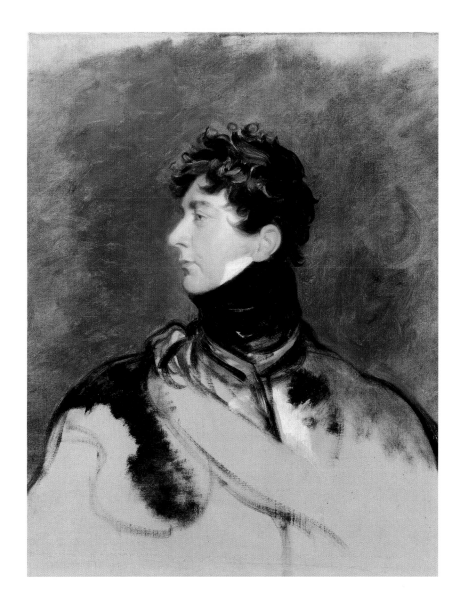

GEORGE IV (1762–1830)
Sir Thomas Lawrence
*c.*1814
Oil on canvas, 91.4 x 71.1cm (36 x 28")

In 1814 Lord Stewart, who had been appointed ambassador in Vienna and was a previous client of Thomas Lawrence, wanted to commission a portrait by him of the Prince Regent (later King George IV). He therefore arranged that Lawrence should be presented to the Prince Regent at a levee. Soon after, the Prince visited Lawrence at his studio in Russell Square. Lawrence wrote to his brother that 'To crown this honour, [he] engag'd to sit to me at one today and after a successful sitting of two hours has just left me and comes again tomorrow and the next day.' The result was a drawing in the Royal Collection, this dashing oil sketch of his head in profile like a Classical god, and a large portrait of him in Field Marshal's uniform, of which Hazlitt wrote, 'Sir Thomas Lawrence has with the magic of his pencil recreated the Prince Regent as a well-fleshed Adonis of thirty-three.'

(NPG 123)

JOHN KEATS (1795–1821)

Joseph Severn
1821–3
Oil on canvas, 56.5 x 41.9cm (22¼ x 16½")

Joseph Severn was a minor artist, distinguished only by the fact that he was a close friend of Keats, whose portrait he painted on many occasions. Indeed, Keats died in Joseph Severn's arms. When the picture was acquired by the NPG, Severn described how it came to be painted: 'After the death of Keats the impression was so painfull on my mind, that I made an effort to call up the last pleasant remembrance in this picture which is posthumous. This was at the time he first fell ill & had written the Ode to the Nightingale (1819) on the mor[ning] of my visit to Hampstead. I found him sitting with the two chairs as I have painted him & I was struck with the first real symptom of sadness in Keats so finely expressed in that Poem.'

(NPG 58)

113

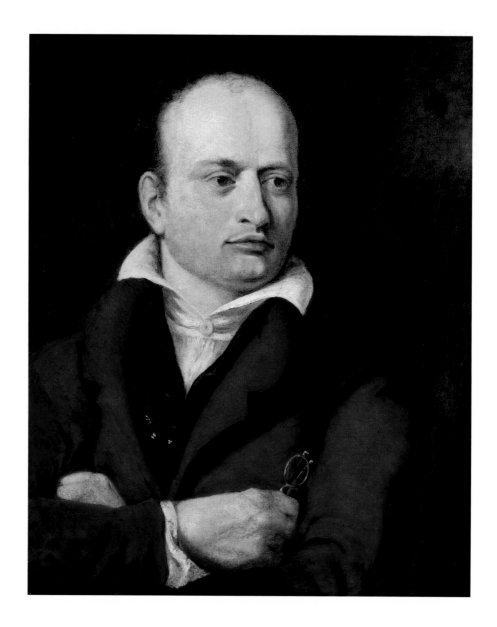

BENJAMIN ROBERT HAYDON (1786–1846)
Georgiana Zornlin
1825
Oil on canvas, 68.6 x 57.2cm (27 x 22½")

This is an appropriately idiosyncratic portrait of Benjamin Robert Haydon, a highly opinionated and arrogant artist with a misplaced belief in his own abilities, now better remembered for his diaries and for his friendship with Keats and Wordsworth than he is for his sprawling canvases. His portrait was painted by Georgiana Margaretta Zornlin, one of his pupils, who presented it to the Gallery in 1878 with a hope that 'by this time, the faults in Haydon's character have been consigned to oblivion, but that he may still be held in remembrance as the enthusiastic promoter of the study of the Elgin Marbles, and the zealous encourager of Art Schools throughout this country'. Aldous Huxley thought that Haydon's head was just like that of Mussolini.

(NPG 510)

114

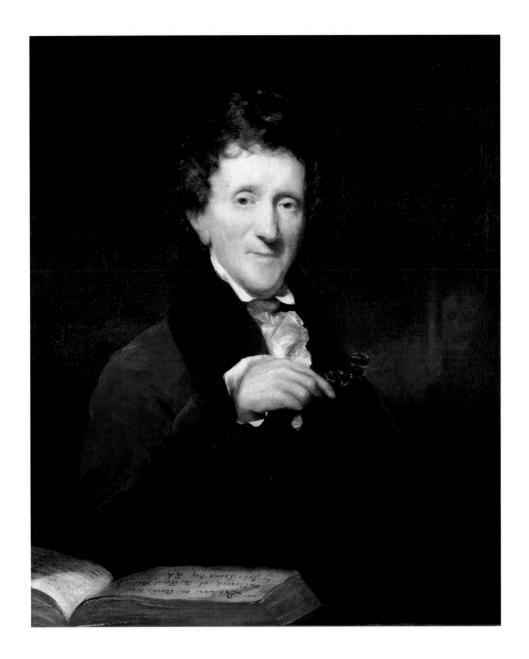

SIR JOHN SOANE (1753–1837)
John Jackson
1828
Oil on canvas, 74.9 x 62.2cm (29½ x 24½")

By 1828 Sir John Soane, the hard-working and brilliant architect of the Bank of England, had grown melancholy as well as rich. His portrait was commissioned by the Governors of the British Institution and was described as 'The Portrait of John Soane, R.A., Painted by order of the Directors of the British Institution, as one of its most liberal Benefactors.' It shows Soane as an old man, slightly quizzical, watery-eyed and thin-lipped; but he was justifiably proud of his achievements and there is a copy of his *Lectures on Architecture delivered at the Royal Academy* open on the table in front of him.

(NPG 701)

WILLIAM WILBERFORCE (1759–1833)

Sir Thomas Lawrence
1828
Oil on canvas, 96.5 x 109.2cm (38 x 43")

The third portrait to be acquired for the collection was this sketch of William Wilberforce, the great anti-slavery campaigner, by Sir Thomas Lawrence. A member of the Clapham Sect (a group of committed Christians), Wilberforce had no particular interest in art, but was persuaded to sit to Lawrence after he had retired from Parliament. The first sitting was on 14 May 1828 – according to Wilberforce, 'a very pleasant hour'. The portrait was to cost Sir Robert Inglis, who had agreed to pay for it, £75. Wilberforce then made strenuous efforts to arrange further sittings, writing to Lawrence: 'I will go to Town DV on Monday next & knock at yr door between 11 & 12 and if either then or at any time before 2 o'clock you should be able to give me an hour or two, I should be much obliged to you'; but the work was still 'not half finished' in 1830 when Inglis rescued it from Lawrence's studio. It has the freshness of an uncompleted painting and a certain ungainliness in the sitter's pose because he was obliged to wear a steel girdle.

(NPG 3)

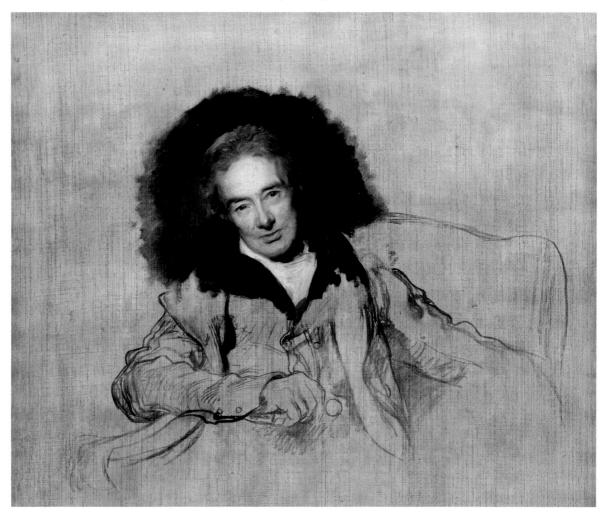

THE BRONTË SISTERS
Branwell Brontë
1833
Oil on canvas, 90.2 x 74.6cm (35½ x 29⅜")

In 1946 Frances Bell, a niece of the Rev. Arthur Nicholls, Charlotte Brontë's husband, recorded the circumstances in which the portrait of the Brontë sisters had been found: 'When Aunt Mary [second wife of Arthur Nicholls] found the portraits now in the National [Portrait] Gallery she asked me to go to the Hill House to look at them. They had been found on the top of the cupboard in what had been uncle Arthur's dressing room. She remembered them & that he had disliked them as they were so very unflattering to "the girls", as he called them.' As it has turned out, this is among the most popular and historically valuable paintings in the Gallery's collection, since, in its crude way, it conveys an authentic sense of the presence of the three sisters and of their personalities. The sisters are from left to right Anne (1820–49), Emily (1818–48) and Charlotte (1816–55). In the background, there was a fourth figure who is always assumed to have been Branwell Brontë himself.

(NPG 1725)

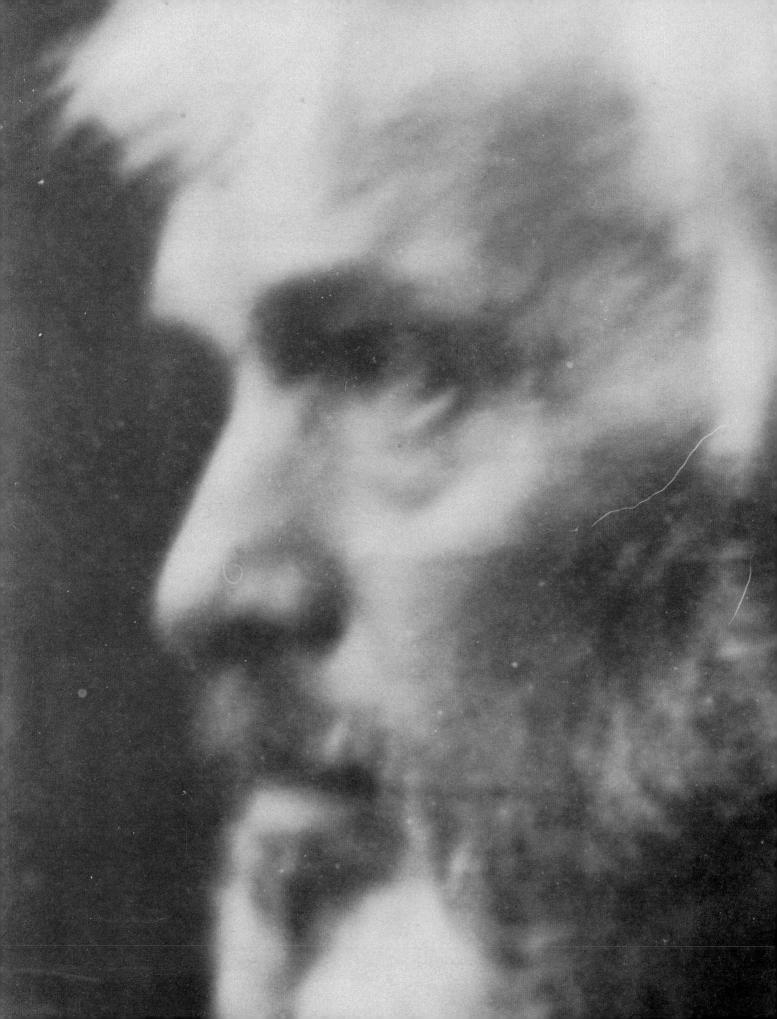

Victorian Portraits

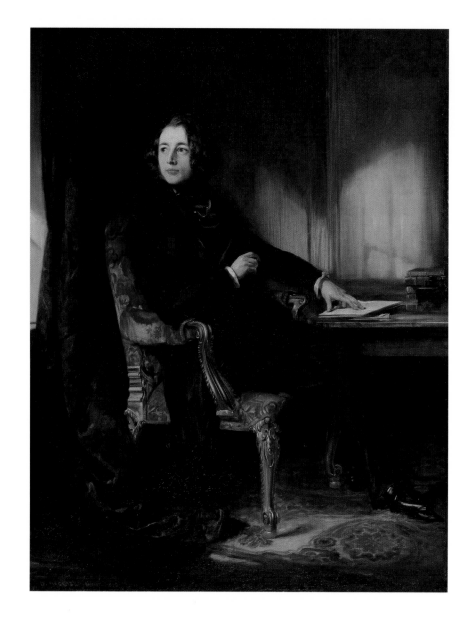

CHARLES DICKENS (1812–70)
Daniel Maclise
1839
Oil on canvas, 91.4 x 71.4cm (36 x 28⅛")

Daniel Maclise, the Irish artist, was a close friend of Charles Dickens and undertook a number of portraits of him. This one was commissioned by Dickens' publishers, Chapman & Hall, so that it could be engraved as the frontispiece for *Nicholas Nickleby*, first published as a serial in October 1839. On 28 June 1839 Dickens wrote that 'Maclise has made another face of me, which all people say is astonishing.' It has remained one of the most lively and lifelike images of him, looking more like a figure from the Regency period, with his handsome frock coat and green trousers, than one of the great moralists of Victorian England. Thackeray certainly was impressed by it and described it 'as a likeness perfectly amazing; a looking-glass could not render a better facsimile. Here we have the real identical man Dickens.'

(NPG 1172)

123

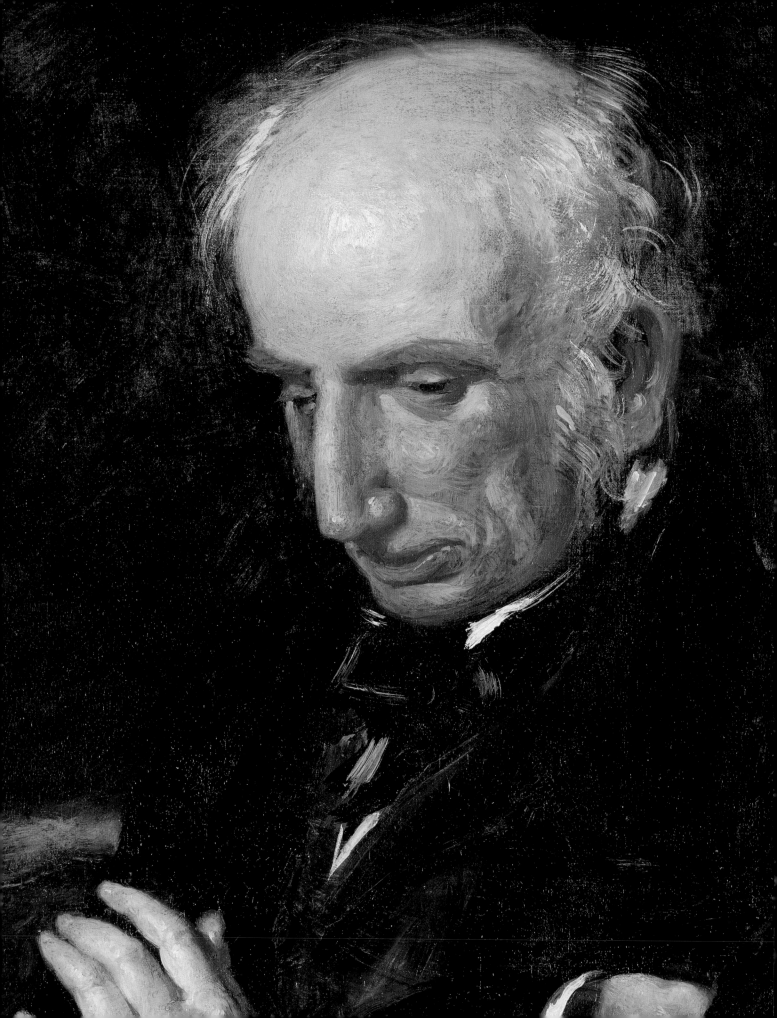

WILLIAM WORDSWORTH (1770–1850)

Benjamin Robert Haydon

1842

Oil on canvas, 124.5 x 99.1cm (49 x 39")

Benjamin Robert Haydon was a long-standing friend of Wordsworth, having first met him in 1814 and then kept up a lively correspondence, as well as undertaking a number of drawings of him. Indeed it was Haydon who introduced Wordsworth to Keats at a dinner party in December 1817. In 1840, towards the end of Wordsworth's life, Haydon sent him an engraving of his picture of *Wellington musing on the Battlefield of Waterloo*. Wordsworth composed a sonnet on it, 'By Art's Bold Privilege', while he was climbing Helvellyn, one of the mountains near his house in Grasmere in the Lake District. This inspired Haydon to undertake a portrait of Wordsworth on Helvellyn, for which Wordsworth sat on three occasions in June 1842. He described the result as 'a likeness of me, not a mere matter-of-fact portrait, but one of a poetical character'. It shows him with arms crossed, in meditative pose, with the mountains beyond, and fixed forever the image of the Romantic poet as an elderly sage.

(NPG 1857)

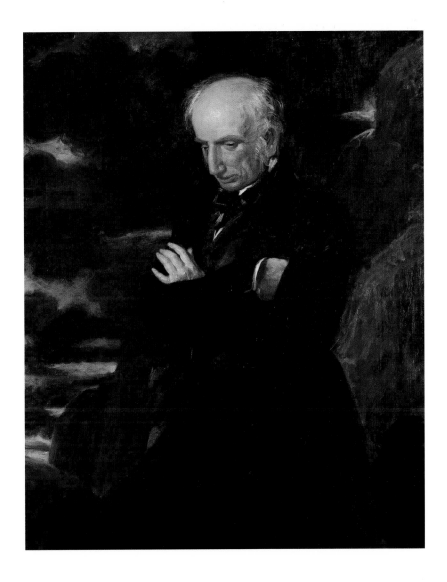

125

WILLIAM WILKIE COLLINS (1824–89)

Sir John Everett Millais

1850

Oil on panel, 26.7 x 17.8cm (10½ x 7")

On 25 August 1894 George Scharf, the Director of the Gallery, wrote to Millais, who was then a Trustee of the Gallery, to say how sad he was that he had not been able to attend the meeting on the previous Thursday when the Trustees had acquired Millais' portrait of Carlyle. He added that, 'Curiously enough, at the last moment before the Meeting, a small portrait of Wilkie Collins attributed also to your pencil, was submitted to the Trustees. It represents Collins with a tremendous forehead, wearing spectacles & the face turned in three-quarters to the spectator's left. His raised hands are joined, palm to palm, & fingers very flexible. Do you remember painting such a portrait?' Millais did indeed remember it, particularly the great bump on the sitter's forehead, but was more concerned by the discoloration owing to the 'nasty brown varnish'. It is an atmospheric portrait, intense and private, as befitted the author of *The Woman in White* and *The Moonstone*.

(NPG 967)

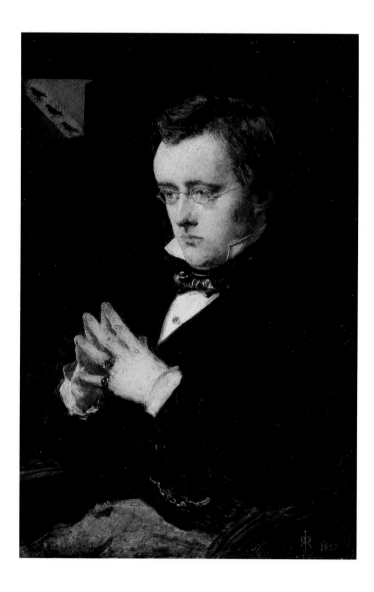

126

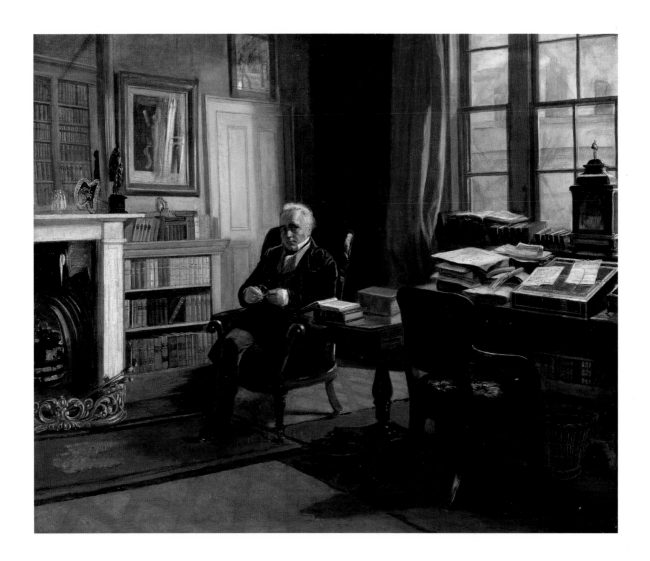

THOMAS BABINGTON MACAULAY, 1ST BARON MACAULAY
(1800–59)
Edward Matthew Ward
1853
Oil on canvas, 63.5 x 76.2cm (25 x 30")

The great historian Macaulay started writing his *History of England* after a long and active career as a politician. This portrait of him sitting polishing his spectacles in his study at the Albany in London was painted just before he became involved in the movement to establish the National Portrait Gallery. He hated the portrait and wrote in his journal that he was 'tired to death of these sittings'. When it was finished, he thought that Ward had 'made me uglier than a Daguerreotype'. But George Scharf, the Director of the Gallery, thought it was 'excellent' and that it showed 'The Room as I knew it'. Certainly Macaulay's study is depicted exactly as described by his biographer, 'comfortable, though not very brightly furnished. The ornaments were few but choice.'

(NPG 4882)

ISAMBARD KINGDOM BRUNEL (1806–59)
Robert Howlett
1857
Albumen print, 28.6 x 22.5cm (11¼ x 8⅞")

This is a highly effective and memorable image of a great Victorian engineer, Isambard Kingdom Brunel, who was responsible for the design of one of the most important Victorian steamships, the *Great Eastern*. Here he is photographed standing nonchalantly in front of the ship's monumental launching chains, his hands in his pockets, a cigar in his mouth and his waistcoat askew, conveying the impression of swaggering casualness about his achievements, just before the ship was launched in November 1857. The photograph was taken by Robert Howlett for a series of engravings published to commemorate the launch in the *Illustrated Times*.

(NPG P112)

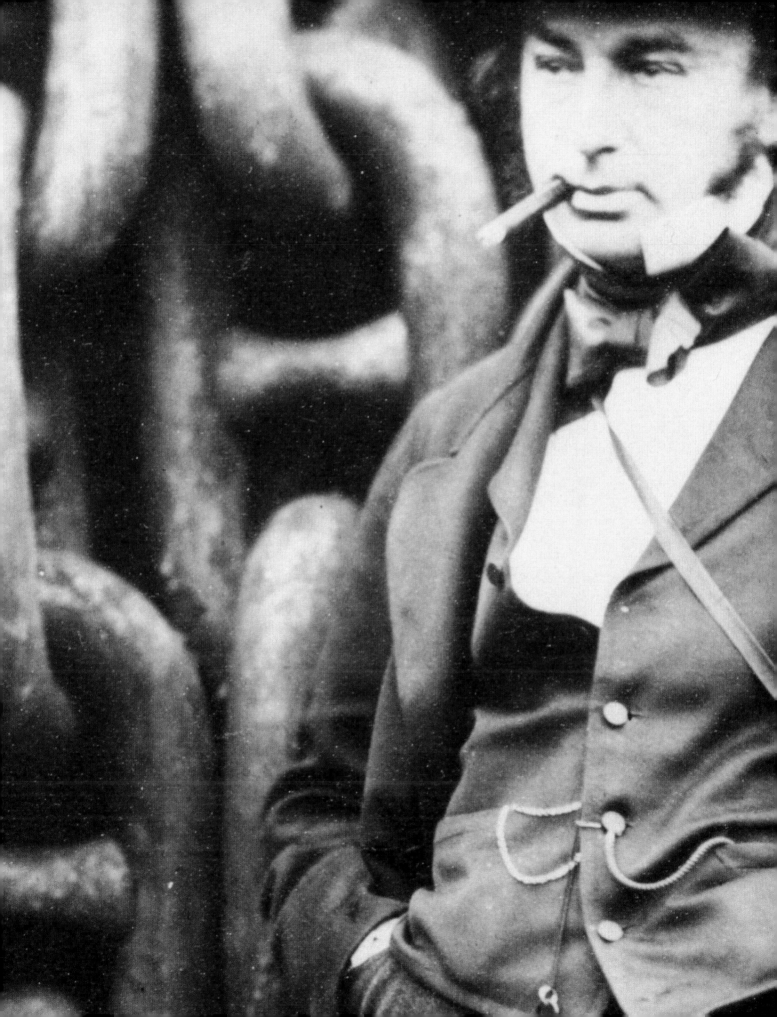

ROBERT BROWNING (1812–89)

Michele Gordigliani
1858
Oil on canvas, 72.4 x 58.7cm (28½ x 23⅛")

Although he is not much read today, Browning is regarded as one of the greatest Victorian poets. This portrait of him was commissioned by an American admirer, Sophia Eckley, when Browning and his wife Elizabeth Barrett Browning were living in Florence. Mrs Eckley was determined that it would be the best available likeness of him and wrote on the stretcher that Browning described it as an 'Incomparable Portrait by far the best ever taken'. It is certainly suggestive of his intense and cerebral character; but according to W.M. Rossetti, writing after Browning's death, 'The face in this portrait is certainly a highly intellectual one; but I think it is treated with too much *morbidezza*, so as to lack some of that extreme keenness, which characterized Browning.'

(NPG 1898)

ELIZABETH BARRETT BROWNING (1806–61)

Michele Gordigliani

1858

Oil on canvas, 73.7 x 58.4cm (29 x 23")

Mrs Browning, like her husband, was a poet, and her portrait was painted as a companion piece to that of her husband. According to a label on the back of the frame, it was done 'expressly for Sophia May Eckley, & pronounced by Robert Browning to be the best Portrait ever taken of the Poetess'; but at the time, Robert Browning was not convinced that it was a good likeness and wrote to Mrs Eckley that 'The portrait is not perfect certainly; the nose seems over long, and there are some other errors in the face; also, the whole figure gives the idea of a larger woman than Ba.' It shows Elizabeth Barrett Browning looking dark-haired and intense, and it is perhaps not surprising to learn that Mrs Eckley had introduced her at this time to spiritualism.

(NPG 1899)

DAME ALICE ELLEN TERRY (1847–1928)
George Frederic Watts
1864
Oil on strawboard, 48 x 35.2cm (18⅞ x 13⅞")

Watts first met Ellen Terry in 1862 when she was fifteen and Watts forty-five. She came to his house as a chaperone for her elder sister, also an actress, and Watts fell for her charms, so abundantly evident in her portrait. They were married in 1864, the year of the portrait, but separated a year later and were divorced in 1877. So this image, both poignant and slightly saccharine, and showing her dressed in black and smelling camellias, represents the intense love on the part of a middle-aged artist for a young, passionate and extraordinarily beautiful actress who briefly succumbed to the man she called 'the Signor'. According to Graham Robertson, who had been a friend of Ellen Terry and wrote about the picture in 1934, 'It actually holds the wistful soul of Ellen Terry and is, in a way, prophetic of her life. She spent nearly all her days trying to persuade herself that there was scent in camellias, while the perfume really came from the hidden violets near her heart.'

(NPG 5048)

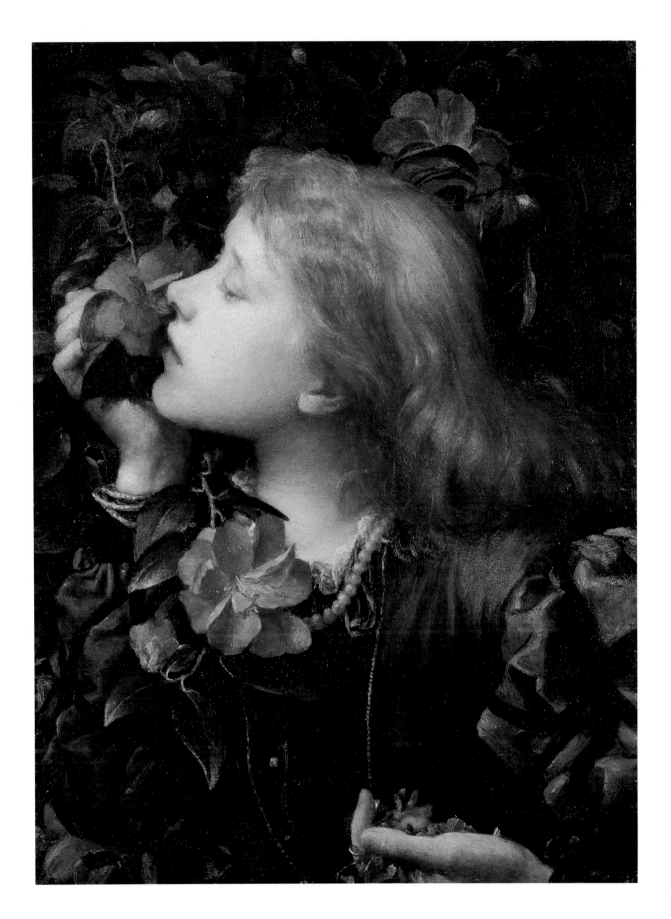

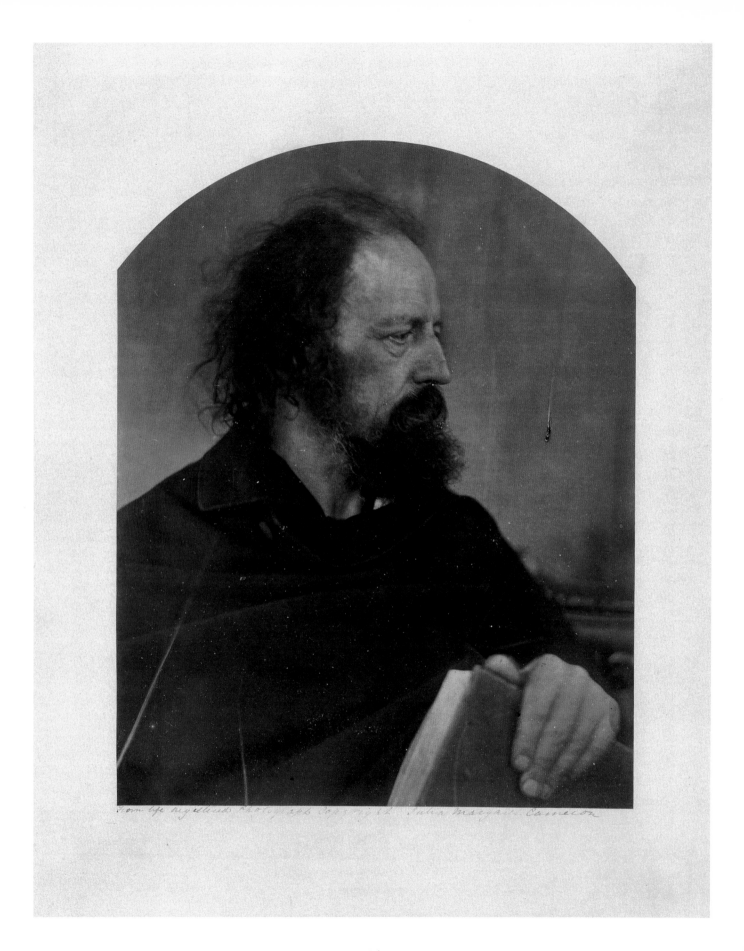

From life Registered Photograph Copyright Julia Margaret Cameron

ALFRED, LORD TENNYSON (1809–92)
Julia Margaret Cameron
1865
Albumen print, 24.9 x 20.1cm (9¾ x 7⅞")

Julia Margaret Cameron was one of the first and remains one of the greatest portrait photographers. The wife of a coffee-planter in Ceylon, she took up photography in her late forties, strongly influenced by the mid-Victorian fascination for High Renaissance painting and by the Romantic medievalism of the Pre-Raphaelites. Before taking up photography, she had bought two cottages at Freshwater on the Isle of Wight, which she called 'Dimbola' after her house in Ceylon. Tennyson, who had long been a friend, was now a neighbour. He was to be one of her most important sources of inspiration, both in her illustrations for his *Idylls of the King* and, more generally, as a source for her style of poetic romance. She photographed him on a number of occasions. This was the version he liked best, writing under it, 'I prefer the Dirty Monk to the others of me.'

(NPG x18024)

ALGERNON CHARLES SWINBURNE (1837–1909)
George Frederic Watts
1867
Oil on canvas, 64.8 x 52.1cm (25½ x 20½")

G.F. Watts painted Algernon Swinburne, the aesthete and poet, in the summer of 1867 as part of his project to paint all the most important people of his time. First exhibited as a 'House of Fame' at the Grosvenor Gallery in London, the majority of these works were later presented to the National Portrait Gallery. In a letter dated 22 May 1867, Swinburne wrote: 'Of course it is a great honour for one to be asked to sit to him, now especially that he accepts no commissions and paints portraits only for three reasons – friendship, beauty and celebrity; having the "world" at his feet begging to be painted. But it takes time and trouble, and he won't let me crop my hair, whose curls the British public (unlike Titian's) reviles aloud in the streets.' However, Swinburne liked the result, adding *'Il faut souffrir pour être – peint'*. It is indeed effective as an image of Swinburne, with his shock of carrot hair, high brow and wispy beard.
(NPG 1542)

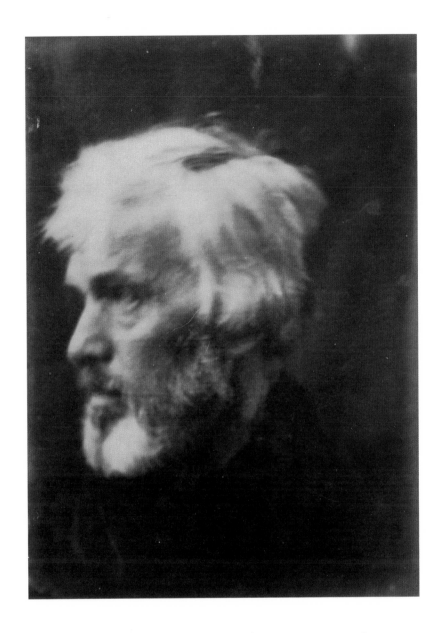

Thomas Carlyle (1795–1881)
Julia Margaret Cameron
1867
Albumen print, printed in reverse, 33.7 x 28.6cm (13¼ x 11¼")

This amazing profile head of Carlyle as an old man, moving slightly in front of the camera, is deliberately and convincingly intended to make him look like an Old Testament prophet. Carlyle himself did not particularly like it, writing that 'It is as if suddenly the picture began to speak, terrifically ugly and woe-begone, but has something of a likeness – my candid opinion.' On the other hand, Roger Fry, who was an early enthusiast for Julia Margaret Cameron's work, was eulogistic, writing that 'Neither Whistler nor Watts come near to this in the breadth of the conception, in the logic of the plastic evocations, and neither approach the poignancy of this revelation of character.'
(NPG P123)

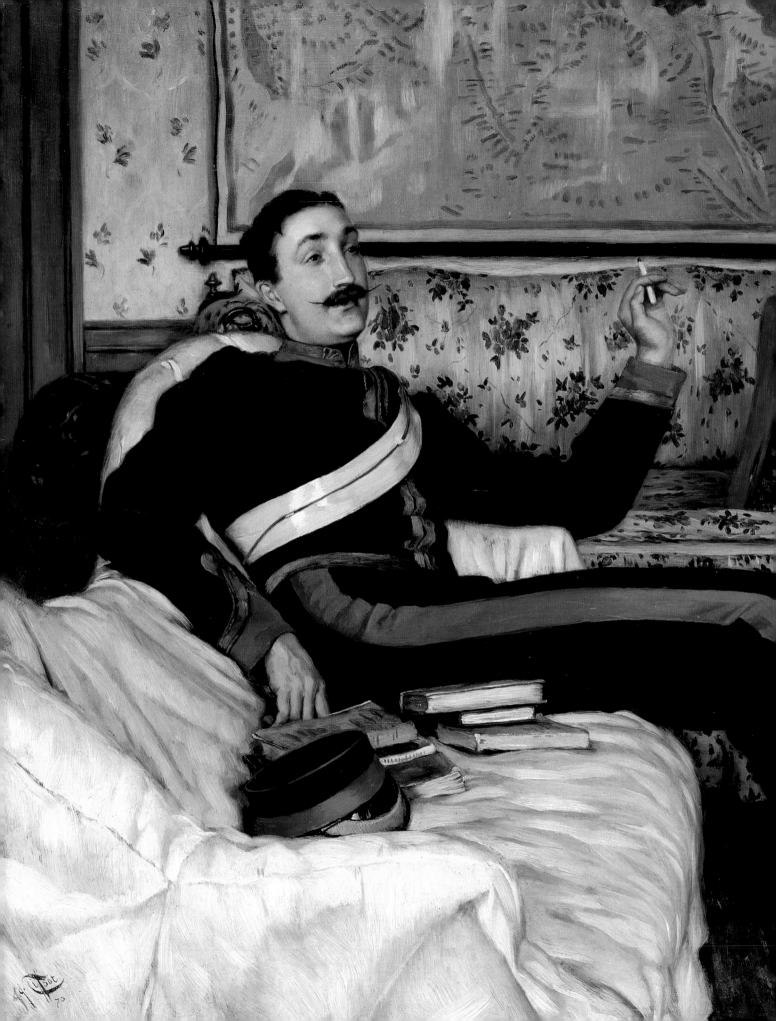

FREDERICK GUSTAVUS BURNABY (1842–85)
James (Jacques-Joseph) Tissot
1870
Oil on panel, 49.5 x 59.7cm (19½ x 23½")

Captain Burnaby was not a person of any great significance when he was painted by the French artist Tissot. Distinguished principally by his height (he was six feet four), he spent his generous leave from the army travelling round the world and publishing accounts of his exploits, including *A Ride to Khiva* in 1876, which established his reputation as an adventurer. He later became well known as a balloonist. What is more important about the portrait is the way in which it captures the mood of an army officer at the time – easy, confident, lounging on a sofa with a cigarette and with the map of the world on the wall behind him.
(NPG 2642)

WILLIAM MORRIS (1834–96)
George Frederic Watts
1870
Oil on canvas, 64.8 x 52.1cm (25½ x 20½")

On 15 April 1870 William Morris wrote to his wife Janey (who at the time was having an affair with Dante Gabriel Rossetti), 'I am going to sit to Watts this afternoon, though I have got a devil of a cold-in-the-head, which don't make it very suitable.' Perhaps a combination of the cold and his depression at the failure of his marriage accounts for the slightly rheumy look of his portrait. According to Mrs Watts, it was painted at a single sitting, although it is possible that Watts may have done more work on it when it was exhibited in 1880. Otherwise, there is singularly little contemporary comment on it, apart from a later and well-judged remark by G.K. Chesterton that 'There is something appropriate in the way in which the living, leonine head projects from a background of green and silver decoration. This immersion of a singularly full-blooded and aggressive man in the minutiae of aesthetics was a paradox that attracted men to Morris.'
(NPG 1078)

Sir Richard Burton (1821–90)

Sir Frederic Leighton
1872–5
Oil on canvas, 59.7 x 49.5cm (23½ x 19½")

This austere, ruminative and intense image of one of the great explorers of Victorian England captures his slightly brutal character very effectively. The artist Frederic Leighton met Burton in 1869 while they were taking a cure at Vichy, and on 26 April 1872 Burton began sitting for his portrait. According to Lady Burton, he was extraordinarily difficult about it, anxious that his necktie and pin might be omitted and pleading with the artist, 'Don't make me ugly, there's a good fellow.' Apparently the portrait was left unfinished when Burton departed for Trieste in October 1872, and it was not completed until 1875. It was exhibited at the Royal Academy the following year, but it is possible that Burton did not like it, because Leighton kept it at his house in Kensington. He intended to leave it to the National Portrait Gallery, of which he was a Trustee, but forgot, so the then Director, Lionel Cust, arranged for it to be donated by Leighton's sisters.

(NPG 1070)

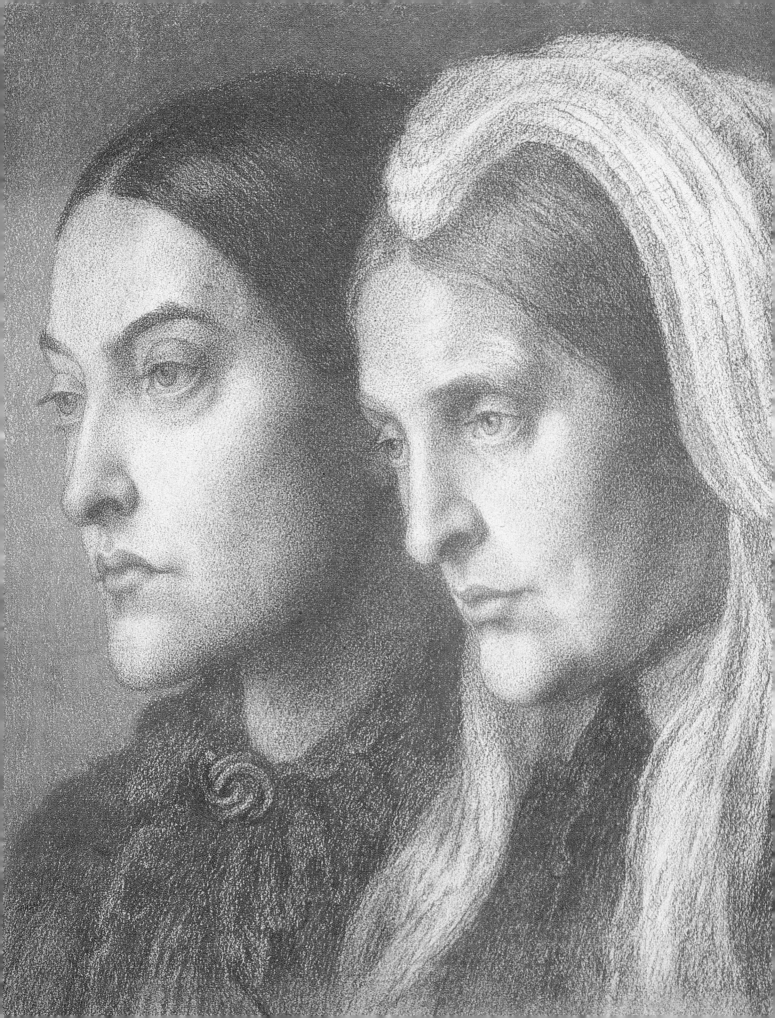

CHRISTINA ROSSETTI AND HER MOTHER, FRANCES ROSSETTI

Dante Gabriel Rossetti

1877

Chalk, 42.5 x 48.3cm (16¾ x 19")

In August 1877 Dante Gabriel Rossetti went to convalesce near Herne Bay after an operation for what he described as 'a serious rupture of internal blood-vessels', now assumed to have been haemorrhoids. He was in acute pain and seriously depressed, so both his mother, Frances (1800–86), and his sister, Christina (1830–94), went down to keep him company. For a while, he thought that he might never paint again, but then undertook a number of sketches, including this wonderful chalk drawing of his mother and sister together, their profiles so similar, Christina with prominent jaw and thyroid eyes, their mother's head bent forward with age. It was donated to the Gallery by William Michael Rossetti, the youngest member of the family, in September 1895, the year after Christina Rossetti's death.

(NPG 990)

JOHN RUSKIN (1819–1900)
Sir Hubert von Herkomer
1879
Watercolour, 73.7 x 48.3cm (29 x 19")

Hubert Herkomer (the von was added later) was a self-taught artist and son of a woodcarver. In 1879 he undertook this watercolour portrait of John Ruskin, the great writer on art, as one of a group of studies of famous men that he intended to bequeath to his children. He described the circumstances in which it was painted in a later newspaper article: 'I painted John Ruskin in 1879. It was a watercolour, a drawing of head and shoulders, life-size, painted at Denmark Hill, in the little garret bedroom which had formerly been his nursery. He seemed most anxious not to look at the painting until I had quite finished it; whilst sitting he was theorizing about the methods of painting. I used in those days to paint abnormally large watercolours and always covered the paper first with a wash of some ochre or grey, then sketched the subject with charcoal. I would then commence with a hog-hair brush, working up the ground colour with some fresh tones, and out of a kind of chaos produce a head.' Ruskin liked the result, describing it as 'the first that has ever given what good may be gleaned out of the clods of my face'.
(NPG 1336)

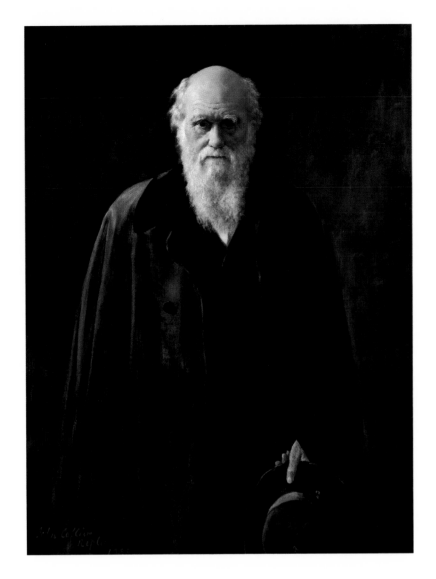

CHARLES DARWIN (1809–82)
John Collier
1881
Oil on canvas, 125.7 x 96.5cm (49½ x 38")

This portrait of Charles Darwin, the great scientist and author of *On the Origin of Species*, is a copy by the artist of a portrait undertaken by John Collier for the Linnaean Society. Collier was himself the son-in-law of another prominent late Victorian scientist, Thomas Henry Huxley. The portrait was presented to the Gallery by Darwin's elder son, William Erasmus Darwin, who wrote to Lionel Cust in 1896: 'The picture is a replica of the one in the rooms of the Linnaean Society & was made by Collier after the original. I took some trouble about it, and as a likeness it is an improvement on the original.' It shows Darwin as an old man in the year before his death. According to Darwin's third son, Francis, 'The portrait represents him standing facing the observer in the loose cloak so familiar to those who knew him, and with his slouch hat in his hand. Many of those who knew his face most intimately, think that Mr. Collier's picture is the best of the portraits, and in this judgement the sitter himself was inclined to agree.'

(NPG 1024)

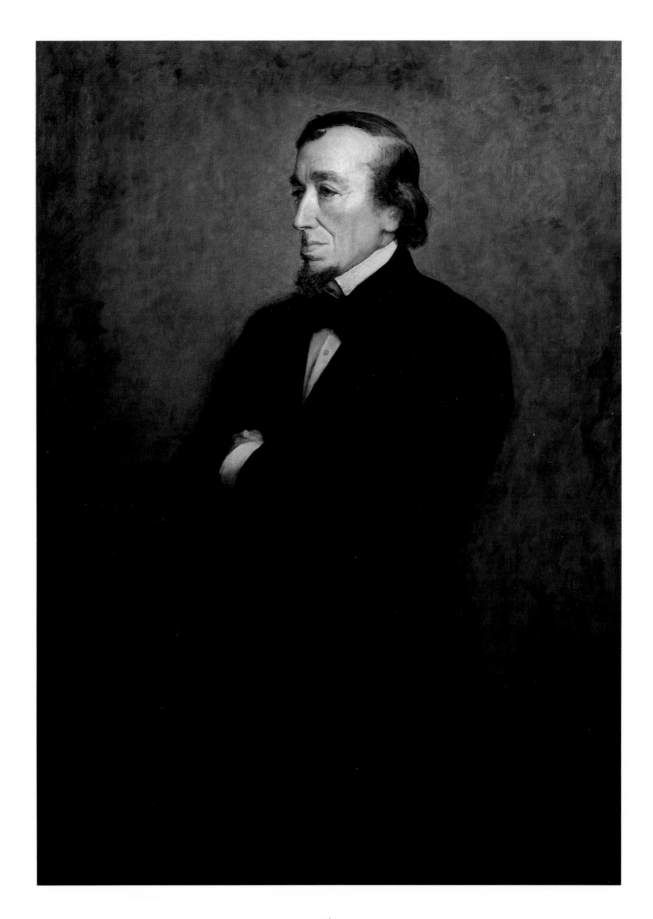

148

BENJAMIN DISRAELI (1804–81)
Sir John Everett Millais
1881
Oil on canvas, 127.6 x 93.1cm (50¼ x 36⅝")

This portrait of the great Prime Minister Benjamin Disraeli is the quintessence of Victorian portraiture: concentrating on the essentials of facial expression, dignifying the sitter and indicating his contribution to politics and national life. Originally Lord Ronald Gower had wanted Disraeli to sit to Millais, so that the portrait could be acquired by the National Portrait Gallery. In 1881 Millais wrote to Disraeli pleading, 'I know that sitting to an Artist is attended with great inconvenience to Every public man, but I do hope you will allow me to make a portrait of your Lordship.' Disraeli replied, 'I am a very bad sitter, but will not easily forego my chance of being known to posterity by your illustrious pencil.' At the time of Disraeli's death, the portrait was unfinished and was completed at Queen Victoria's request; but after being exhibited at the Royal Academy, it was acquired not by the Portrait Gallery, but by the Fine Art Society for 1,400 guineas. The Society sold it to the politician and bookseller the Rt. Hon. W.H. Smith, who wanted to acquire portraits of his cabinet colleagues, and it was his descendants who ultimately gave the work to the Gallery in 1945.

(NPG 3241)

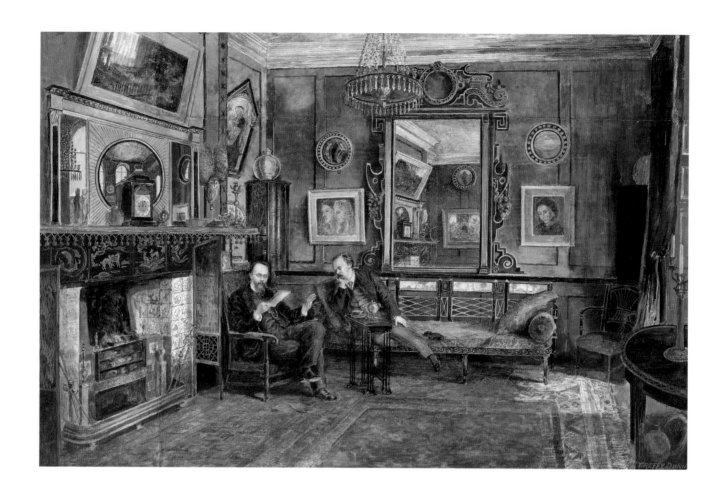

DANTE GABRIEL ROSSETTI AND THEODORE WATTS-DUNTON
Henry Treffry Dunn
1882
Gouache, 54 x 81.9cm (21¼ x 32¼")

This is an example of a portrait that exemplifies character by reference to the sitter's surroundings. It shows the artist and poet Dante Gabriel Rossetti reading the proofs of his *Ballads and Sonnets* to Theodore Watts-Dunton (1832–1914), a solicitor with literary inclinations who became the companion of Rossetti's later years. They are sitting together in the ground-floor drawing-room of the house they shared in Cheyne Walk, a room which was described by the artist Henry Treffry Dunn as 'One of the prettiest and most curiously furnished old-fashioned parlours that I had ever seen. Mirrors and looking-glasses of all shapes, sizes and design lined the walls. Whichever way I looked I saw myself gazing at myself. What space there was left was filled up with pictures, chiefly old and of an interesting character.' It is likely that the work was undertaken posthumously as a record of the interior, since Dunn, who had previously been a studio assistant to Rossetti, acted as guardian of his effects after the artist's death on Easter Day 1882.
(NPG 3022)

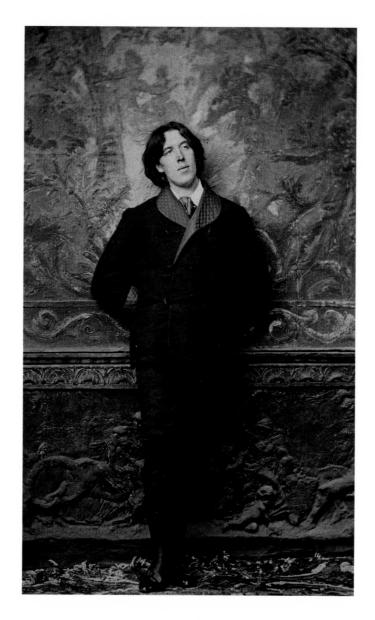

OSCAR WILDE (1856–1900)
Napoleon Sarony
1882
Albumen 'panel' print, 30.5 x 18.4cm (12 x 7¼")

This photograph of Oscar Wilde lounging against an appropriately artistic backdrop was taken by the New York studio photographer Napoleon Sarony. Wilde had arrived in New York in January 1882 on the steamship *Arizona*, with 'nothing to declare but his genius'. He needed a publicity photograph for his lecture tour, so he went to Sarony's studio and Sarony provided just what he wanted: an image of limpid dandyism in quilted smoking-jacket, silk knee-breeches and patent leather slippers. Apparently, 'Wilde arrived holding a white cane across his fur-lined overcoat. Sarony took him first in his seal-skin cap, then bare-headed in his long trousers, then bare-headed in his knee-breeches.' As Sarony declared, Wilde was 'A picturesque subject indeed!'

(NPG P24)

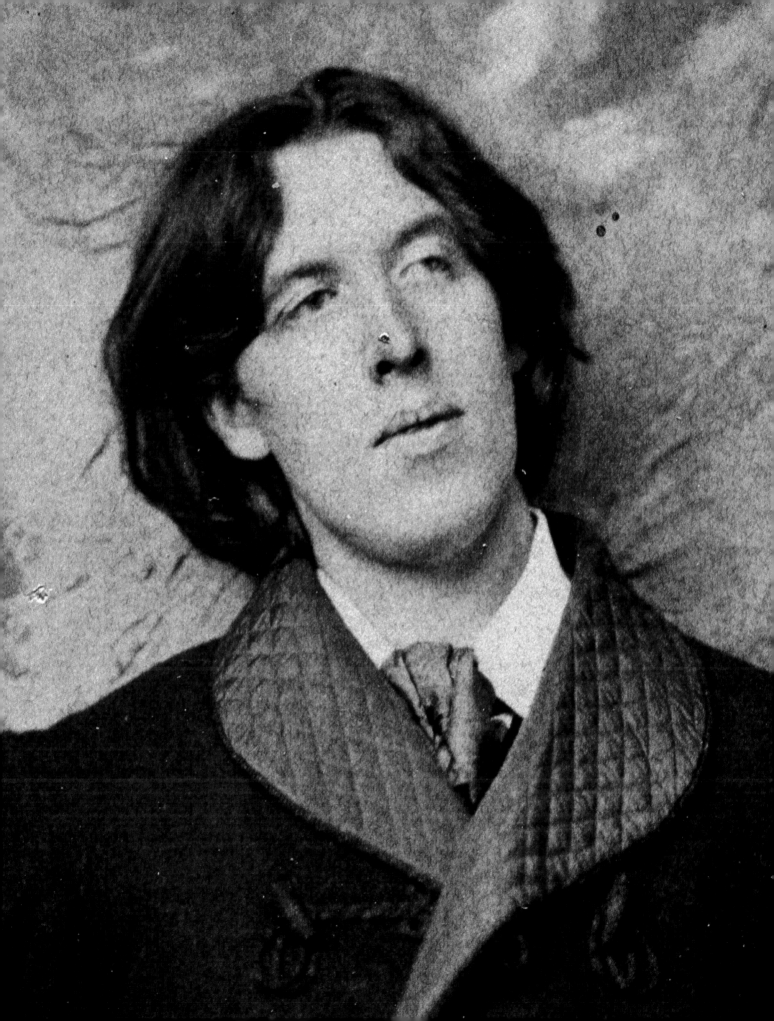

DINNER AT HADDO HOUSE
Alfred Edward Emslie
*c.*1884
Oil on canvas, 36.2 x 57.8cm (14¼ x 22¾")

One of the most atmospheric of the group portraits in the Gallery's collection is this record of a dinner party of Liberal grandees at Haddo House in Aberdeenshire. In 1884, according to *We Twa*, the reminiscences of Lord and Lady Aberdeen, 'a long-cherished desire was fulfilled, when Mr and Mrs Gladstone agreed to include Haddo House in the programme of their autumn visit to Scotland, thus revisiting a house full of associations for Mr Gladstone connected with his friend and Chief of the early days of his political career'. Alfred Emslie was obviously asked to commemorate the event, although he is said to have had no canvas with him, so took down an old picture and painted this one on top. It shows Lady Aberdeen seated at the head of the table with her back to the artist and in conversation with Gladstone to her right. On her left is Lord Rosebery, who looks totally indifferent to the conversation of his neighbour, Lady Harriet Lindsay.

(NPG 3845)

SIR WILLIAM SCHWENK GILBERT (1836–1911)
Frank Holl
1886
Oil on canvas, 100.3 x 125.7cm (39½ x 49½")

It is hard to think of this rather gloomy looking gent, with his military moustache, high-necked collar and hunting crop, as one half of the immortal partnership of Gilbert and Sullivan, responsible for some of the greatest comic operas, *H.M.S. Pinafore*, *Iolanthe*, *The Mikado*, and *The Yeoman of the Guard*. The circumstances in which it was painted are unusually well recorded in correspondence in the Gallery's archive. On 2 November 1886, Gilbert wrote to Frank Holl, 'My wife insists that I shall have my portrait painted, & that being so, my thoughts naturally turn towards you. I hope your engagements will not interfere to prevent my having the pleasure of sitting to you.' On 22 November, he was worrying about what to wear: 'My usual writing dress would hardly do for exhibition – consisting as it does, of a nightshirt & dressing gown. . . . As I am obliged to ride for two hours every day (to drive away gout) I shall generally get to Fitzjohns Avenue on a horse. Would an easy-going riding dress do?' He was obviously as grumpy about the sittings as he looks. The portrait was completed by the end of the year and cost £525.

(NPG 2911)

THOMAS HARDY (1840–1928)
William Strang
1893
Oil on panel, 43.2 x 38.1cm (17 x 15")

This is an early oil portrait by William Strang, who was known principally at this period for his etchings. Indeed, the commission followed on from an etched portrait that Strang produced in 1893 as the frontispiece to Lionel Johnson's *The Art of Thomas Hardy*. William Rothenstein described Hardy as having 'a small dark bilberry eye which he cocked at you unexpectedly. He was so quiet and unassuming, he somehow put me in mind of a dew-pond on the Downs.' Hardy himself said that he was often mistaken for a detective.

(NPG 2929)

W.STRANG.
1893.

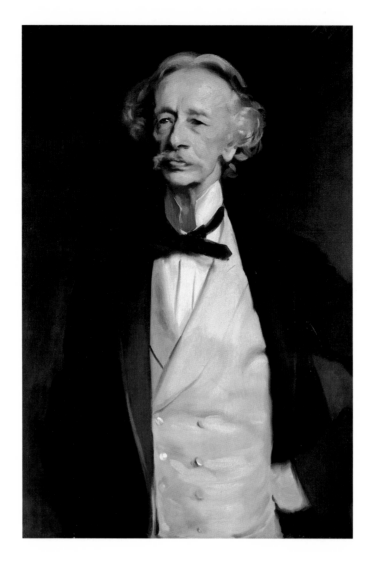

COVENTRY PATMORE (1823–96)
John Singer Sargent
1894
Oil on canvas, 91.4 x 61cm (36 x 24")

Interestingly, this portrait of the poet Coventry Patmore was given to the Gallery by his widow only three years after it was painted and immediately following his death, so the Trustees obviously did not always adhere to the so-called Ten Years Rule. It is a wonderful piece of painting: atmospheric and suave, showing Patmore with his left arm resting on his hip and looking both alert and quizzical. Basil Champneys, who edited Patmore's works after his death, described the circumstances in which it was painted: 'It was not very long before the final failure of his health that he was persuaded, mainly by Mr Gosse's advice, to sit to Mr Sargent for the picture which is now in the National Portrait Gallery. I ran down to Lymington soon after it had been sent home, and Patmore was full of praise for it. It was "the best portrait which Sargent, or probably any other painter, had ever painted". . . . It seemed to me to incline towards caricature, and to present a somewhat truculent character, alert and active rather than reflective, thus missing the aspect of "seer" which, in later years, had alone seemed to me characteristic of him.'

(NPG 1079)

AUBREY BEARDSLEY (1872–98)
Frederick Evans
1894
Platinum print, 13 x 9.8cm (5⅛ x 3⅞")

In the summer of 1894, when this photograph of Aubrey Beardsley was taken by his friend and publisher Frederick Evans, Beardsley was already dying of tuberculosis. He was busy working on illustrations to Wagner's *Tannhäuser*, but was so weak that he spent much of his time sitting about moping. The photograph catches this aspect of him – with his long, thin fingers, his watery eyes and his fine profile, described by Oscar Wilde as like 'a silver hatchet'. Beardsley himself was delighted by the photograph, writing to Evans, 'I think the photos are splendid; couldn't be better. I am looking forward to getting my copies.'

(NPG P114)

162

EDWARD CARPENTER (1844–1929)
Roger Fry
1894
Oil on canvas, 74.9 x 43.8cm (29½ x 17¼")

In 1886 Goldsworthy Lowes Dickinson and C.R. Ashbee invited Edward Carpenter, the sandal-wearing socialist, to lecture in Cambridge. He made a huge impression, not least on Roger Fry, who was then in his second year as an undergraduate. Together with Ashbee, Fry went to visit Carpenter in Derbyshire and they became friends. In 1894 Fry painted this portrait of him, looking suitably raffish, alone in a bleak interior and wearing what Fry called his 'anarchist overcoat'. Following Carpenter's death in 1929, Fry offered the portrait to the Gallery: 'In view of the position that the late Edward Carpenter held in the world of social reform you may, I think, wish to have a portrait of him. I knew him well in my youth and one of my earliest more or less complete works was a portrait of him. I should be very glad to offer this to the National Portrait Gallery should it be found acceptable.'

(NPG 2447)

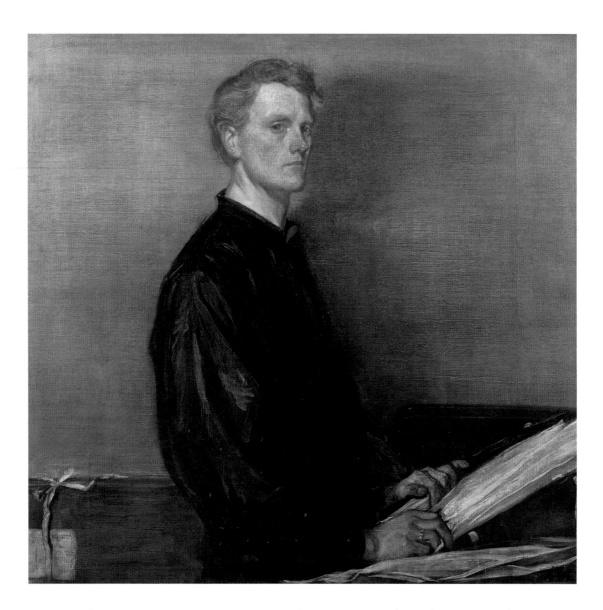

CHARLES HASLEWOOD SHANNON (1863–1937)
Self-portrait
1897
Oil on canvas, 92.7 x 96.5cm (36½ x 38")

Charles Shannon is best known now as one half of an artistic friendship and partnership with Charles Ricketts. The son of a clergyman, he was educated at St John's School, Leatherhead, and then went to art school in Lambeth, where he met Ricketts. According to William Rothenstein, 'Shannon was as quiet and inarticulate as Ricketts was restless and eloquent. He had a ruddy boyish face, like a countryman's, with blue eyes and fair lashes; he reminded me of the shepherd in Rossetti's *Found*. Oscar Wilde said that Ricketts was like an orchid, and Shannon like a marigold.' He was also, as is evident from this self-portrait, a fine artist, painting in a style clearly influenced by Whistler, but one that also demonstrates the fact that both Ricketts and Shannon were deeply knowledgeable about the history of painting, particularly of the High Renaissance.

(NPG 3107)

CHARLES RICKETTS (1866–1931)
Charles Haslewood Shannon
1898
Oil on canvas, 95.3 x 99.1cm (37½ x 39")

Charles Ricketts was an artist, illustrator, theatre designer, author and printer; but he is perhaps best remembered now for his friendship with his fellow artist Charles Shannon. According to Rothenstein, 'Ricketts, with his pale, delicate features, fair hair and pointed gold-red beard, looked like a Clouet drawing. Half French, he had the quick mind and the rapid speech of a southerner.' This portrait of Ricketts by Shannon was painted two years after Ricketts had founded the Vale Press. It is a record of their friendship, slightly tentative in its character, with Ricketts turning his head away so that he is seen in profile. He liked it for precisely this reason since it shows him 'turning away from the 20th century to think only of the 15th'. It is labelled on the back 'The Man in an Inverness Cloak.'

(NPG 3106)

167

THE EARLY 20TH CENTURY

GWENDOLEN MARY JOHN (1876–1939)
Self-portrait
*c.*1899
Oil on canvas, 61 x 37.8cm (24 x 14⅞")

Gwen John painted herself looking reserved, confident and self-possessed, either while she was still a student at the Académie Carmen in Paris in late 1898 or following her return to London in 1899, before she settled permanently in Paris. With her hands on her hips and a big black bow round her neck, she returns the spectator's gaze with an air suggestive both of a lack of real interest and a slight air of challenge, which holds one's attention as one tries to puzzle out the conflicting clues to her character. Gwen John was then in her early twenties, but this is a great work of art, demonstrating how much she had learned both at the Slade under Henry Tonks and at the Académie Carmen. It is hard to square with her own description of herself at this period when 'shyness and timidity distort the very meaning of my words in people's ears. That I think is one reason why I am such a waif.'

(NPG 4439)

VIRGINIA WOOLF (1882–1941)
George Charles Beresford
1902
Platinum print, 15.2 x 10.8cm (6 x 4¼")

This is the most popular image in the National Portrait Gallery – at least as a postcard. It was taken in July 1902, when Virginia Woolf (Virginia Stephen as she then was) was just embarking on her career as a writer and when the photographer George Charles Beresford had recently set up a commercial studio in Yeoman's Row, off the Brompton Road. Since her father, Sir Leslie Stephen, and her sister, Vanessa, were photographed at the same time, one may presume that the idea was Sir Leslie's. Apparently six photographs were taken of Sir Leslie, fourteen of Virginia and an unspecified number of Vanessa. The result, so far as Virginia was concerned, was remarkable, showing her looking pale and contemplative, and emphasizing her beautiful liquid eyes and strong aquiline features.

(NPG P221)

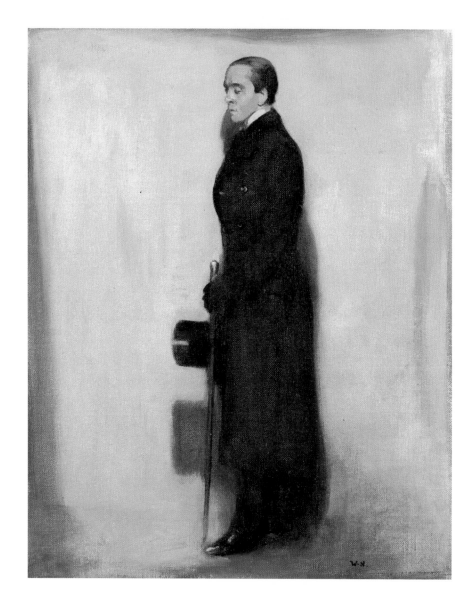

SIR MAX BEERBOHM (1872–1956)
Sir William Nicholson
1905
Oil on canvas, 50.2 x 40cm (19¾ x 15¼")

The artist William Nicholson and the caricaturist Max Beerbohm were close friends throughout their lives, and used to meet for breakfast once a month. They were described by the writer and gallery owner Lillian Browse as 'curiously alike in their fastidiousness, sensitivity and whimsicality', although William Nicholson's taste in clothes was louder than Beerbohm's. This portrait of Beerbohm by Nicholson suggests Beerbohm's hypersensitivity about his appearance, with his closely fitting long black overcoat like an undertaker's, his dark, sleeked hair and the top hat, later described by Robert Graves as 'a certain superbly glossy top hat' and left in Nicholson's studio to store paintbrushes when Beerbohm emigrated to Italy. The portrait was bequeathed to the Gallery by Mrs Gertrude Kinnell in 1953 and was accepted by the Trustees only with the proviso that it could not be exhibited during Beerbohm's lifetime.

(NPG 3850)

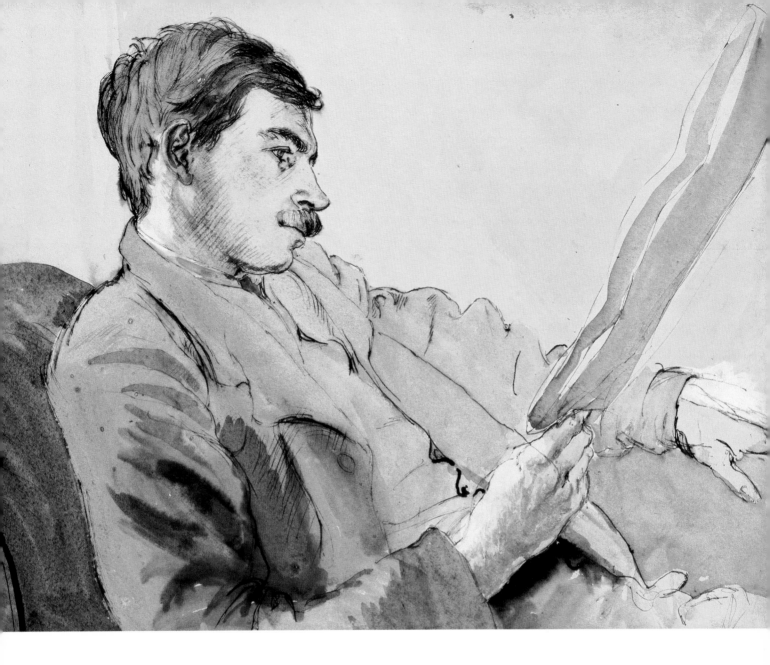

JOHN MAYNARD KEYNES, BARON KEYNES (1883–1946)

Gwen Raverat

*c.*1908

Watercolour, 27.9 x 36.8cm (11 x 14½")

This informal drawing of Maynard Keynes is thought to show him in his mid-twenties, before he had appendicitis, after which he grew much fatter. It is by Gwen Raverat, who was born a Darwin, grew up in the house that is now Darwin College, Cambridge, and was a friend of Maynard Keynes from their childhood. Indeed, her sister Margaret married Keynes' brother Geoffrey. So this watercolour, as well as being a nicely relaxed image of the great writer on economics, is also a record of that circle of high-thinking and interbreeding families in Cambridge, whom the academic Noel Annan has described as an intellectual aristocracy.

(NPG 4553)

RUPERT BROOKE (1887–1915)

Clara Ewald

1911

Oil on canvas, 54.6 x 73.7cm (21½ x 29")

The young Rupert Brooke, handsome, well-born and full of promise as a poet, sat to the German artist Clara Ewald when he was staying in Munich in spring 1911. He was not enjoying himself and terribly missed Cambridge; but fortunately he had an introduction to Clara Ewald and made friends with her son Paul, who was studying physics at Munich University. According to Paul Ewald, 'He would come in for tea and often stay for supper. My impression was that he found it very difficult to adapt himself to Germany and that in his thoughts he lived more in Cambridge than in Munich. This he expresses himself in his letters. So, partly perhaps to cheer him up, my mother painted him.' Most of the people who had known Rupert Brooke reckoned that the result was not a very good likeness – indeed, a later version, which was presented to King's College, Cambridge, caused a good deal of controversy, not least because it was regarded by some of the dons as too effeminate. But it has become one of the images by which he is now well known, including the hat, which he borrowed for the occasion from the artist's son.

(NPG 4911)

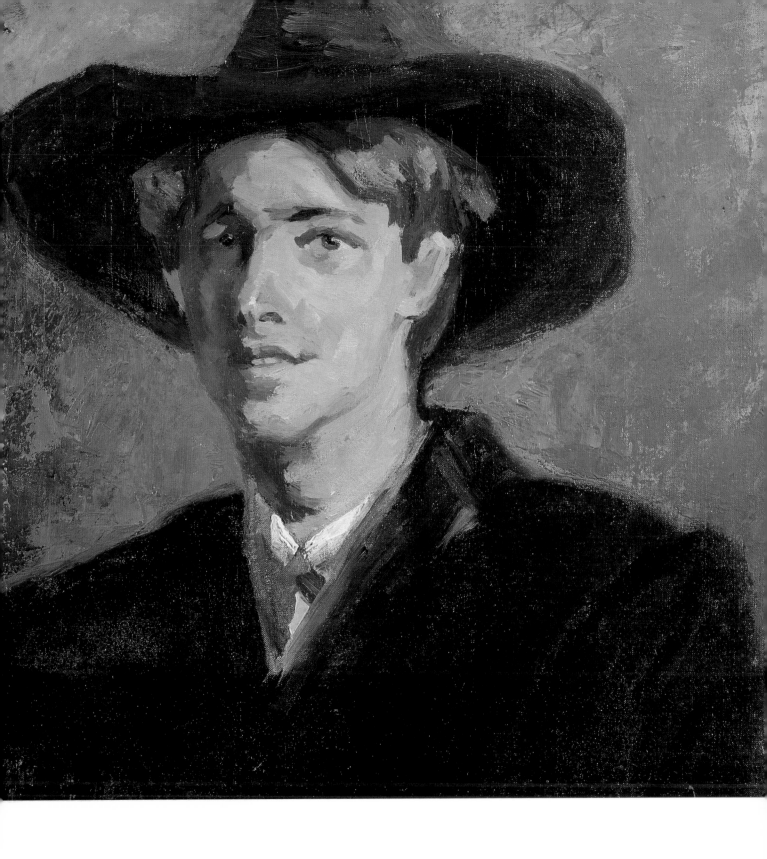

Captain Scott + his Dia

ROBERT FALCON SCOTT (1868–1912)
Herbert George Ponting
1911
Carbon print, 35.6 x 45.7cm (14 x 18")

On 29 November 1910, Captain Scott set out from New Zealand on an expedition to reach the South Pole. With him was a well-known travel photographer, Herbert Ponting, who documented all aspects of the expedition. This photograph of Scott shows him writing his journal in the base hut at Cape Evans, surrounded by the paraphernalia of the expedition – old socks, binoculars, family photographs, a row of pipes, his old naval overcoat on the bed and even a complete set of the *Dictionary of National Biography*. It is inscribed 'Captain Scott & his Diary. Scott's Last Expedition, 7 October 1911.' Scott reached the South Pole on 16 January 1912, only to find that he had been beaten to it by a rival expedition led by the Norwegian Roald Amundsen. Together with all those who had gone to the Pole with him, including Captain Oates, Scott died on the journey back.

(NPG P23)

Scotts Last Expedition H.G. Ponting.

14 X

DAME LAURA KNIGHT (1877–1970)
Self-portrait
1913
Oil on canvas, 152.4 x 127.6cm (60 x 50¼")

At the time this self-portrait was painted Laura Knight, then in her early thirties, and her husband Harold were living at Newlyn in Cornwall. The portrait shows Laura Knight looking away from the act of painting Ella Naper, a friend and neighbour, who was also evidently willing to act as a model. The bright red cardigan, which Laura Knight had bought at a jumble sale for half-a-crown, the even brighter scarlet background to the artist's model, and the way the eye travels from artist to model to the painting of the artist's model, together create an unusually complex and satisfying composition.

(NPG 4839)

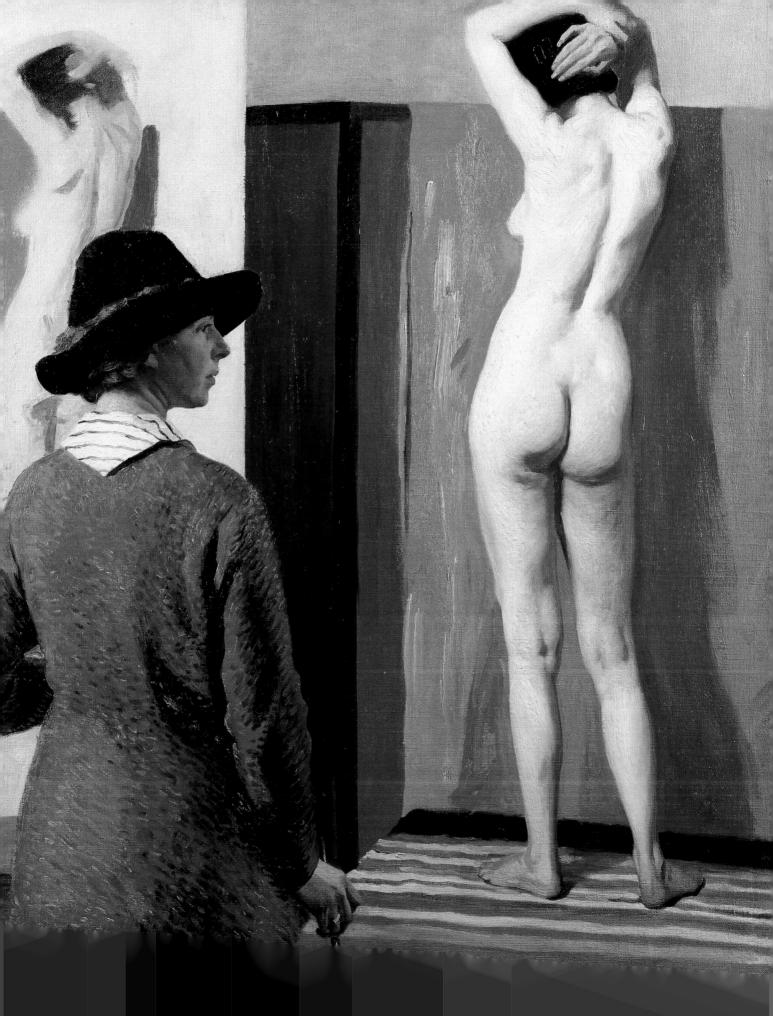

OTTOLINE MORRELL (1873–1938)

Augustus John
1918–20
Oil on canvas, 69 x 51.1cm (27⅛ x 20⅛")

Lady Ottoline Morrell, the chatelaine of Garsington Manor outside Oxford, was a ferocious socialite, friend and lover of artists and writers, including Augustus John, whom she first met in 1906 and with whom she had a brief affair in 1908. He began this portrait in 1918. When it was exhibited in 1920, most people were critical of it, the *Manchester Guardian* writing that 'It is like one of the queer ancestral portraits you see in a scene on the stage, although it is done by a man of genius'; but Lady Ottoline herself liked it and hung it over the mantelpiece in the drawing-room of her London house. It is well described by Michael Holroyd in his biography of Augustus John: 'Her head, under its flamboyant topsail of a hat, is held at a proud angle and she wears, like rigging, several strings of pearls (painted with the aid of tooth powder) above a bottle-green velvet dress. Her eyes are rolled sideways in their sockets like those of a runaway horse and her mouth bared soundlessly.'

(NPG 6095)

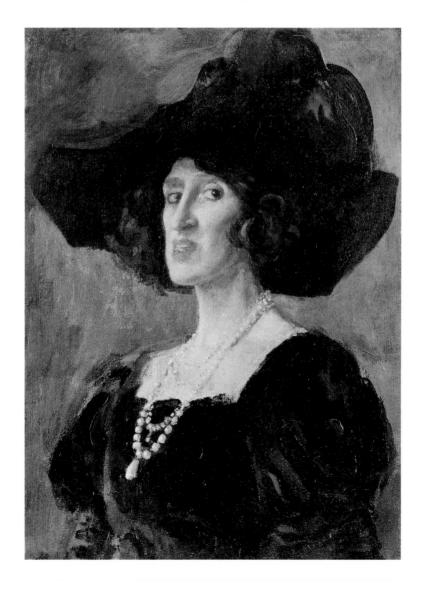

THOMAS EDWARD LAWRENCE (1888–1935)

Augustus John
1919
Pencil, 35.6 x 25.4cm (14 x 10")

This sketch of T.E. Lawrence, better known as 'Lawrence of Arabia', was done by Augustus John with his customary ease and dexterity when both artist and sitter were at the Paris Peace Conference held at Versailles in spring 1919. Lawrence was acting as an adviser and interpreter for Emir Feisal and hating it, writing that 'Those five months in Paris were the worst I have ever lived through.' Augustus John, on the other hand, was hugely enjoying himself, living at the expense of the British government in order to paint the conference. The sketch was done at John's flat in a couple of minutes, while T.E. Lawrence was looking out of the window into the street, pensive and rather moody. But he liked the result and reproduced it in the subscribers' edition of *The Seven Pillars of Wisdom*. It shows him as he wished to be remembered, independent-minded, reflective and passionately pro-Arab, even to the extent of wearing Arab dress.

(NPG 3187)

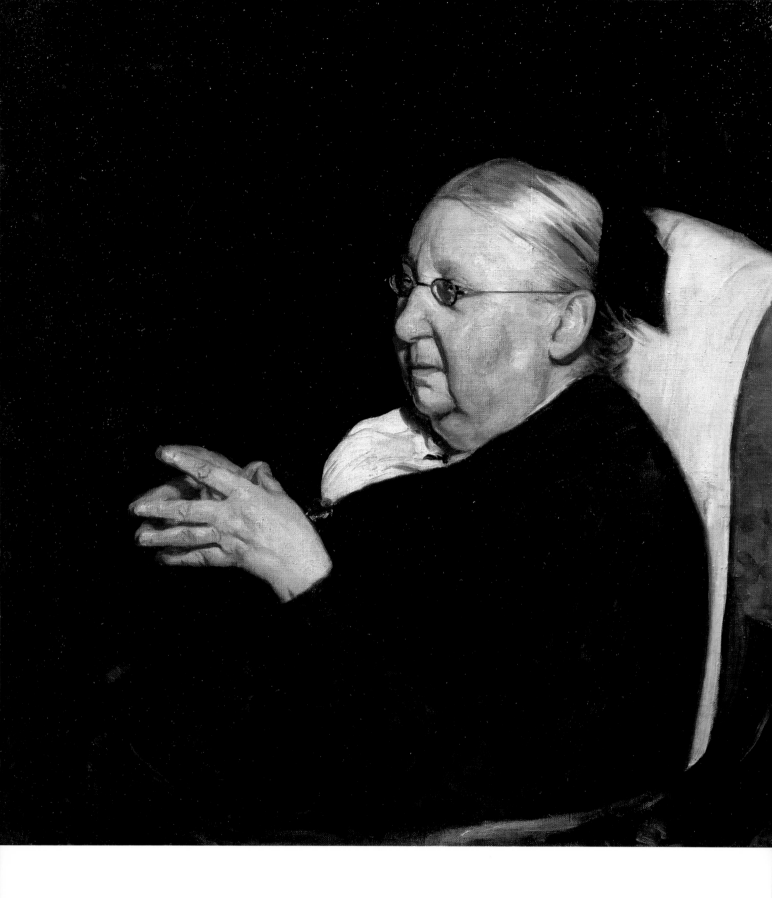

GERTRUDE JEKYLL (1843–1932)
Sir William Nicholson
1920
Oil on canvas, 76.2 x 76.2cm (30 x 30")

Gertrude Jekyll was trained as a painter at the School of Art in South Kensington, but because of myopia turned to embroidery, interior decoration and, late in life, to gardening. She became editor of *The Garden* and a frequent collaborator with Sir Edwin Lutyens, who encouraged her to sit for her portrait at her house in Munstead in autumn 1920 (she apparently was extremely reluctant). According to William Nicholson, 'It was a great event for me to meet Gertrude Jekyll, and I remember thinking her exactly the person I should like to paint. It wasn't an easy job, however, because she thought herself unpaintable – she said she needed all the light for her work – that after work she needed rest, and that there was one chair in front of the fire where she always rested. However, I managed to overcome one by one all these little difficulties, and painted her while she rested.' When the portrait was exhibited at the Grafton Gallery in 1921, Jekyll wrote, 'It is no enterprise of mine & I do not even know who is its mover or what its destination – all I had to do with it was to sit, which I did after a good show of resistance as I think ugly people had better not be painted.'

(NPG 3334)

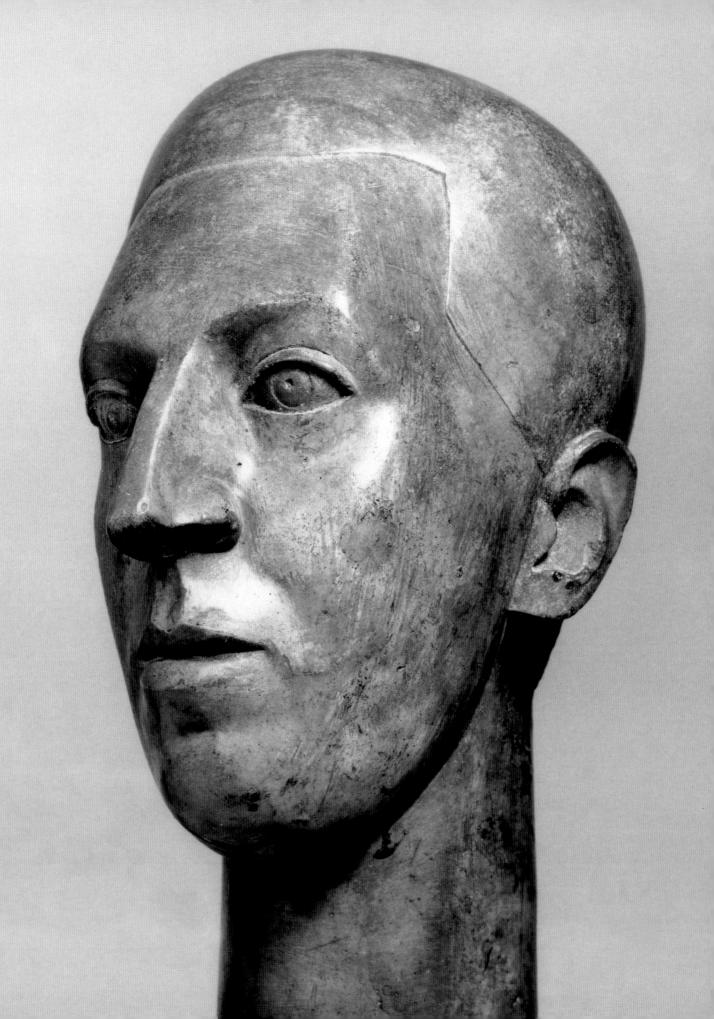

SIR OSBERT SITWELL (1892–1969)

Frank Dobson

1922

Painted plaster cast, height 32.4cm (12¾")

This fine, thoughtful and slightly cubist bust of Sir Osbert Sitwell was the result of a commission from the sitter to Frank Dobson in 1921. Dobson was widely regarded as an extremely promising sculptor, working in a modern idiom under the influence of Brancusi and Gaudier-Brzeska. Sitwell went for sittings in the artist's house in Manresa Road, Chelsea, almost every day for a period of three months in late 1921 and early 1922, just at the time when he, his sister Edith and their lodger William Walton were planning the musical entertainment *Façade*. In fact, Dobson subsequently provided the backcloth for *Façade*. T.E. Lawrence regarded the bronze version of the bust as a brilliant work, 'the finest portrait bust of modern times. . . . Appropriate, authentic and magnificent in my eyes, I think it's his finest piece of portraiture and in addition it's as loud as the massed band of the Guards.'

(NPG 6320)

Bertrand Russell, 3rd Earl Russell (1872–1970)

Roger Fry
*c.*1922
Oil on canvas, 54 x 45.1cm (21¼ x 17¾")

It is appropriate that Bertrand Russell should be represented by a portrait by Roger Fry. Both were dry, rather cerebral intellectuals, but both had more than a touch of worldliness, alongside their high moral principles, their pacifism and socialism. Both were members of the 'Apostles', a secret academic society, when they were undergraduates at Cambridge. Both were to be lovers of the well-known socialite Ottoline Morrell, who had such an appetite for the company of intellectuals at Garsington before the First World War. Moreover, Fry was a great admirer of Russell's work, writing in 1920 that 'He is one of the men of genius of our time.' So the portrait forms a nice record of the milieu that surrounded the Bloomsbury group: high-minded and preoccupied with the world of ideas.

(NPG 4832)

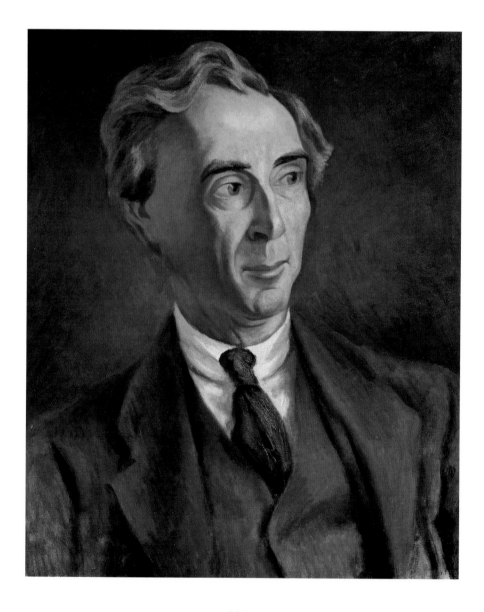

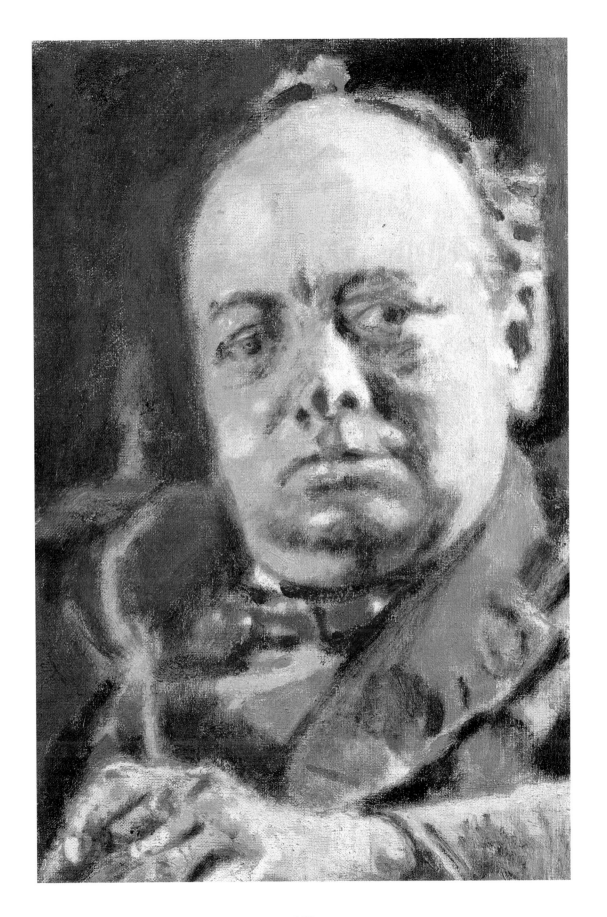

189

(Previous page)

SIR WINSTON SPENCER CHURCHILL (1874–1965)
Walter Richard Sickert
1927
Oil on canvas, 45.7 x 30.5cm (18 x 12")

Churchill's must be the most famous face of the twentieth century, wreathed in cigar smoke and with his look of formidably aggressive determination. Sickert caught his character well in this sketch undertaken when Churchill was Chancellor of the Exchequer. At the time, Sickert was giving Churchill painting lessons at the latter's house, Chartwell in Kent, so he may have had sittings for this work; but often Sickert worked straight from photographs, trying to catch the essential characteristics of someone famous without the distraction of what the sitter really looked like. Churchill himself disliked the portrait and gave it away soon after it had been presented to him.

(NPG 4438)

FREDERICK DELIUS (1862–1934)
Ernest Procter
1929
Oil on millboard, 32.1 x 26.2cm (12⅝ x 10¼")

Delius, who was blind as well as paralysed in the latter part of his life, is here depicted five years before his death with his nose in the air as if savouring a smell of the most intense deliciousness or remembering far-off music of his own composition. The picture was produced by Ernest Procter as a sketch for a larger work, which shows the composer in his wheelchair listening to a rehearsal for a performance of his choral work *A Mass of Life*, during the Delius Festival held at the Queen's Hall in west London in November 1929.

(NPG 3861)

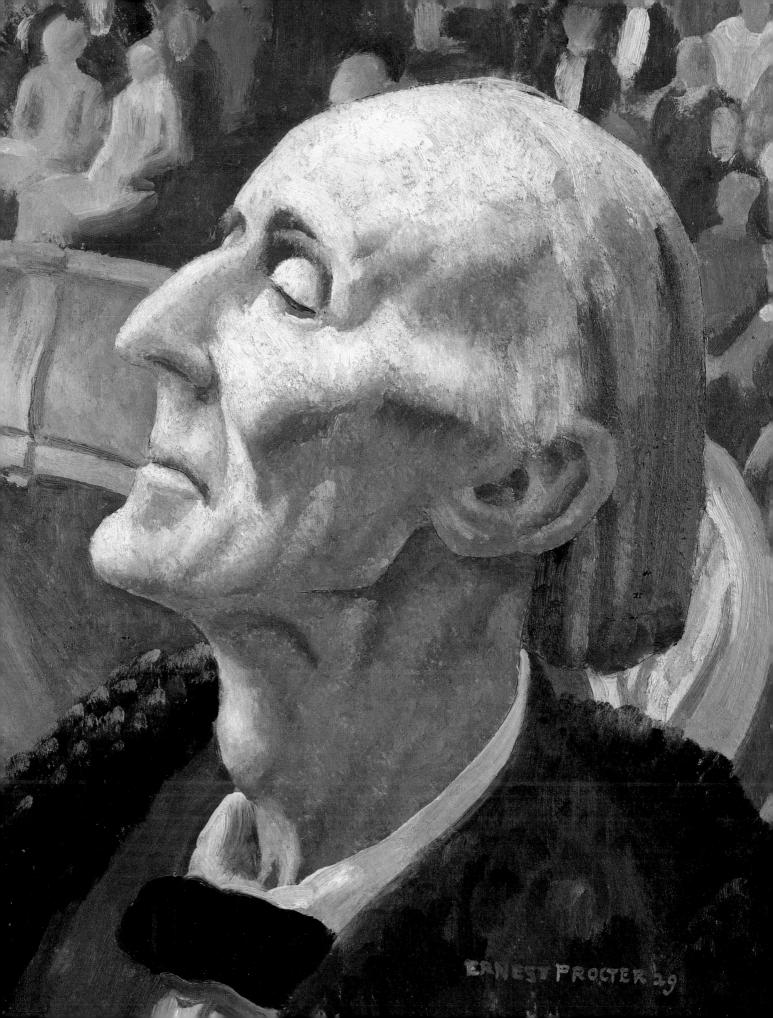

ERNEST PROCTER 29

JOHN MAYNARD KEYNES (1883–1946)
WITH BARONESS KEYNES (1892–1981)
William Roberts
1932
Oil on canvas, 72.4 x 80.6cm (28½ x 31¾")

John Maynard Keynes was a great patron of the arts and liked to buy the work of young British artists, often on the advice of his friends. He commissioned this portrait of himself and his wife, the Russian ballet dancer Lydia Lopokova, from William Roberts, paying for it on 4 July 1932. It is in Roberts' slightly abstracted, rather sculptural style but effectively conveys a sense of Keynes' formidable personality, book in one hand (he was a great bibliophile), cigarette in the other and, slightly oddly, wearing a heavy overcoat.
(NPG 5587)

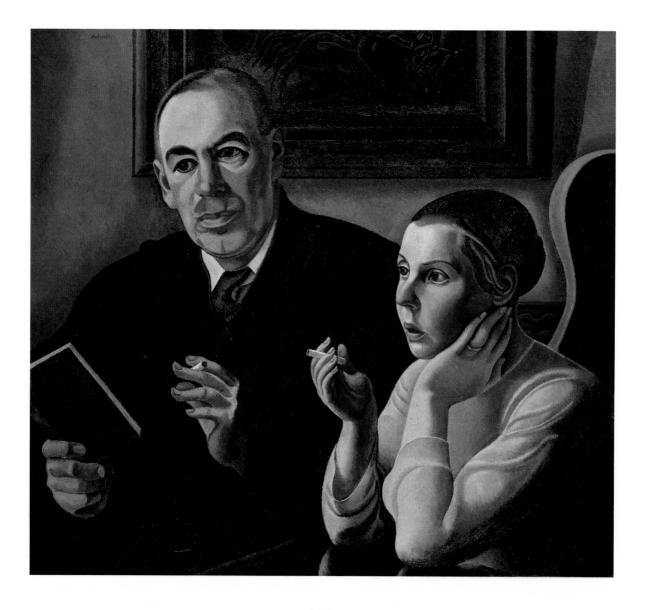

Rebecca West (1892–1983)
Wyndham Lewis
1932
Pencil, 43 x 31cm (17 x 12¼")

In 1932 Wyndham Lewis held an exhibition at the Lefevre Galleries called 'Thirty Personalities', subsequently published as *Thirty Personalities and a Self-Portrait*. It consisted of thirty drawings of celebrities of the day, including Rebecca West, the novelist, critic and former mistress of H.G. Wells. Lewis had met her before the First World War, when he described her arrival at a dinner party as 'a dark young maenad then, who burst through the dining-room door (for she was late) like a thunderbolt'. West became a contributor to the Vorticist magazine *BLAST* and remained an admirer of Lewis' writings. The drawing well conveys her intelligence and Amazonian good looks.

(NPG 5693)

Wyndham Lewis. 1932.

BEN NICHOLSON (1894–1982)
AND BARBARA HEPWORTH (1903–75)

Ben Nicholson
1933
Oil on canvas, 27.3 x 16.8cm (10¾ x 6⅝")

In her autobiography Barbara Hepworth described how she and the artist Ben Nicholson, whom she had first met in April 1931 and was to marry in 1934, travelled to the South of France in spring 1932: 'It was my first visit to the South of France, and out of three days at Avignon the most important time for me was spent at St Rémy. It was Easter; and after a bus ride we walked up the hill and encountered at the top a sea of olive trees receding behind the ancient arch on the plateau, and human figures sitting, reclining, walking, and embracing at the foot of the arch, grouped in rhythmic relation to the far distant undulating hills and mountain rocks.' During these three happy days early in their relationship, Ben Nicholson drew their profiles superimposed on one another in an image that is slightly prehistoric, as if preserved in the caves of Lascaux, with the hills of Provence in the background. The work hung over the mantelpiece at 7 The Mall Studios in Belsize Park, where they lived together.

(NPG 5591)

CHRISTOPHER ISHERWOOD (1904–86)
Humphrey Spender
1935
Bromide print, 21 x 14.6cm (8¼ x 5¾")

In 1979 Humphrey Spender provided information about his photograph of the novelist Christopher Isherwood as follows: 'This was taken in Berlin in about 1935. He is standing against the window of the apartment made famous in *Goodbye to Berlin* with its landlady who called him Herr Issyvoo. It was an intended irony, though perhaps rather too subtle, that the upraised arm echoes the "Heil Hitler" greeting gesture. He is looking at, and commenting on, some activity in the street two floors below.' It is an appropriately melancholy image, slightly narcissistic, combined with Spender's interest in precise pictorial record.

(NPG P41)

THE POST-WAR PERIOD TO
THE PRESENT DAY

SIR ALFRED HITCHCOCK (1899–1980)

Irving Penn

1947

Vintage gelatin silver print, 24.4 x 19.4cm (9⅝ x 7⅝")

Irving Penn's photograph of Alfred Hitchcock was taken in 1947 and published in American *Vogue* on 15 February 1948. It is a fine, cool and dispassionate image of the great master of suspense, showing him, as often in Penn's photographs, sitting nowhere, perched on a pile of industrial carpet and only half-concentrating on the camera.

(NPG P593)

THOMAS STEARNS ELIOT (1888–1965)

Patrick Heron

1949

Oil on canvas, 76.2 x 62.9cm (30 x 24¾")

Patrick Heron has himself described how he came to undertake his well-known portrait of the poet T.S. Eliot: 'I wrote to Eliot in January, 1947, saying that I had for a long time been thinking around the problem of a portrait, and asking him if he would object to this; and, if not, if he'd give me sittings. He replied very charmingly, giving his consent and saying that he "had, of course, been warned of your interest in the possibilities of my features". (He must have heard of this from my father, who knew him.) The drawings, and one study in oils, were made at sittings during 1947 and 1949: but the *Portrait* which you now have was made about a year after I'd had the last of these sittings, that is, towards the end of 1949, I think. It was first shown in an exhibition I held at the Redfern Gallery in April–May 1950.' This provides all the information one needs about the portrait but perhaps fails to convey its significance as an attempt to keep alive the conventions of portraiture through Cubism, so that Eliot is seen simultaneously both full face and in profile.

(NPG 4467)

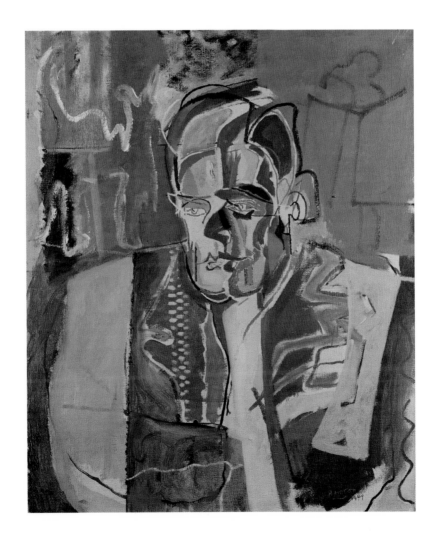

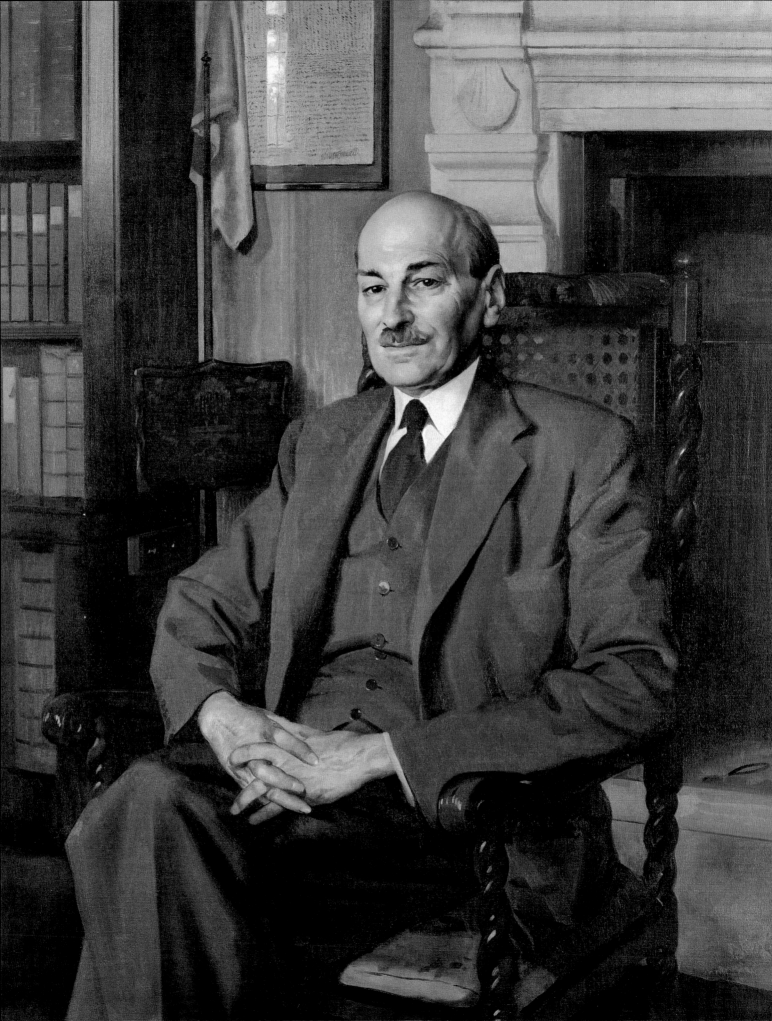

CLEMENT ATTLEE, 1ST EARL ATTLEE (1883–1967)
Sir James Gunn
1950
Oil on canvas, 126.8 x 101.2cm (50 x 39⅞")

This appropriately earnest portrait of *The Rt. Hon. C.R. Attlee CH, MP* was commissioned by the Labour Party in 1950, presumably following their victory in the general election in February, when Labour won by a majority of ten. It shows Attlee as he must have wished to be remembered, like a retired, rather successful bank manager, which indeed was precisely the style he cultivated as Prime Minister. Gunn, who specialised in such straightforward official portraits, was an appropriate choice for the work. He was a brilliant technician and highly conservative in his attitudes to his art, writing that 'An Artist does not need to be a judge of character if he paints what he sees and paints it sincerely.'
(NPG L205)

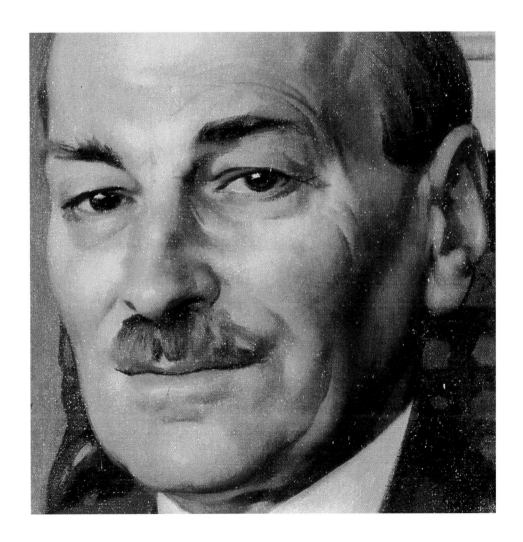

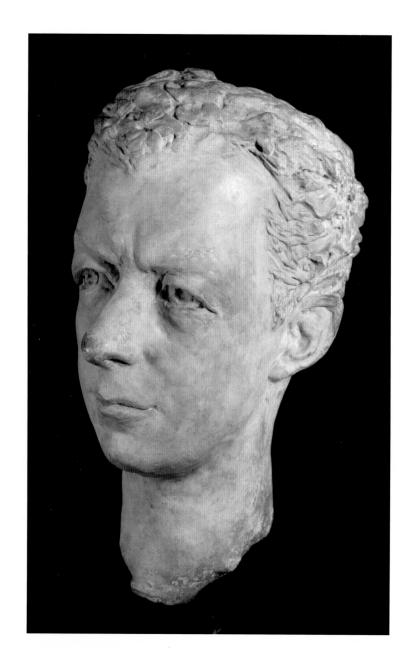

BENJAMIN BRITTEN, BARON BRITTEN (1913–76)
George Ehrlich
1951
Plaster cast for bronze head, height 38.1cm (15")

George Ehrlich was born in Vienna in 1897, trained as a painter at the Kunstgewerbeschule, turned to sculpture in the late 1920s, and emigrated to London just before the Second World War. In England much of his work was devoted to animals and small children, but in November 1951 he undertook a portrait bust of Benjamin Britten. It stands outside the tradition of British post-war sculpture, which is hardly surprising given that the artist was a product of an intensely academic training just after the First World War; but it is none the worse for that. Indeed, it is a convincing, rather intense image of a great composer.

(NPG 5910)

SIR EDUARDO PAOLOZZI (b.1924)
John Deakin
1952
Bromide print, 30.1 x 26cm (11⅞ x 10¼")

John Deakin was a photographer who worked for *Vogue* during the early 1950s before he was fired because of his dissipated lifestyle; but his life propping up the bar in the pubs and clubs of Soho enabled him to take extraordinarily unflinching photographs of a wide group of artists, writers and other bohemians, including Francis Bacon, who used his photographs as the basis for paintings, Lucian Freud, Dylan Thomas and Louis MacNeice. This photograph of the sculptor Eduardo Paolozzi in his youth is characteristic of Deakin's work: full frontal and raw, it has been taken without using any tricks of the photographer's trade and instead relies on the relationship between photographer and sitter, creating an image of dark-eyed impassivity.
(NPG P296)

WYSTAN HUGH AUDEN (1907–73)
Richard Avedon
1960
Bromide print, 60 x 48.3cm (23⅝ x 19")

Throughout a long career as one of the most prolific post-war American photographers, Richard Avedon has taken many memorable images of famous sitters. The majority are photographed in the studio, but this portrait of the poet W.H. Auden was taken through a snowstorm in St Mark's Place, New York, on 3 March 1960.

(NPG P614)

KENNETH CLARK, BARON CLARK (1903–83)
Graham Sutherland
1962–4
Oil on canvas, 54.6 x 45.7cm (21½ x 18")

Graham Sutherland, who was an old friend of Kenneth Clark and owed much to his support, has caught his arrogant character well. Clark retreated from his plutocratic upbringing as the son of a Scottish textile magnate into the world of the arts and became an extraordinarily dominant figure. Director of the National Gallery at the age of 31, he spent the 1950s as Chairman of the Arts Council and of the Independent Television Authority. At the time this portrait was painted, in the early 1960s – sittings took place in the garden of Sutherland's house at Trottiscliffe in Kent between February 1962 and December 1964 – Clark was a Trustee of the British Museum, on the Advisory Council of the Victoria and Albert Museum and had recently been Slade Professor at Oxford for the second time. It is hardly surprising that he looks like a highly refined mogul.

(NPG 5243)

CHRISTINE KEELER (b.1942)
Lewis Morley
1963
Bromide print, 50.8 x 41.3cm (20¼ x 16½")

Lewis Morley's photograph of Christine Keeler sitting naked the wrong way round on an Arne Jacobsen chair has become one of the defining images of the 1960s. A combination of pin-up and icon, suggestive both of sexual liberation and at the same time of the penalties of sexual exploitation, it occupies a morally ambiguous universe. It was taken in May 1963, when Christine Keeler came to Lewis Morley's studio over the Establishment Club in Greek Street to be photographed to promote a film on the Profumo Affair. One of the prints was stolen and published in the *Sunday Mirror*.
(NPG P512(13))

HAROLD WILSON (1916–95)

Ruskin Spear
*c.*1974
Oil on canvas, 51.1 x 38.1cm (20⅛ x 15")

Ruskin Spear frequently did not paint from life but from press photographs or from photographs he took himself. He liked to produce paintings that conveyed information about someone's public persona. As it happened, his portrait of Harold Wilson was based on sittings at 10 Downing Street, but he might as well have done it from photographs, because it is a portrait of a man who did not allow much insight into his personality, but hid behind veiled eyes and a cloud of tobacco smoke. As Ruskin Spear wrote, 'The man is a great actor, using his pipe as an extension of himself, stabbing with its stem to emphasize points.' When the portrait was exhibited at the Royal Academy Summer Exhibition in 1974, it was called *Man with a Pipe*.
(NPG 5047)

SIR JOHN SUMMERSON
(1904–92)
Leonard Rosoman
1984
Oil on canvas, 152.1 x 122cm (60 x 48")

Tall and spare, and an elegant prose stylist, Sir John Summerson typified the professional mandarinate that dominated government and the arts after the Second World War. Educated at Harrow and the Bartlett School of Architecture, Summerson turned to writing about architecture in the early 1930s, under the pseudonym 'Coolmore'. In 1945 he became Curator of Sir John Soane's Museum in Lincoln's Inn Fields and remained in this post until his retirement in 1984, aged 80, combining his not very onerous official duties with numerous committees and a succession of major books. Leonard Rosoman was commissioned to undertake a portrait of him shortly before his retirement and depicted him, most appropriately, at the Soane Museum.

(NPG 5730)

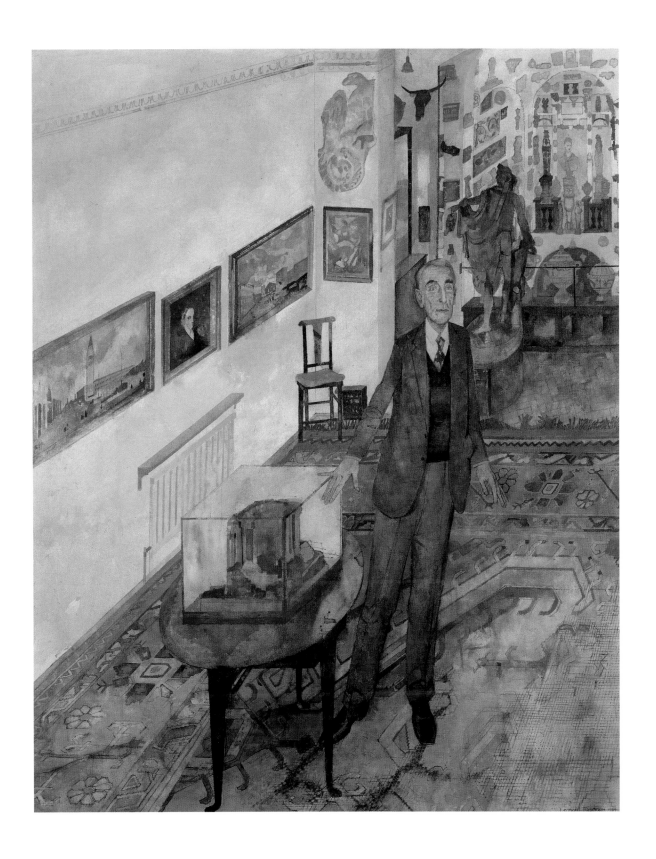

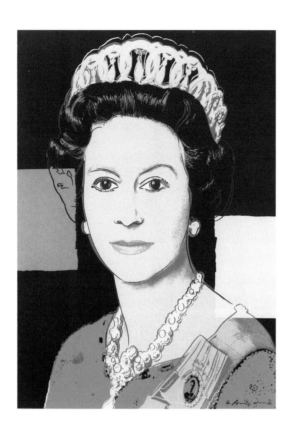 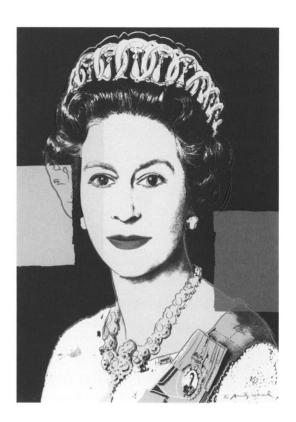

QUEEN ELIZABETH II (b.1926)
Andy Warhol
1985
Silkscreen prints, each 100 x 80cm (39⅜ x 31½")

Portraits in the Gallery's collection are supposed to be from the life, but the Queen certainly did not sit to Andy Warhol. Instead he based his set of four silkscreen prints on an earlier Royal Jubilee photograph taken in 1977 by Peter Grugeon. The prints were part of a group of 'Reigning Queens' and make ironic play with the classic iconography of the monarchy in exactly the same way that Warhol had previously subverted advertising imagery by the replication of images of Campbell's soup tins. In an interview with Warhol soon after this series, he was asked if he had included himself in the set. He replied, 'Er, er, oh well, everybody knows that I'm a queen . . . but the prints are of royal ones and stuff.'
(NPG 5882/1-4)

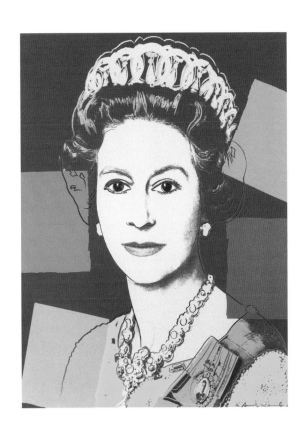 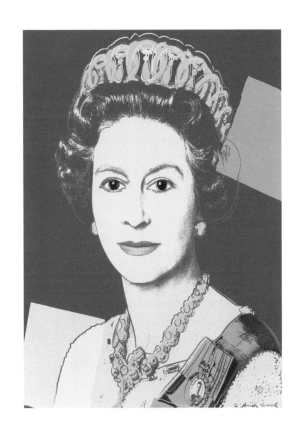

STEPHEN HAWKING (b.1942)
Yolande Sonnabend
1985
Oil on canvas, 91.2 x 71cm (35⅞ x 28")

In the 1980s, encouraged by Margaret Gowing (who was both a Trustee and an historian of science), the Gallery embarked on an active policy of commissioning portraits of scientists, on the grounds that science and technology make a contribution to British culture which is not always well understood by the general public. One of the first such commissions was of Stephen Hawking, who at the time was known only to specialists for his distinguished work on relativity. It was only in 1988 that Hawking became universally known as the author of *A Brief History of Time*, which had a massive readership in spite of the fact that few who have read it claim to have understood it.

(NPG 5799)

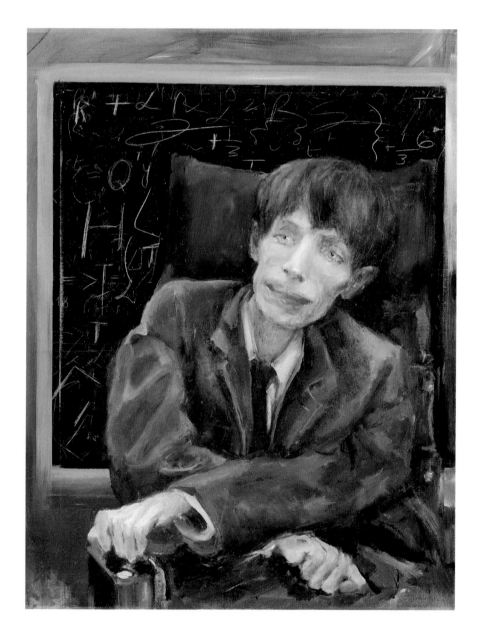

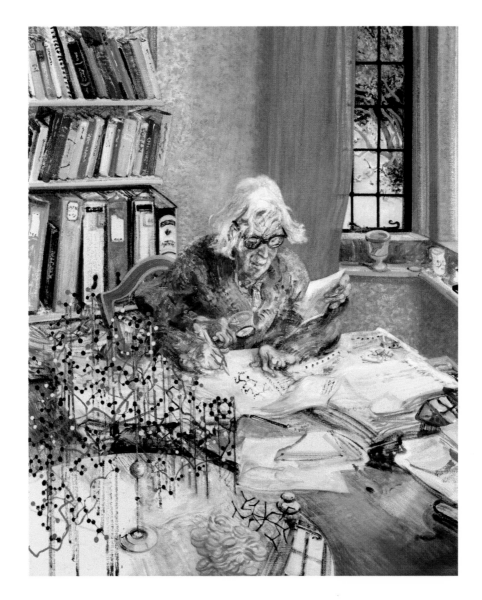

DOROTHY MARY HODGKIN (1910–94)
Maggi Hambling
1985
Oil on canvas, 93.2 x 76cm (36¾ x 30")

Dorothy Hodgkin was one of the most important chemists of the post-war period, making her reputation by the analysis of the structure of penicillin, winning the Nobel Prize for Chemistry in 1964 for her work on Vitamin B_{12} and going on to research insulin. Maggi Hambling has provided an effective image of a scientist obsessed by her work, surrounded by papers and files, with the model of insulin on the table in front of her, and her hands moving rapidly over the page as she sketches crystallographic structure. Hambling was deeply impressed by Hodgkin, writing that she was 'one of the most important and genuinely enlightened people of our time and I wanted to convey this sense of her. It's almost as though she were an ancient alchemist, making magic.' Apparently Dorothy Hodgkin's only regret was that she hadn't brushed her hair.

(NPG 5797)

DAME IRIS MURDOCH
(b.1919)
Tom Phillips
1986
Oil on canvas, 91.4 x 71.1cm (36 x 28")

Tom Phillips, an Oxford-educated and unusually polymathic artist, was commissioned to undertake a portrait of the writer Iris Murdoch in 1984. On 10 May 1984 he wrote, 'I'm a fairly ruminative portraitist & with such a philosophical sitter the job should take about a year.' In fact, it took three. As Phillips wrote after it was completed: 'The picture was painted in a corner of my studio in Peckham. Iris is sitting in my usual sitter's chair, half looking out of the window (or fully looking out if dogs or intriguing people passed by). The work spanned three years: I think there were fifteen sittings in all: each lasted up to two hours with a break or two for coffee.' The result is a dry, dispassionate painting with Titian's *Flaying of Marsyas* in the background and the leaves of a ginkgo tree in front.

(NPG 5921)

HAROLD EVANS (b.1928) AND TINA BROWN (b.1953)
David Buckland
1987
Cibachrome print, 99.1 x 76.2cm (39 x 30")

Hard, glossy and unreal, this photograph by David Buckland manages both to commemorate and to satirise the fictions of 1980s image-building. Harold Evans, as former editor at the *Sunday Times*, is associated with the promotion of colour supplement culture with its emphasis on lifestyle features and profiles, although he was also a great supporter of investigative journalism. His wife Tina Brown made her name as editor of *Tatler* before moving to New York, where she was editor first of *Vanity Fair* and now of *The New Yorker*. Together they stand as icons to the fact that glossy magazines are now the fastest route into the halls of fame.

(NPG P380)

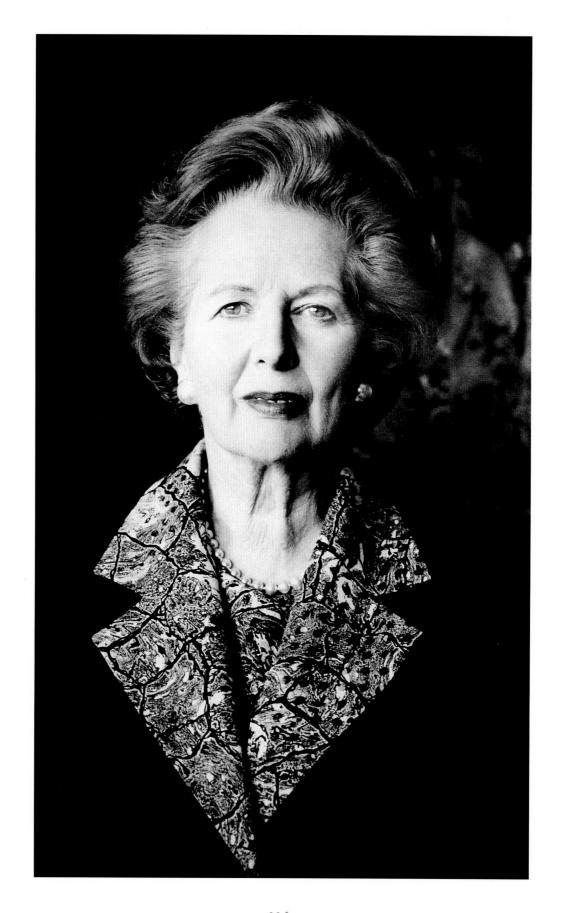

MARGARET THATCHER, BARONESS THATCHER (b.1925)
Helmut Newton
1991
Bromide print, 199 x 114cm (78½ x 45")

This huge and mildly alarming photograph of the former Prime Minister looking regal has always intrigued me as to why on earth she came to sit to a photographer who is best known for elegantly erotic shots of young girls. The answer is that Margaret Thatcher was the woman in the world whom Helmut Newton most admired. For years he wrote asking her to sit to him, and in 1991 she finally agreed. Newton produced a picture of her after she had fallen from power, which demonstrates her remarkable force of character.

(NPG P507)

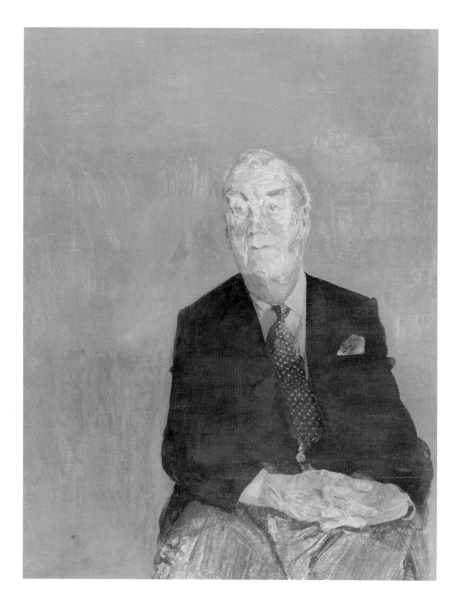

WILLIAM WHITELAW, 1ST VISCOUNT WHITELAW (b.1918)
Humphrey Ocean
1992
Oil on canvas, 127 x 101.6cm (50 x 40")

Humphrey Ocean's portrait of Lord Whitelaw was one of the Gallery's most problematic commissions. The Trustees wanted to commemorate Lord Whitelaw not only as an important source of good advice to Mrs Thatcher when she was Prime Minister, but also because he had helped the Gallery valiantly when it was fund-raising for its major development scheme. They selected as artist Humphrey Ocean, who had made his reputation through the Gallery's BP Portrait Award, and had subsequently undertaken a number of commissions for the Gallery, including Paul McCartney and Philip Larkin. But when the work was delivered, the Trustees declared 'It's not our Willie!' Indeed, it is not. The work shows an old man, who has ceased to hold power in the engine-room of government and looks sad and slightly deflated. But it is effective as a portrait precisely because it is an evocation of the consequences of old age.
(NPG 6223)

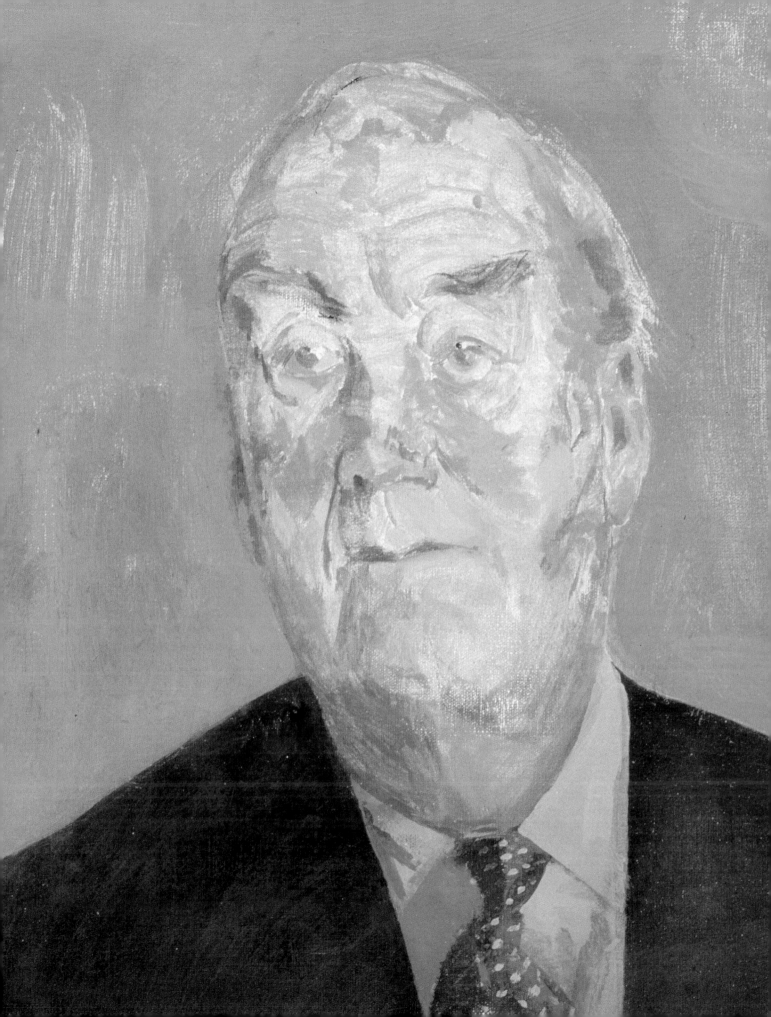

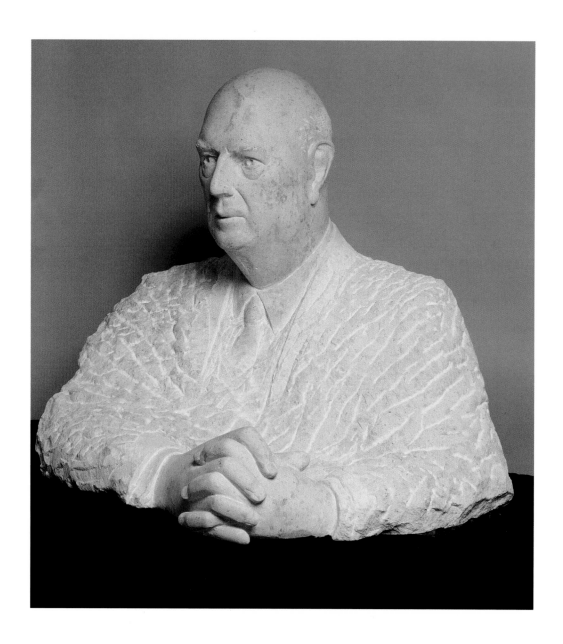

NOEL ANNAN, LORD ANNAN (b.1916)
Glynn Williams
1993
Limestone bust, height 75.5cm (29¾")

I have always liked the fact that the late twentieth-century collection should be dominated by the large and powerful portrait bust of Noel Annan, who is not necessarily well known to the general public but whose career as an academic politician epitomises the post-war liberal consensus. After a distinguished career in military intelligence, Annan went back to King's College, Cambridge, as a politics don, became Provost aged 39 and then migrated to the corridors of power in London by becoming Provost of University College, London. His prominent domed forehead and expression of alert intelligence are a monument to the Oxbridge dons who in the 1950s and 1960s made a significant contribution to public life.

(NPG 6220)

GLENDA JACKSON (b.1936)
Glenys Barton
1993
Ceramic, height 40cm (15¾")

Glenys Barton, a sculptor in ceramic, has herself written of this piece: 'The double portrait depicts the actress and the politician. My most vivid memory of Glenda in the sixties was as Gudrun in *Women in Love*. As a romantic would-be young artist I identified with the character of Gudrun, a sculptor herself, in the film. From then on I was always interested in Glenda's career and, inclined towards the left politically myself, was even more impressed when she became a Labour MP.' The two heads of Jackson, the younger as Gudrun Brangwen in *Women in Love*, are an effective way of conveying the contrast between public and private, and between the actress and the politician.

(NPG 6224)

DEREK JARMAN (1942–94)
Michael Clark
1993
Oil on card, 45.1 x 33.3cm (17¾ x 13⅛")

Michael Clark's portrait of Derek Jarman, the brilliant artist, film-maker, writer and gardener, was done on card at the Soho patisserie Maison Bertaux, just before Jarman's death from AIDS. By the time of his death Jarman had become a cult figure, and this is the last known portrait for which he sat. Jarman talked during sittings about his film *Blue* and Clark then worked from photographs. He added an inscription from Lorca in mirror writing: GOZA EL FRESCO PAISAJE DE MI HERIDA. . . . PERO PRONTO! . . . EL TIEMPO NOS ENCUENTRE DESTROZADOS—'Enjoy the luscious landscape of my wound . . . but hurry! . . . time meets us, and we are destroyed.'

(NPG 6322)

233

STEPHEN FRY (b.1957)
Maggi Hambling
1993
Charcoal, 153 x 101.6cm (60¼ x 40")

Tall, gangling and mildly effete, Stephen Fry has been the subject of innumerable portrait drawings by Maggi Hambling, many of which concentrate not on his face but on his gait. This portrait of his face half-crumpled by neurotic anxiety was preferred to her finished painting of him. It was acquired by the Trustees on the afternoon of the day that Fry disappeared from public view, halfway through the run of an exceptionally unsuccessful production of Simon Gray's play *Cell Mates*.
(NPG 6323)

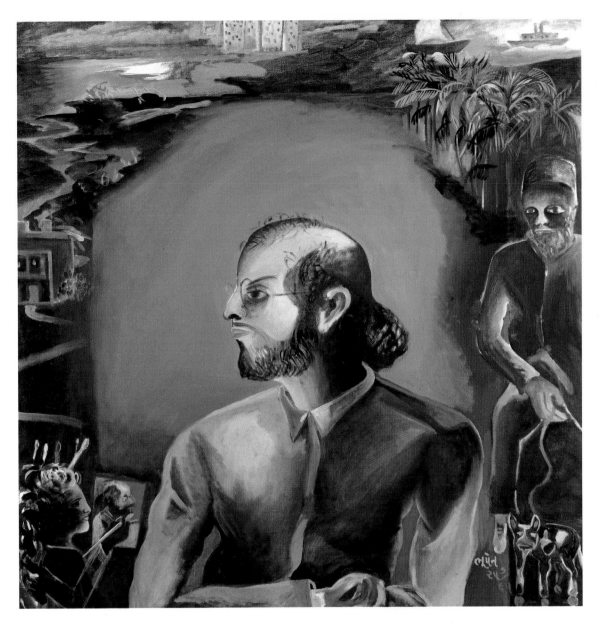

SALMAN RUSHDIE (b.1947)
Bhupen Khakhar
1995
Oil on linen, 121.9 x 121.9cm (48 x 48")

Salman Rushdie came to the Gallery for a party in July 1995 and mentioned that he was being painted by the prominent Indian painter Bhupen Khakhar for a BBC documentary due to be shown in early September to coincide with the publication of his book *The Moor's Last Sigh*. The portrait, entitled *Salman Rushdie: The Moor*, was shown at the Gallery in September 1995 and the Trustees acquired it at their meeting in November. It is particularly appropriate as a way of showing Rushdie, as it combines the Western tradition of portraiture with elements of Mughal painting, including narrative scenes derived from *The Moor's Last Sigh* round the edge.

(NPG 6352)

235

GERMAINE GREER (b.1939)
Paula Rego
1995
Pastel on paper, laid on aluminium, 120 x 111.1cm (47¼ x 43¾")

The portrait of Germaine Greer by Paula Rego is one of the most successful – and popular – of the Gallery's commissions. Although Paula Rego does not normally accept commissions, she agreed to paint Germaine Greer, the most public advocate of feminism and author of *The Female Eunuch*. This was partly because Germaine Greer has been a long-standing supporter of Paula Rego's work, having written an introductory essay to a catalogue of her paintings when she was artist-in-residence at the National Gallery. Arrangements were made for sittings to take place at Paula Rego's studio in Camden Town during the hot August of 1995. Germaine Greer was wearing her favourite Jean Muir dress and old, gold shoes and her hands were rough from gardening. In all they had thirty hours of sittings and listened to the entire *Ring* cycle. The result is a powerful example of contemporary portraiture: vigorous, straightforward, but monumental as well.
(NPG 6351)

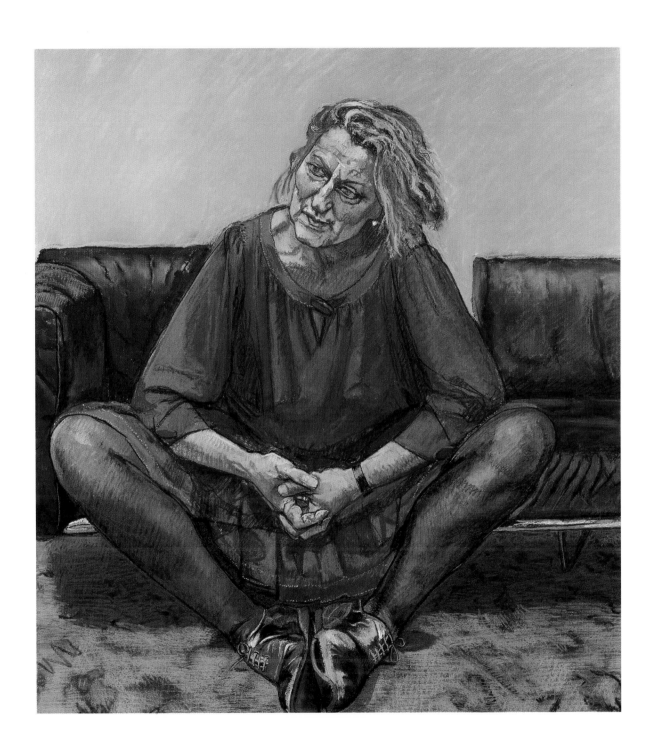

237

INDEX